THE PLANAR DIMENSION

EUROPE, 1912-1932

THE PLANAR DIMENSION

BY MARGIT ROWELL

This project is supported by a grant
from the National Endowment for the Arts
in Washington, D.C., a Federal Agency

Published by

The Solomon R. Guggenheim Foundation,

New York 1979

ISBN: 0-89207-017-X

Library of Congress Card Catalogue Number: 78-74711

© The Solomon R. Guggenheim Foundation, New York, 1979

LENDERS TO THE EXHIBITION

Robert d'Anethan, Paris

Mme Arp, Clamart, France

Mr. and Mrs. Joseph Ascher

Mr. and Mrs. Herman Berninger, Zürich

Max Bill, Zürich

Robert and Andrea Bollt, New York

M. Bricheteau, Paris

George Costakis

Dr. and Mrs. André F. Essellier, Zürich

Gladys C. Fabre, Paris

Miriam Gabo

Ursula and Hans Hahn

Carl Laszlo

M. and Mme Claude Laurens, Paris

Yulla Lipchitz

McCrory Corporation, New York

Mr. Neirynck, Sint-Martens-Latem, Belgium

Lev Nussberg, Paris

Christian Schad

Mr. and Mrs. James Johnson Sweeney

Collection Thyssen-Bornemisza, Switzerland

Cecilia Torres-García, New York

Lydia and Harry L. Winston Collection (Dr. and Mrs. Barnett Malbin), New York

Bayerische Staatsgemäldesammlungen, Munich

The Cleveland Museum of Art

The Solomon R. Guggenheim Museum, New York

Hirshhorn Museum and Sculpture Garden, Smithsonian Institution, Washington, D.C.

I.M.A.

Kunsthaus Zürich

Kunstmuseum Basel

Louisiana Museum, Humlebaek, Denmark

Moderna Museet, Stockholm

Musée d'Art Moderne, Strasbourg

Musée d'Art Moderne de la Ville de Paris

Museé National d'Art Moderne, Centre Georges Pompidou, Paris

Museum Ludwig, Cologne

The Museum of Modern Art, New York

Muzeum Sztuki, Łódź, Poland

National Gallery of Art, Washington, D.C.

Philadelphia Museum of Art

The Phillips Collection, Washington, D.C.

Stedelijk Museum, Amsterdam

Stedelijk van Abbemuseum, Eindhoven, The Netherlands

Tate Gallery, London

Tel Aviv Museum

Yale University Art Gallery, New Haven

Galerie Bargera, Cologne

Galerie Jean Chauvelin, Paris

Galerie Gmurzynska, Cologne

Henkel KGaA, Düsseldorf

Leonard Hutton Galleries, New York

Annely Juda Fine Art, London

Lords Gallery, London

Marlborough Fine Art (London), Ltd.

N. Seroussi, Galerie Quincampoix, Paris

Galerie Tronche, Paris

Kunsthandel Wolfgang Werner, KG, Bremen

ACKNOWLEDGEMENTS

The Planar Dimension: Europe, 1912-1932 is an investigation both visual and theoretical of formal developments peculiar to one area of modern sculpture. While various aspects of this theme have been written about, to the best of our knowledge the phenomenon has not until now been isolated, nor has any major exhibition been devoted to it.

The Solomon R. Guggenheim Museum is able to introduce the subject with an exemplary selection of works and an illuminating catalogue essay because Margit Rowell, the Museum's Curator, conceived the theme and provided the visual and verbal rationalizations. It is proper, therefore, to extend to Miss Rowell the Guggenheim's gratitude for extensive preparatory research and for an exceptionally lucid and informative text, which is not only valid independently but serves as commentary upon the selection.

Every loan show is the result of owners' generosity, and acknowledgements to lenders are therefore often viewed as a mere formality. Loans for precisely defined theme exhibitions are less interchangeable than those required for more general presentations, as specific rather than generic examples are needed to convey concepts in their undiluted intent. We are glad to report that the logic and inherent forcefulness of our theme persuaded most museums and private collectors to grant our requests for loans. The fact that fragile, vulnerable and unique pieces, often by the masters of modern art, were involved heightened the difficulties of securing loans, increased our responsibilities as borrowers and deepened our indebtedness toward those who temporarily parted with their possessions to see them incorporated in *The Planar Dimension*. These generous institutional and private lenders are listed separately in this catalogue, unless they requested anonymity.

I also wish to acknowledge on behalf of Margit Rowell and the Guggenheim Museum the contributions made by the following individuals: Gladys C. Fabre, Donald Karshan, Gilbert Lloyd, Sir Norman Reid, William Rubin, Jeffrey Solomons and Heinz Teufel. Without their knowledgeable participation and generous disposition toward us, many key examples would be missing from our exhibition, while others would have come to the Museum without the information which renders them particularly useful in the context we propose.

Finally, Philip Verre, Curatorial Coordinator, and Carol Fuerstein, Editor, must be singled out from among the many Museum staff members who aided in the preparation of the exhibition and catalogue; they are to be thanked for their direct, central and effective assistance to Margit Rowell.

Thomas M. Messer, *Director*
The Solomon R. Guggenheim Museum

fig. 1
Anthony Caro
Java. 1976. Steel, 65 x 86 x 35″
André Emmerich Gallery, New York

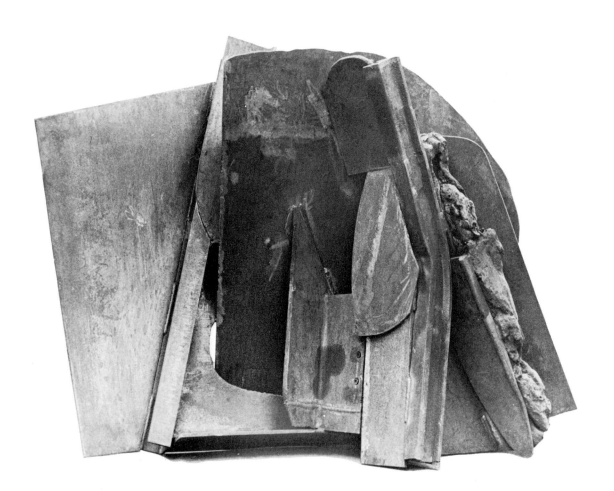

THE PLANAR DIMENSION 1912-1932:
FROM SURFACE TO SPACE

by Margit Rowell

The planar dimension is the painter's dimension. Yet, to the generations which came of age in the 1960s and 1970s, planar is synonymous with sculpture and planar sculpture synonymous with one aspect of modernism. From this standpoint, the use of the planar dimension in sculpture is perceived as a peculiarly American formal development, comparable to Abstract Expressionism in painting.

The comparison is apt. Abstract Expressionism, although an American vernacular, sprang from iconographic sources and technical inventions of European origin. Similarly, sculptors who have followed David Smith in using the plane today may be considered indebted to Picasso's and Gonzalez's formal innovations. It is an enigma of history why Picasso's constructions, invented over sixty-five years ago, while they inspired a few immediate successors, had to await the advent of Smith for a consistent development of the logical syntax they implied.

This hiatus occurred, as we may now suggest, because Picasso's constructions—extensions of the picture plane into the space in front of the wall—were extremely equivocal objects. They referred to the painted plane but seemed to deny pictorial space. Virtually three-dimensional, they dissolved the mass or volume of traditional sculpture. They were architectonic without being architectural. These contradictions, viewed from diverse perspectives, provided artists with a wealth of options for subsequent formal developments, options which could not be exploited in terms of sculpture alone. The goal of this exhibition is to explore the singular possibilities presented by Picasso's constructions. It is furthermore hoped that this study will enrich our framework of assumptions about three-dimensional works of art from the period 1912-32.

The objects brought together here are extremely varied in style, form, intention and content. Yet they do possess several common characteristics. First, while none of these works may be defined as strictly two-dimensional, all are constituted of two-dimensional components or planes. Here we do not mean a plane

to be the outer surface of a concave volume, the result of a process of hollowing out a representational three-dimensional figure which leaves a void. In this context we are referring to the flat picture plane used as a two-dimensional environment or support. It exists in space as a geometric surface, having length and breadth but no thickness. In painting the plane is an abstraction, a translation of visual images into conceptualized forms. Spatialized it is no different, except that its structural autonomy is underscored.

The resulting objects embody a profound contradiction which is distinctly modern: for a kind of idealism or conceptual form is coupled with its opposite, a kind of materialism or attention to materials. The solid mass of sculpture is pared away, dematerialized, leaving the plane, a product of the conceptual mind. At the same time, this conceptualized image requires unconventional techniques and media. And each of these materials calls attention to itself, to the fact that it is literally what it is and not a metaphor for something else. Finally, and as a consequence, the volumes of the objects are translated into spatial voids. Space, once the outer envelope of sculpture, becomes its very substance.

Starting in around 1912 the artists who experimented with planes in space, as opposed to mass or planes on a canvas surface, often were, or at least considered themselves, painters. It is difficult to explain the precise motivations for these at times brief and occasionally uncharacteristic incursions into actual space. And yet they are understandable in that the planar dimension was the natural element of these artists. They detached the two-dimensional surface from the wall and installed it, as surface, in front of the wall. And these abstract components of pictorial space, translated into concrete materials and actual space, would alter our expectations in regard to twentieth-century painting, sculpture and architecture.

Cézanne was the first to conceive of the plane as a defined area of surface space to close the wall. He reconstructed the canvas surface and in so doing demonstrated the dialectical process of perceptual experience

in actual physical terms: first, our retina records a densely woven fabric of visual sensations existing in a single plane in space; second, we conceptually process these juxtaposed planes to understand their positions in depth in relation to each other and to ourself. During the second phase of perception cognition takes over from vision and forms begin to coalesce. But Cézanne, like life—as opposed to art up to that time—provided no visual clues, no shifts of scale, vanishing points, accents, focusing, shading. His paintings did not filter the experience through a predetermined aesthetic coding of the surface.

The earliest objects presented here evolved as a direct consequence of Cézanne's reassessment of the painted surface. The questions crystallized in these Cubist constructions are an extension of Cézanne's critical probings of his own art: most generally concerning the relation of real space or surface to illusionary space, depth or even to the wall; more specifically about the complex and by now ambivalent interrelations between solid and void, figure and ground, line and plane, modeling (implied light and shadow) and modulating (patches of pure color or hue). Cézanne dissolved these polarities according to his own necessities. And after Cézanne no thoughtful painter or sculptor could accept these terms as givens but was obliged to rethink them in relation to his own ends.

I Cubism

Cubist constructions provided the first and most eloquent examples of this new, tentative expression. In 1912 Picasso turned to experiments in actual space in an attempt to mold a new pictorial syntax, conceivably to break away from the Cézannean aesthetic which still prevailed in Analytical Cubism. The singularity of Picasso's constructions, situated at the juncture between the Analytical and Synthetic phases of Cubist painting, may be attributed to their formulation of a painter's vision in three-dimensional terms.

Analytical Cubist painting retained vestiges of illusionism. The separation between object and surrounding space was not clear. The planar components which constituted both areas of the image were visually interlaced and simultaneously served conflicting functions: as material object and empty space, two-dimensional plane and depth perspective, representation and pure pattern. In Synthetic Cubism the image was clarified and no longer generated such confusion. The radical difference between these two modes of painting stems from the fact that Analytical Cubism was an abstraction or distillation of forms from nature, whereas Synthetic Cubism was the formal embodiment of a concept.

Telescoping Picasso's progression, one could say that in Analytical Cubism the volume of the subject was flattened to its outer skin and the skin then thinned, sometimes to transparency. In the constructions the skin, stretched taut and smooth, would split, baring the subject's anatomy. The plates and planes thereby revealed would constitute the structure and substance of Synthetic Cubist painting. After expelling the space from his constructions, Picasso would flatten and adjust their planar skeletons to the wall. Thus Picasso's constructions stand half-way between illusionistic painting with referents in the real world and autonomous conceptualized images. Therein lies their ambiguity.

The subjects of Picasso's constructions derived directly from Analytical Cubist canvases: a bottle, a violin, a guitar, somewhat later a glass or dice. The monochromatic treatment of the initial constructions, occasionally inflected by crosshatching, also echoes his earlier pictures. Although pictorially conceived, the motifs have no backgrounds; they are instead silhouetted against the wall. This represents not only a logical evolution from the blurred and indeterminate Analytical Cubist ground, but also may result from Picasso's interest in African sculpture.

The Ivory Coast masks which appealed to Picasso, Braque, Derain, Vlaminck were hung directly on their walls. Architectonic, hieratic, frontal, these primitive sculptures are emblems of human presences, not their imitations. The signs constituting these emblems are often far-removed from facial features in their natural state: orifices appear in relief, projecting planes are hollowed out, rounded curves become acute angles. Picasso, having abstracted visible reality to its ultimate schematic form, was no doubt susceptible to the alternatives provided by primitive art and reassured as to the impact such a reduced formal syntax could obtain.[1]

Despite Picasso's documented fascination with African art, it would be insufficient to analyze his constructions solely from this standpoint. The cutting away of planes, the transparency or invisibility of certain components of the subject, the layering and foreshortened perspectives implied by others derive from Picasso's own painting. Moreover, his attitude to materials confirms his dependence on a pictorial aesthetic. The earliest constructions, made of cardboard, sheet metal, colored papers, wood and twine, showed the artist's relative indifference to the nature of each substance. All were cut, folded and pinned together, repeating the layered frontality of his paintings. In some of these constructions Picasso integrated fragments of discarded objects, purposely distorting their original function. Clearly the image was more important than the medium.

Translations are by the author, unless otherwise noted.

[1] For a thorough discussion of the relation of African sculpture to Cubism, see D. H. Kahnweiler, "Negro Art and Cubism," *Horizon*, London, vol. XVIII, Dec. 1948, pp. 412-421.

Around 1914 Picasso began painting certain elements in his constructions, indicating once more that the intrinsic quality of materials was secondary, since once painted it was camouflaged. In most cases color was introduced as a painterly means to articulate and clarify composition: accentuating the separation between planes, substituting for modeling, inferring inclined planes or imaginary perspectives, emphasizing spatial position, or simply as suggestive decoration. Finally, Picasso's crude technique not only points up the highly experimental quality of the constructions but also suggests that his goal was not the creation of a well-crafted object or sculpture. On the contrary, his concern was to elaborate a structural syntax and a repertory of signs which he could then reconduct into the idiom of painting.

An examination of these constructions reveals the diversity of their pictorial/sculptural solutions. One of the earliest pieces, a small paper guitar of 1912 (cat. no. 1), is interpreted in Analytical Cubist terms, simultaneously portraying front and side views, suggesting volume and flattened image through a pictorial, non-functional planar organization. The slanted planes imply shallow perspective, which is echoed in the penciled and colored shadows on the neck and contours of the guitar. Yet this perspective is, in fact, understood as an illusion, contradicted by the flat, almost symmetrical frontality of the total silhouette.

Although the sheet metal *Guitar* of the same year (cat. no. 2) is based on similar principles, the resulting object is altogether different. Here the frontal planes, positioned at some distance from the wall, are almost entirely cut away, revealing a penetration into depth. At the same time, the broken frontal planes suggest a continuity of surface which delimits the object's space. And the deep inner spaces, intensified by strongly cast shadows and bounded by the front edges or pieces of the remaining planes, exist as mass or volume of empty, negative space.

The sheet metal *Guitar* represents a major contribution to the history of modern sculpture, for here the sculptor's "mass" has been emptied of solid substance and filled with a new substance: space itself, modeled by light and shadow, measured by line (edge) and plane. Yet line and plane are traditionally the painter's means, which merely indicates that the pictorial concept is ever-present, albeit in residual form.

Picasso would produce variations on this theme, expressing to a greater or lesser degree the ambiguity of the object's substance and function. For example, in the Tate Gallery's *Still Life* of 1914 (cat. no. 3), the water-level in the glass is rendered as a plane, whereas the volume of transparent liquid is a void. This is a clear illustration of syntactical inversion in which an abstraction becomes concrete and a physical mass is translated into a void. Elsewhere (cat. no. 5), the subject motifs are flattened to two-dimensional silhouettes,

their contents spilled beyond these contours and the space behind them layered to create a composite idea of substance or volume. In the *Musical Instruments (Mandolin)* of 1914 (cat. no. 7), made of natural wood with painted highlights, the features of the subject motifs (a mandolin and clarinet) are translated into emblematic signs, disproportionate, dislocated and assembled into an open formal arrangement.

In the painted sheet-metal *Guitar*, again of 1914 (cat. no. 4), the parts and relations between parts no longer pretend to translate the morphology of the original subject except in the most emblematic way. The guitar is merely a pretext for assembling colored planes in space. In fact, the colors, shapes and patterns, the concave and convex pleated components have little to do with the reality of the subject and much more to do with an autonomous pictorial architecture.

Paradoxically, these constructions, devised as a testing ground for pictorial problems, mark not only a turning point in modern painting but a breakthrough in twentieth-century sculpture.

Their departure from traditional sculpture may be defined in the following terms. First, these constructions are frontal. Whether pinned to the wall or standing free in space, they are not intended to be viewed from all sides. Yet, despite this implicit dependence on a wall as "ground," they exist in real space. Because they refer more directly to painting (and the two-dimensional plane) than to sculpture (three-dimensional mass), new materials and new techniques were required to implement their images. And the thin unmodeled planes which delineated their spatial substance called for a modulation through flat color. Finally, the three-dimensional configuration described by these planar components was, in fact, an integrated spatial image, fusing subject and environment, inner and outer space. In many cases the traditional mass was translated—quite tentatively, for these were experimental works—into a void or a continuous transition between two-dimensional elements and empty spaces. The mass as empty open space, articulated by planes, inflected by light or color, would constitute a new potential substance for the sculptor. So that in playing with cardboard, which was essentially what he was doing at the outset, Picasso transgressed the boundaries of the traditional carved or modeled idiom and pioneered a new direction for twentieth-century sculpture.

Unlike Braque and Picasso, Henri Laurens was destined to be a sculptor. But it is unlikely that he would have arrived at his sculptural idiom of 1915-18 without the example of Cubist painting. Although his constructions are related to those of Picasso, they also reveal fundamental differences in vision and objectives.

The influence of Cubist painting appears in Laurens' work beginning in around 1915; it is visible in the

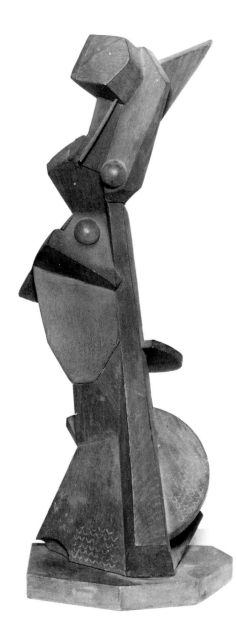

fig. 2
Henri Laurens
Spanish Dancer. 1915. Painted wood, 20⅞″ h.
Collection Musée d'Art Moderne de la Ville de Paris

cubed and faceted volumes of the *Spanish Dancer* (fig. 2). Shortly thereafter the volumes give way to suggestive spheres, cones and cylinders constituted of thin curved planes (cat. no. 8). However, as in Picasso's constructions, these reduced emblematic images evoke a strong, vital, even dynamic presence.

Simultaneous with his earliest constructions Laurens began a series of *papiers collés*, some of which were based on the same themes (fig. 3; compare to cat. no. 9). A comparison of these *papiers collés* to Picasso's own (fig. 4) is useful in determining the basic differences between the sculptor's and the painter's vision.

As a painter, Picasso acknowledged the space determined by the edges of the paper, as well as the irreducible two-dimensionality of his support. He therefore conceived his composition both frontally and in relation to the frame. By contrast, Laurens was oblivious to the spatial exigencies of two-dimensional surface and format. Since the space of sculpture is real space and therefore virtually infinite, he concentrated his attention solely on his figure, assembling it according to an open-ended additive process which sometimes threatened to burst the frame, or else situated the subject in an awkward relation to the surrounding space.

Laurens' prime concern was the autonomous architecture of his figure. In an attempt to articulate its separate elements in a rhythmic and dynamic whole, and to express volume, he built his *papiers collés* on strong diagonals around a central core, suggesting thrusts into depth or projection, rarely respecting the two dimensions of the support.

The same fundamental divergence of vision and approach is seen in the two artists' constructions. Certainly, superficial resemblances between the two groups of works can be found. The subject matter is comparable: guitars, bottles, glasses and other objects characterized by transparency or open form. By 1915-16 Laurens' constructions, like Picasso's, consist of thin planes of sheet metal and wood. The work of each is frontal, open, layered and painted. And both artists have pared down the constituent parts of their compositions to the value of signs, conveying elusive and shifting points of view.

Yet Laurens' priorities were sculptural. In contrast to Picasso's usually shallow space, arrived at through the tight interplay of pictorial planes, Laurens' slanting planes suggest depth or perspective; and his thin curved shells cup invisible mass. As he noted himself, "*Il est nécessaire que, dans une sculpture, les vides aient autant d'importance que les pleins. La sculpture est, avant tout, une prise de possession de l'espace, d'un espace limité par les formes.*"[2]

[2] "The voids must have as much importance as the masses. Sculpture is a taking possession of space, a space limited by forms." Quoted in Deutsche Gesellschaft für Bildende Kunst, Berlin, *Henri Laurens*, Sept. 27 - Nov. 12, 1967, n.p.

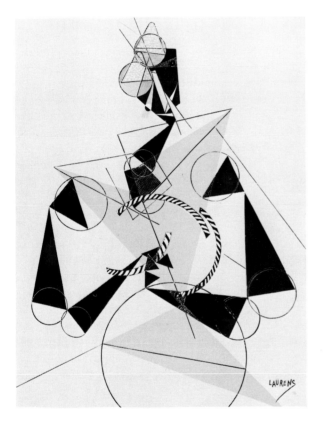

fig. 3
Henri Laurens
Clown. 1915. Gouache and pasted papers
Whereabouts unknown

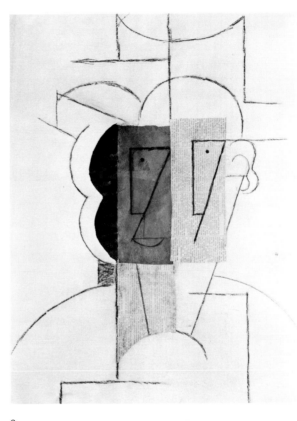

fig. 4
Pablo Picasso
Man with Hat. 1912. Charcoal, ink and pasted papers,
24½ x 18⅝″
Collection The Museum of Modern Art, New York
Purchase

In opening the spaces more consistently, more force-fully, Laurens pushed Picasso's experiments one step further. Laurens' inner volumes are more significant as places than their outer shells. Shadows are important, accentuating emptiness as mass. Painted components are neither descriptive nor decorative but emphasize fragmented volume, rather than continuity of surface, and the shifting perspectives which articulate these virtual volumes. *"Quand une statue est rouge, bleue, jaune, elle reste toujours rouge, bleue, jaune. Mais une statue qui n'est pas polychromée subit les déplacements de la lumière et des ombres sur elle et se modifie sans cesse. Pour moi, il s'agissait, en polychromant, de faire en sorte que la sculpture eut sa propre lumière."*[3]

These considerations evoke Juan Gris and his attempts to control the viewer's response (fig. 5). Gris began with an abstract organization of forms in space which he then identified as specific objects: *"Le pouvoir de suggestion de toute peinture est considérable. Chaque spectateur tend à lui attribuer un sujet. Il faut prévoir, devancer et ratifier cette suggestion . . . en transformant en sujet cette abstraction, cette architecture due uniquement à la technique picturale."*[4] Laurens' choice of materials depended on the kinds of spatialized forms he sought to elicit. Circular inner spaces were contoured in sheet metal. More angular spaces were engendered by abutted or intersecting planes of painted wood. Laurens cut his materials in precise shapes, producing positive or negative silhouettes. These constructions were not random assemblages; their carved, curved and adjusted elements were intended to embrace a specific presence in space. And as his constructions evolved, only the barest planar articulation remained, as membrane and skeleton of a dematerialized spatial entity.

Jacques Lipchitz came to Paris from Lithuania in 1909 at age eighteen. Although he was not born in France, his earliest artistic influences seem to have come to him in Paris, and therefore his work may be studied in relation to the French Cubist School.

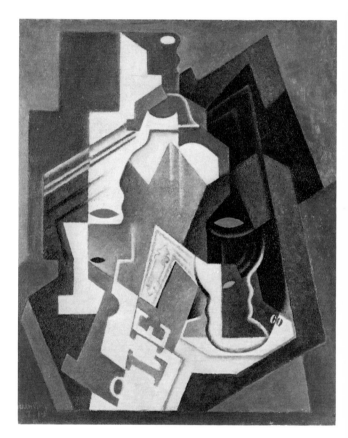

fig. 5
Juan Gris
The Siphon Bottle. 1919. Oil on canvas, 21¾ x 18"
Lydia and Harry L. Winston Collection
(Dr. and Mrs. Barnett Malbin), New York

[3] "When a statue is red, blue, yellow, it remains red, blue and yellow. But a statue which is not polychromed falls victim to the displacements of light and shadow which modify it ceaselessly. For me, painting a sculpture is endowing it with its own light." *Ibid.*

[4] "The power of suggestion in every painting is considerable. Every spectator tends to ascribe his own subject to it. One must foresee, anticipate and ratify this suggestion . . . by transforming into a subject this abstraction, this architecture which is solely the result of pictorial technique." Quoted in Orangerie des Tuileries, Paris, *Juan Gris*, Mar. 14-July 1, 1974, p. 40; translated in Christopher Gray, *Cubist Aesthetic Theories*, Baltimore, 1953, p. 132.

Lipchitz was a sculptor to the core, and, while he was impressed by Cézanne and Cubism, his work never reflected pictorial concerns to the degree evident in the constructions of Picasso or even those of Laurens. Even in his relatively two-dimensional pieces, the figure's palpable presence is emphasized. Furthermore, the sculptor's techniques of carving and modeling, the sculptor's materials such as wood and stone, the sculptor's preferred subject matter—the human figure—were never completely absent from his oeuvre. Finally, his use of color was occasional.

In 1914 the influence of Cubism began to make itself felt in the broken rhythms and faceted volumes of Lipchitz's bronze figures (such as *Sailor with Guitar*, Philadelphia Museum of Art). But by 1915 he was seeking new solutions and therefore looked toward other forms of art, among them Egyptian frescoes and African sculpture.

In Lipchitz's own words, "In an Egyptian relief, the head, arms and legs are normally shown in profile, with the eyes and torso frontalized. This approach was not essentially different from the multiple and simultaneous views that the Cubist painters were seeking. These first Cubist sculptures of mine . . . also tended to be flat and frontalized in the manner of Egyptian figures."[5]

The first of these figures, *Bather* (cat. no. 14), was initially modeled in clay. Its two-dimensional silhouette—organized by a slight staggering of planes parallel to the surface—implies more a Cubist than Egyptian contraction of front and profile views. Yet it is clear that this is a pictorial image transposed into a free-standing form.

The same flattened and compressed gestures are seen in the *Dancer* also of 1915 (cat. no. 15). Lipchitz's turn to wood may have been influenced not only by his interest in African sculpture but by his close friendship with Brancusi. Yet this piece is far removed from Brancusi's concerns. Again the silhouette is relatively flat. Although many of the edges of the layered forms are rounded (carved), this does not dispel the effect of two-dimensionality. The distinctly separate wooden parts, corresponding to different positions in space, are laminated flat to one another, thereby condensing the tensions and torsions into a pictorial syntax.

In the second *Dancer* of the same year (cat. no. 16), the parts which were formerly aligned in a single plane are tipped diagonally to one another, introducing unprecedented implications of volume in the space activated by the planar relations. Through the suggestion of volume the reference to African sculpture becomes explicit: the stepped and stylized articulations, the rhythmic combinations of curves and angles defining a single shape, the emblematic facial features and the hieratic proportions which govern their assemblage. But the construction is also ordered by pictorial cues. This is particularly visible in the dancer's skirt which, tipped like a Cubist tabletop, introduces a concept of perspective combining painterly device and spatial reality.

In the *Pierrot* of 1915 (cat. no. 18), Lipchitz pared down the two-dimensional wooden components to thin unmodulated planes and turned them more radically still, this time perpendicular to each other, so that they intersect at right angles through the axis or core of the piece. This process generates an active spatial zone without enclosing it. The *Pierrot* was first made in wood, then in bronze. According to Lipchitz's own description, "The head and body of the figure consist of flat planes placed at right angles to one another in a cruciform shape, tied together by the two horizontal circular planes. . . . The volume of the figure is created by the voids between the planes." Comparing the sculpture to a related drawing, he remarked: "In the drawing, which is, of course, organized on a flat surface, the planes are tilted at angles to the surface to create a limited sense of depth. . . . In the free-standing sculpture it was necessary to emphasize the three-dimensional quality, and for this reason I organized the planes at right angles to one another. This is a kind of bone structure that exists firmly in space like a skeleton."[6]

Lipchitz's development of form in space—from a virtual two to three dimensions—shows a logical progression: from a stratified to a tilted cruciform planar structure. Whereas the initial images were defined as plane itself, the *Pierrot* exists as a scaffolding for volumetric space.

The 1912-18 works by these three sculptors illustrate a diversity of spatial extensions of the two-dimensional plane, the singular invention of Cubist painting. Cut, layered, curved and painted, parallel or perpendicular to other surfaces, the plane has been progressively released from the wall to exist in space as skeleton or shell, generating increasingly conceptualized images, autonomous architectures and open, active spatial volumes.

The Italian artists of this era were concerned with many of the same premises that inspired the constructions studied above. As in France, the predominant artistic mode in Italy was painting. It is, therefore, not surprising that among the most innovative and exemplary Futurist sculptures were those conceived by two painters: Giacomo Balla and Fortunato Depero. Most of their three-dimensional production was created from

[5] Jacques Lipchitz with H. H. Arnason, *My Life in Sculpture*, New York, 1972, p. 25.

[6] *Ibid.*, p. 29.

ephemeral materials and thus, unfortunately, little has survived.

Futurist theory is helpful in elucidating the principles on which these now destroyed objects were built. Boccioni's 1912 *Technical Manifesto of Futurist Sculpture* is the best-known text on Futurist sculpture. However, the same artist's preface to the catalogue of his 1913 Paris exhibition is more explicit and revealing of the Futurist sculptor's aims, particularly in regard to the Futurist constructions or "plastic ensembles" which interest us here.[7]

Boccioni's first point is that architecture is the origin and ultimate end of sculpture. Naturalistic form is sculpture's enemy. "Architecture is for sculpture what composition is for painting."[8] Secondly, at least in relation to the present context, the goal of sculpture is "not pure form but pure plastic rhythm; not the construction of bodies but the construction of the action

of bodies. . . ."[9] Thirdly, Boccioni explains that he seeks "a complete fusion of environment and object, by means of the interpenetration of planes."[10] Finally, he states: "One must completely forget the figure enclosed in its traditional line and on the contrary present it as the center of plastic directions in space."[11]

As painters, Balla and Depero were not tied to an academic training or preconceived assumptions about sculpture's forms, materials and function. In fact, the creation of sculpture was not their aim. Futurist painting was concerned with ideas, not objects; sensations, not perceptions. Already by 1913 Balla had virtually reached abstraction in canvases in which he dissolved the figure into space and fused interpenetrating planes and states of mind, to focus attention on the total image as a complex pattern of force-lines. Having shattered the closed silhouette in painting, thereby creating a sensation of movement, Balla and Depero set out to

[7] For both these texts, see Robert L. Herbert, ed., *Modern Artists on Art*, Englewood Cliffs, N.J., 1964, pp. 45-57.

[8] *Ibid.*, p. 47.

[9] *Ibid.*, p. 48.

[10] *Ibid.*, p. 49.

[11] *Ibid.*

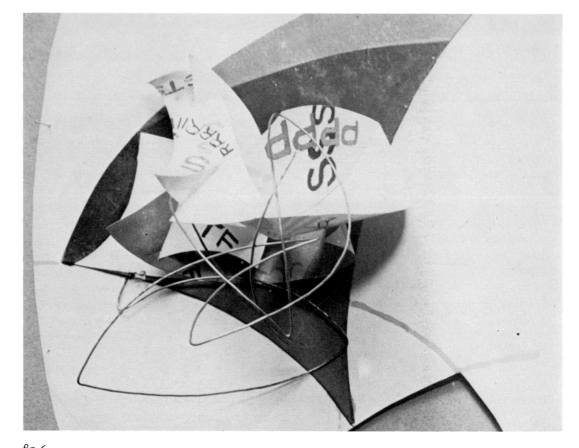

fig. 6
Fortunato Depero
Spatial Construction. 1915. Mixed media
Presumably destroyed

break open mass in space with planar constructions that would express the *volume* of motion. These constructions were assembled of disparate fragments of mirrors, tin, metal wires, wool, celluloid, string, wood. Purely conceptualized images, with no referents in the visible world, these *complessi plastici* or spatial constructions were alogical to the point of complete abstraction, graphic interpretations of force-lines in space (fig. 6).

Balla's and Depero's illustrated 1915 text, *The Futurist Reconstruction of the Universe*, is pertinent to their personal objectives: "We shall first give flesh and bones to the invisible, the impalpable, the imperceptible. We shall find the abstract equivalents of all the forms and of all the elements of the universe, and then we shall combine them according to the whims of our inspiration in order to form plastic constructions which we shall then put into motion."[12]

12 Quoted in Virginia Dortch Dorazio, *Giacomo Balla*, New York, n.d., n.p.

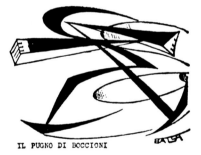

IL PUGNO DI BOCCIONI

fig. 7
Giacomo Balla
Fist of Boccioni. Stamp
Lydia and Harry L. Winston Collection
(Dr. and Mrs. Barnett Malbin), New York

Balla's 1915 *Fist of Boccioni* (cat. no. 19), although not truly typical of his mixed media constructions, is a synthesis of the rhetorical aspects of most Futurist theorizing and the commonplace. Made of modest materials—cardboard and paint—it depicts a rather small, arabesque-like man surging forward on a symbolic crest of active form. Yet viewed as a whole, it represents a forceful spatial gesture, a graphic symbol of dynamics or speed.

This spatial gesture existed initially as a drawing (see fig. 7 for motif translated into a stamp). But Balla realized the inadequacy of the two-dimensional format to "render in depth the dynamic volume of speed."[13] His singular invention was to translate the image into space but not volume: to be meaningful, it had to transcend the notions of gravity, physical mass, closure, texture.

The *Fist of Boccioni* is a two-dimensional cipher in space. The schematized forms combined in its silhouette are found in Balla's paintings of the same year. Yet the picture ground from which they emerged has been eliminated; the image is self-contained. The work's inner spaces, created by the interpenetration of planes, are virtually two-dimensional; although the configuration appears to generate little dialogue with the surrounding space, it can be understood in the terms of Boccioni's *Manifesto*, where he said, "Everything surrounding our body . . . intersects it and divides it into sections by forming an arabesque of curves and straight lines."[14] The sculpture's red color is psychologically and pictorially important, emphasizing its essence as a pictorial motif translated into physical reality. Boccioni was equally aware of this aspect of the new sculpture: "a colored plane can accentuate violently the abstract signification of a plastic value."[15] Slicing through space as a dramatic autonomous entity, this extraordinary structure is the concrete presence of a conceptual abstraction.

II Russian

Experimentation with planes, in reliefs or free-standing sculpture, was not confined to the Parisian or Roman milieu. Alexander Archipenko and Vladimir Baranoff-Rossiné were two Ukranian artists who, as early as 1913, executed astonishing sculptures in this vein. Although their breakthrough works were in fact made in Paris, there is reason to believe that they drew, at least in part, upon the traditions of their native Russian soil for both formal and technical inspiration.

The vast body of writings left by Archipenko is helpful to the understanding of the artist's background and

13 *Ibid.*
14 Herbert, *Modern Artists on Art*, p. 51.
15 *Ibid.*, p. 54.

objectives.[16] New documentation concerning prerevolutionary artistic activity in Russia is equally helpful. These sources confirm that there was little sculptural tradition in Russia prior to modern times. In Archipenko's own words, *"L'introduction du christianisme à Kiev remonte au neuvième siècle. La peinture a tout de suite été influencée par la peinture byzantine. Quant à la sculpture, l'orthodoxie l'interdisant, on a cessé d'en faire."*[17]

This historical situation liberated Russian artists from the constraints of an academic tradition, resulting in a freedom which is visible not only in the work of sculptors such as Archipenko and Vladimir Tatlin, but in the brief incursions into three-dimensional form by painters such as Baranoff-Rossiné, Iwan Kliun, Liubov Popova and Iwan Puni.

Archipenko arrived in Paris in 1908 when he was twenty-five. Although he had studied in Beaux-Arts academies in Kiev and Moscow, one can conjecture that his knowledge of sculpture was slim. During the early years he remained in close contact with colleagues in Russia, evidence that his native antecedents and ties were still strong and meaningful.[18]

The singular form of sculpture created by Archipenko and other Russian artists between 1913 and 1923, whether they were working in Paris or in Russia, was in fact a product of the interaction (brought about by travel, exhibitions and collections, reproductions and correspondence) between Cubist painting and native Russian tradition. The potential of Cubist painting as a source of inspiration has been outlined above. The Russian painting which was meaningful to these sculptors was the icon, its materials and structure.

The icon had a profound formal influence on the painting of Goncharova, Larionov, Malevich and Tatlin as early as 1910. But certain resources of the icon, inappropriate to painting, were not exploited by these artists: in particular, the integration of extraneous materials into a two-dimensional surface and the rich textural effects thereby obtained.

A 1914 text by the sculptor Valdemar Matvejs confirms that these possibilities were significant to sculptors of that period. After pointing out that present-day sculptors combined different materials in their works, but that public taste found this practice unacceptable, more appropriate to crafts than to works of art, Matvejs continued:

> *But let us think of our icons. They are embellished with metallic haloes in the form of crowns, metallic plates on the shoulders, fringes, incrustations. We even have examples of paintings enhanced by precious stones, metals, etc. All of this destroys our contemporary understanding of the painting medium. . . . Of course, we need to admire a single material in isolation. But our soul contains an irrepressible urge to . . . combine this with other materials. And when we find a foreign substance which can be allied with the first, we consider this successful. . . .*

> *The Russian people paints its icons: of the Virgin, saints or others. These are non-real images. The real world is introduced only through the assemblage and incrustations of real and tangible objects. One can say that this produces a combat between two worlds.*[19]

Archipenko's early constructions exemplify the modern sculptor's translation of this "combat of two worlds," the spiritual and the concrete. As he was to state many years later: ". . . in the first decade of the century, I came to the conclusion that the spiritual power of a work of art is derived mostly from the metaphysical realm, that the greatest difficulty lies in the fixation of the correlation of abstract with material reality."[20]

Archipenko usually depicted a single figure composed of physically separate but visually related parts. Although at first glance one would be tempted to relate these works to Cubism, they are truly closer to the icon's semantic system. The reduced repertory of forms consists of thin flat or curved plates tipped into a painted and framed surface or ground, simultaneously part of the image and physically foreign to it. This contradictory presence recalls metallic accessories or incrustations placed upon the icon's painted surface. Archipenko set his initial experiments against canvas grounds, indicating a real reference to pictorial conventions, but soon adopted wood or paperboard supports.

The rich color, the contrasts between metal and wood, flat, illusionistic space and real projecting planes, curved and straight lines echo not only the primitive,

[16] See particularly Alexander Archipenko and others, *Archipenko, Fifty Creative Years 1908-1958*, New York, 1960.

[17] "In Kiev, the introduction of Christianity goes back to the ninth century. Painting was immediately influenced by Byzantine painting. Since sculpture was prohibited by the orthodox religion, it was no longer practiced." Quoted in Yvon Taillandier, "Conversation avec Archipenko," *XXe Siècle*, xxxviie année, supplément au no. 22, Christmas 1963, n.p.

[18] Andrei B. Nakov, "Notes from an Unpublished Catalogue," *Studio International*, vol. 186, Dec. 1973, p. 223.

[19] Valdemar Matvejs (signed with pseudonym V. Markov), *Printsipy tvorchestva v plasticheskikh iskussvakh. Faktura* (The Principles of Creation in the Plastic Arts. Faktura), St. Petersburg, 1914. The author is grateful to Jean-Claude Marcadé for the communication and translation of this text.

[20] Archipenko, *Archipenko, Fifty Creative Years*, p. 35.

expressive and stylized character of the icon but also its supremely decorative quality. Indeed, Archipenko's constructed wall reliefs are iconic, hieratic. In view of the artist's emphasis on the metaphysical or spiritual aspects of sculpture, he would probably have concurred with this analogy.

In the earliest assembled constructions Archipenko used reflective surfaces such as highly polished metals, mirrors and glass (fig. 8). Although it would appear that he initially employed these materials for complex spatial and pictorial motifs, he soon limited his means to painted wood and metal, resulting in a reduced formal syntax. In so doing, he was probably responding to a conceptual tradition then being rediscovered by his Russian colleagues: the principle of *Faktura*.

The term *Faktura* (most simply translated as "materials" or "texture") embraces the concept that a given material generates a precise repertory of forms. This principle was revived during the Futurist period in pre-revolutionary Russia, when poets such as Kruchenykh and Khlebnikov sought to revitalize language by stripping words of their acquired connotations and bringing back their original significance. By choosing syllables, words, phonemes according to phonetic value alone and juxtaposing them according to textural considerations, they attempted to create a new textual fabric rich with new meanings. These efforts produced the *zaum* or transrational tongue.

Simultaneously, the visual artists understood *Faktura* to mean the use of old or the introduction of new materials, while safeguarding the integrity of their expressive potential. In other words, the forms of painting were to be produced by paint itself. For example, these artists understood Cézanne's singular brushstroke to be a *Faktura* which articulated the organization of his surface. In their view, the consistency of paint and the orientation of brushwork created the "reality" of Larionov's Rayonism. The important aspect of this premise is the concept of the literal value of the material as the determinant of form and, thus, the meaning the work of art will obtain.

As we shall see in relation to Tatlin, material and technique (*Faktura* and *Tektonika*) in the strictest sense formed the basis of Constructivism. Archipenko had a simpler more instinctive approach to these problems. Yet his understanding of the determining role of materials was precise and closely related to Tatlin's ideas about the "culture of materials." As he said, "Stylistically, those constructions which are done in non-plastic material inevitably have a geometric character. A sheet of bent metal has only two possible geometric bendings, cylindrical or conical. . . . I utilize a flat board, sheet of metal, glass, mirror, etc., cut them in adequate patterns, superimposing them in a specific way that leads the mind toward a new aesthetic law. The inevitable planes, corners and contoural curves of the assembled flat materials [are] the inevitable conse-

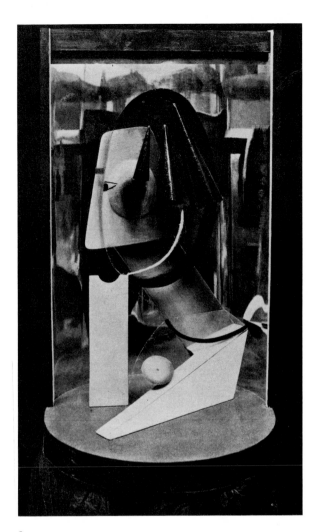

fig. 8
Alexander Archipenko
Head. 1914. Glass, metal and wood, 22″ h.
Destroyed

quence of non-plastic materials and technical conditions."[21]

Thus, Archipenko's sculptural aesthetic, often considered a kind of hybrid outgrowth of Cubism, probably relates to quite different origins. Yet his source of inspiration was, nonetheless, of a pictorial nature. French Cubism served to reassure him as to his objectives, and any analogies between it and his own work made his production more immediately acceptable to a French audience.

Baranoff-Rossiné, roughly Archipenko's contemporary, approached sculpture from a different vantage point. Since he was fundamentally a painter, his sculptural production was extremely limited. The only remaining example of his two known sculptures of the years 1913-14 is a model of painting spatialized.

Symphony Number 1 of 1913 (cat. no. 22) is a free-standing polychromed planar sculpture. Although it marks out a three-dimensional area, it is neither volume nor mass, but an openwork drawing in space. Constituted in part of found (preformed) wooden fragments, it reveals no attempt to replicate human anatomy; yet the rhythmic articulation of the whole imposes a reading of a human form. At the same time, the whimsical non-descriptive color obstructs the viewer in his search for directly representational clues.

Symphony Number 2 (now lost), according to a contemporaneous description, was comprised of zinc plates and gutter pipes, pepper-mill shapes, disks, coil springs and steel wires.[22] Perhaps the works most closely related to these two sculptures are Archipenko's 1912-14 sculptures (*Médrano I, Woman in front of a Mirror* [fig. 9], *Portrait Head,* all lost) and the slightly later and widely reproduced construction by the painter Kliun, *Cubist at Her Dressing Table* (fig. 10), exhibited in Moscow in December 1915 (also presumably destroyed). Kliun had sought to create in this sculpture, which was constituted of partly found, partly carved and painted flat components, a direct presence through scale, gesture and articulations, situated somewhere between reality and abstraction. The figure he produced had an immediate impact, a suggestive poetry, a transrational logic which allows for few associations beyond its specific image.

Baranoff-Rossiné's sculpture may be described in these same terms; however his construction differs from Kliun's in that his architecture is more important than his image, and the total orchestration more important than any single part. No anatomical details are painted; all are expressed as signs. Kliun's construction was positioned against a wall panel; its space was there-

fore defined as that generated by a picture ground. Baranoff-Rossiné's *Symphony Number 1* stands free, but is equally pictorial through the use of color, planes and a strongly graphic articulation; its ground is the total ambient space. While the concept of space as ground still exists here, this ground is multi-dimensional, unframed, undefined.

Archipenko and Baranoff-Rossiné, working in France during the period covered here, were inevitably influenced to some extent by Cubist conventions. By contrast, Tatlin's 1915 constructions were more deeply rooted in Russian tradition and his own personal history and were extremely different in style and intentions from those of his compatriots.

Like many Russians of his generation, Tatlin began his artistic life as an icon painter. He subsequently underwent an academic training and remained a painter until 1913. According to most accounts, his visit to Picasso's studio during the spring of that same year radically deflected the course of his activity to the making of planar reliefs or "counter reliefs." Tatlin's personal definition of the latter term is not known. One may only conjecture that he conceived these works as far removed from (or counter to) traditional carved or modeled wall sculpture.

Although Picasso's unconventional constructions are a plausible catalyst, they provide insufficient background for understanding the Russian artist's personal vision. For the spatial and semantic complexities of Tatlin's 1914-15 constructions are very distinct from Western (even Cubist) pictorial syntax. Once again, icon painting and the principles of *Faktura* and *Tektonika* seem to supply the necessary clues.

The icon provided Russian artists with an alternative and native tradition from which to draw. As noted above, they perceived the icon as a system of predetermined signs in which the real and the spiritual, the physical and the metaphysical, real objects, real space and painted illusionism coexisted. *Faktura* involved the study of real materials and their structural and expressive potentials. Tatlin would enlarge this "truth to materials" to encompass much more. His aesthetic code, known as the "culture of materials," extended the artist's work with materials in two directions: one moral, the other aesthetic. According to Tatlin, the artist who respected the specifications of materials was obeying natural laws and would create "necessary forms" of universal significance. These forms would therefore address themselves to the mass audience of the new society. Tatlin's ultimate aim in regenerating language was to reform the sensibility of the new masses.

Tatlin was undoubtedly impressed by the freedom with which Picasso manipulated non-artistic materials; yet he could accept neither Picasso's means nor ends. Picasso's constructions retained references to an obsolete pictorial mode, the painted still life, which corre-

21 *Ibid.,* p. 47.

22 *Symphony Number 2* was exhibited at the 1914 Salon des Indépendants in Paris. The artist was so devastated by its reception, that he apparently threw it into the Seine.

sponded to the conventions of bourgeois society. He did not respect his materials, rather he distorted them. His vision was subjective, his formal decisions arbitrary.

Tatlin sought to use new materials to formulate new images, new meanings. The materials would be commonplace (wood, glass, metal), not artistic. The simple repertory of forms would consist of those inherent in each material. Material dictated more specific forms for Tatlin than for Archipenko. He saw the most elementary (common) form of wood as a flat board or geometrically cut plane; metal, prepared in thin sheets, as a rolled cylinder or cone; glass as a flat pane or a circular shape. This became his lexicon of forms and he used it consistently to determine content. His colors would be those of each natural substance. And the particular formal and textural juxtapositions within the object would generate the specific contrasts, rhythms and tensions which animated it.

Tatlin's formal choices—not only in the use of disparate materials or *Faktura,* which had both real and symbolic meaning, but in his spatial organization—derived from the icon. In conventional Western art perspective may be defined in terms of a pyramid of space. The tip of the pyramid is at the farthest point in depth, behind the object, and therefore penetrates the wall. In the icon the tip is in front of the object, in the viewer's eye, and the base of the pyramid is the wall's surface. Thus, the icon's inverse perspective projected the object and its meaning into the viewer's actual space, the space of existential experience. In order to emphasize his notion of "real materials in real space," Tatlin sometimes suspended his constructions at a distance from the wall.

Tatlin's singular relationship to his materials may reflect a unique aspect of his personal history: his experience as a seaman. There are reasons to conjecture,

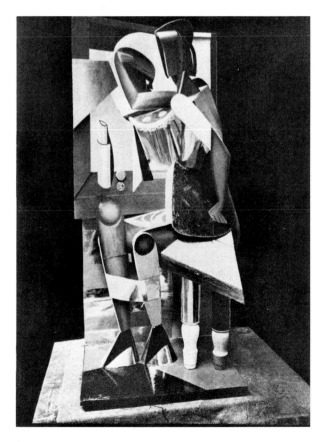

fig. 9
Alexander Archipenko
Woman in front of a Mirror. 1914.
Glass, metal and wood with mirror, 84″ h.
Destroyed

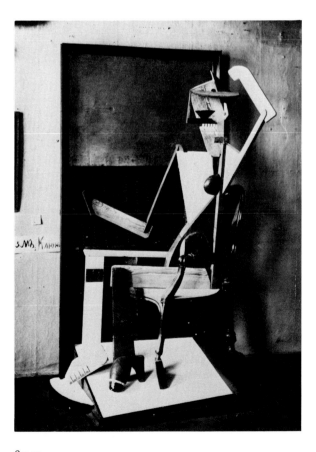

fig. 10
Iwan Kliun
Cubist at Her Dressing Table. Exhibited 1915.
Mixed media
Presumably destroyed

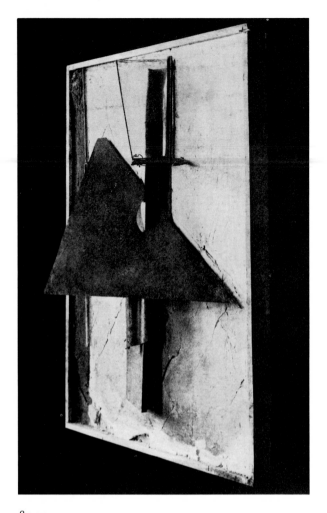

fig. 11
Vladimir Tatlin
Assemblage of Materials. 1914. Mixed media
Presumably lost

although it is impossible to prove, that he may have been trained as a marine carpenter. According to first-hand reports, photographs and the evidence of the few objects from his hand that have survived, Tatlin's manual skill was exceptional. He had the extensive knowledge of the tensile specifications of materials which corresponds to the basic training of a marine carpenter. His drawings for his reliefs were basically shop drawings, without the personal handwriting which is related to style. Finally, his images and techniques bear traces of such a background.

Tatlin's constructions, composed of fairly simple geometric forms, are organically and functionally articulated. For example, in the assemblage of materials of 1914 (fig. 11), the central relief element is mounted like a triangular sail attached to a mast, connoting flexibility of movement and relativity of position. It should be noted that no image is portrayed but one of formal and textural relations. The corner reliefs of 1914-15 (see cat. no. 34) consist of thin metal plates, some in sail-like shapes, bent or curved (conveying an effect of slight billowing), rigged as overlapping planes on guy-wires which, stretched taut to the wall, once again infer movement, play, flexibility. These "reliefs" are not pinned to the wall but anchored at some distance from it. They are virtually suspended in a void, evoking the spatial indeterminancy of sails in infinite space.

Thus, Tatlin's reliefs, projected into the viewer's space, are true, prototypical, images of several aspects of his own existence. The artist drew on his empirical knowledge to create forms which belonged to a common reservoir of experience and were therefore universally legible.[23]

The criticism of Cubism which Tatlin surely attempted to articulate in his reliefs was expressed in writing by Naum Gabo and Antoine Pevsner in their 1920 *Realistic Manifesto:* "One could heed with interest the experiments of the Cubists, but one cannot follow them. . . . The end result amounts to the same old graphic, the same old volume and to the same decorative surface as of old."[24]

In fact, the *Realistic Manifesto* in many ways confirmed Tatlin's premises, despite the declared differences between the Realist and the Constructivist groups. However, Tatlin extolled the virtues of "real materials in real space," whereas for Gabo, space itself was the substance of the new art. Gabo stated his posi-

[23] For a fuller discussion of the influence of Tatlin's seaman's experience on his oeuvre, see Margit Rowell, "Vladimir Tatlin: Form/Faktura," *October,* vol. 7, winter 1978, pp. 83-108.

[24] Quoted in John E. Bowlt, ed., *Russian Art of the Avant-Garde: Theory and Criticism, 1902-1932,* New York, 1976, p. 211.

tion in 1920 in the *Realistic Manifesto*, referring to space as "depth." By 1937 his terminology was more precise:

Up to now, the sculptors have preferred the mass. . . . Space interested them only in so far as it was the spot in which volumes could be placed or projected. It had to surround masses. We consider space from an entirely different point of view. We consider it as an absolute sculptural element, released from any closed volume, and we represent it from inside with its own specific properties. . . . We experience this sense as a reality, both internal and external. Our task is to penetrate deeper into its substance. . . .

In our sculpture space has ceased to be . . . a logical abstraction or a transcendental idea and has become a malleable material element. It has become a reality . . . and it is incorporated in the general family of sculptural emotions where up to date only the weight

and volume of mass have been predominant. It is clear that this sculptural emotion demands a new method of expression. . . . It demands also a new method of execution.[25]

Thus for Gabo and Pevsner, space was the new material and required its own techniques. In order to delineate "the space in which the mass exists made visible,"[26] Gabo, as early as 1915, formed volumes in space through an open cellular structure of intersecting planes. He would later define this technique as "stereometric" as opposed to "volumetric," signifying the generating of open spatial volumes from an inner core or axis, as opposed to closed (solid) masses.

[25] Naum Gabo, "Sculpture: Carving and Construction in Space," *Circle: International Survey of Constructive Art*, London, 1937, pp. 106-107.

[26] *Ibid.*, p. 106.

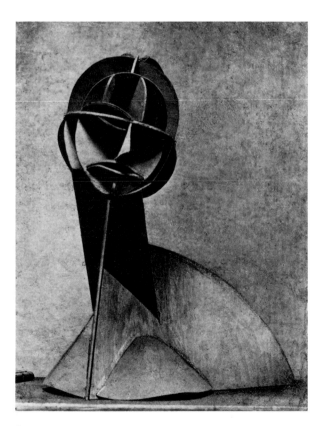

fig. 12
Naum Gabo
Constructed Head No. 1. 1915. Wood
Present whereabouts unknown

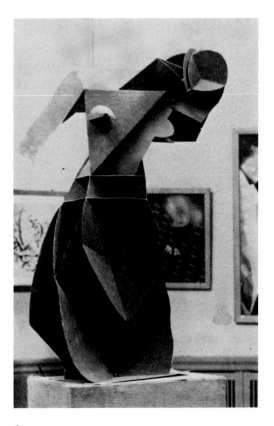

fig. 13
Naum Gabo
Torso. 1917. Sheet metal covered with sand, 54″ h.
Present whereabouts unknown

Laurens and Lipchitz arrived at this solution at about the same time, but they developed it no further (see cat. nos. 13, 18). However, the idea was so central to the perceptions of Gabo and Pevsner that these sculptors subsequently, and logically, began to work with clear plastics so that they might dematerialize the skeleton or scaffolding of their constructions and create spatial volumes at the edge of invisibility (see figs. 14, 15). Furthermore, the complex and ambiguous relationships between the plane as surface shell, inner structure or transparent membrane and space as void or mass were intensified through the use of clear plastics (which ideologically represented the dawn of a new age). These new materials and techniques, dictated by the substance of space itself, would lead Gabo and Pevsner ultimately to abstraction or "absolute" form.

In Russia Realism and Constructivism represented two distinct attempts to regenerate artistic language through emphasis on elementary materials and their intrinsic forms. Malevich's reality was different. It was that of the "pure painterly work of art."[27] Malevich's philosophical orientation was metaphysical, not materialistic. Understandably, he was violently opposed to Tatlin's culture of materials, which, moreover, threatened to destroy the reference to pictorial space.

Nonetheless, starting around 1915, some artists in Malevich's circle (such as Kliun) experimented with relief constructions. Few of these works survive today, and even fewer are available in the West. The works of Puni offer the only examples of the extension of Suprematist painting into actual space during this pioneering period. Puni's Suprematist phase was brief, lasting only from approximately 1915-16, and his reliefs are not necessarily generically typical. Furthermore, only a small number of them survive in their original form.

Puni's earliest known relief construction, *The Card Players* of 1914 (fig. 16, now lost), is similar in some respects to Archipenko's first figural constructions which he had seen in Paris during visits of 1912 and 1914. *Relief with Hammer*, also of 1914 (cat. no. 29), demonstrates Puni's interest in the utilitarian object, stripped of its function and introduced as pure form. Puni's mature reliefs of 1915-16 appear to be closer to Malevich's philosophical orientation and formal vocabulary. Some examples reflect the essence of the phenomenal world, its abstract reality and inner relationships. Yet the abstract motifs are not reduced to dematerialized formal figures but exist as glass, wood and cardboard. And compared to Malevich's infinite space, Puni's space is rigorously organized and sometimes includes illusory indications of framing or perspective (see cat. no. 32).

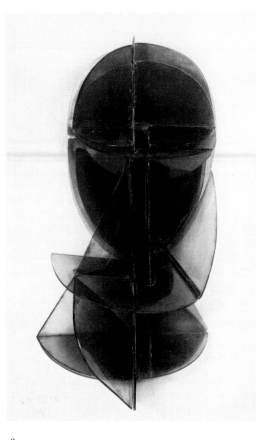

fig. 14
Antoine Pevsner
Head of a Woman. 1923. Plastic on wood, 14¼" h.
Collection Hirschhorn Museum and Sculpture Garden, Smithsonian Institution, Washington, D.C.

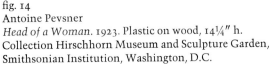

27 Bowlt, *Russian Art of the Avant-Garde*, p. 118.

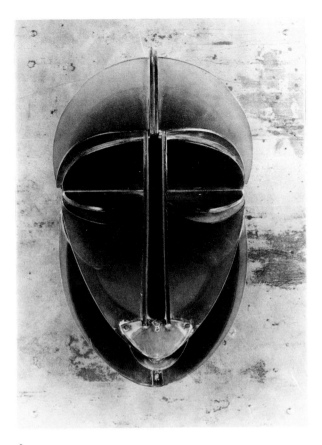

fig. 15
Antoine Pevsner
Mask. 1923. Celluloid and metal, 14½″ h.
Musée National d'Art Moderne,
Centre Georges Pompidou, Paris

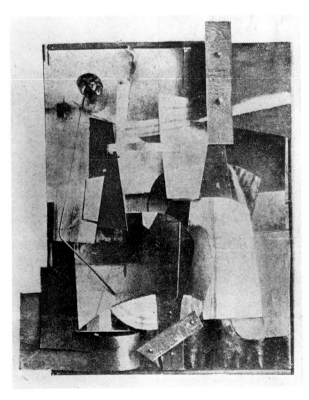

fig. 16
Iwan Puni
The Card Players. 1915. Mixed media, 55⅛ x 47¼ x 11″
Presumably lost

25

It has recently been proposed that these reliefs were mere sketches and were meant to be executed in materials such as metal, which was scarce and costly in prerevolutionary Russia (and that therefore Puni was indeed interested in the true nature of materials).[28] This may only be argued in relation to some of the almost monochrome works (cat. nos. 30, 31). The primary or at least artificial hues of both motifs and grounds in others[29] relate them to the Suprematist pictorial reality rather than to a culture of materials. As a result, the incursion of these relief assemblages into space is more symbolic than real.

III Other Europe

Conventional art-historical categories for unifying styles and periods appear inadequate in the present context. This inadequacy is even more apparent in relation to the works which follow. Until now our attention has been concentrated on creative activity in France and Russia, since these were the centers of that activity from approximately 1912-17. The scope of the following section is in many ways broader, encompassing artists from most of continental Europe. However, these artists were connected in one way or another to Paris, so that we must consider Paris once again our focus.

The lack of a single classification for these works is perhaps justification enough for showing them together. Although some of the artists were involved with Dada and Surrealism, many others developed their styles in reaction to these movements, which then dominated Paris. A majority of the artists were painters and their tentative experiments add little in the way of spatial innovations. Yet their contributions to the visual experience of the twentieth century cannot be ignored. For, in their reinterpretation of the picture plane as picture plane, they are resolutely modern.

The Dada experiments with planar reliefs may be understood in the framework of a kind of iconoclasm or a desacralization of the conventional mystique of the painted canvas. Visual perception was jarred, preconceived notions about art were invalidated by these assemblages of layered motifs (which often included discarded objects) and the abrupt removal of legible images, illusion and perspective, drawn contours, personalized brushstroke. Most of the Dada artists took their cue from collage which allowed them the freedom to play with forms, just as the Dada poets played with words.

The connotations of the Surrealist-related works are more complex. In the visual arts, Surrealism is a painter's idiom. And Surrealist painting is primarily concerned with poetic or literary content; it is this subject matter which dictates form and imposes medium. Consider, for example, Magritte or Dali and their polished academic style—a supremely appropriate vehicle for conceptual content. As William Rubin has pointed out, sculpture did not lend itself to the Surrealist techniques of automatism or to "the delineation of the irrational perspectives of a fantasy world; its very concreteness, its displacement of finite space, seemed alien to the imagination."[30] It is true that, with a few exceptions, sculpture of the classical Surrealist period (the 1920s and the 1930s) was generally lacking in formal invention.[31]

It follows that the Surrealist artists who used the plane were essentially painters, and their planar experiments were extensions in space, though not necessarily in concept, of their paintings. Why they momentarily spatialized their images can only be speculated. Probably they, like the Dadaists, were motivated by a desire to defy convention in creating three-dimensional painted forms which, as neither painting nor sculpture, were freed from the academic connotations of these two mediums. No doubt they were also moved by the period's more general tendency toward anonymous archetypical images; for the quirks of an artists's subjectivity are less visible in a carved contour or a gesture of assemblage than in a drawn line. In addition, an assembled composition allows more latitude for chance encounters, particularly if the technique is inhabitual to the artist and his hand and eye are free from the automatisms of habit or skill. Some artists referred to the game or toy and made objects to excite the imagination on a more fundamental level. Others worked with boxes, to create frames of secrecy or intimacy for their projected fantasies. But in all cases Surrealist forms in space carried an inherent ambiguity: they did not pretend to be representational, but rather served as the concrete embodiment of imaginary images.

Despite art history's claims on Jean Arp as a sculptor, he considered himself a painter well into the late 1930s, and his planar reliefs, starting in 1915, are generically of a pictorial order. According to Arp, the stratified wooden elements he positioned or dispersed on a wooden panel were the "concretions" of a poetic language which emerged and flowered from the depths of his irrational mind; or they were the unpremeditated product of a game of chance. Wood was the simplest,

28 Eberhard Roters, *Iwan Puni (Jean Pougny) 1892-1956*, Berlin, 1975, n.p.
29 See those in the collections of the McCrory Corporation, New York, and the National Gallery, Washington, D.C., for example.

30 William S. Rubin, *Dada and Surrealist Art*, New York, 1968, p. 249.
31 For a discussion of several significant exceptions which lie beyond the scope of this study, see Rosalind E. Krauss, *Passages in Modern Sculpture*, New York, 1977, pp. 105-146.

most easily worked substance with which to implement this spontaneity. Depth or volume were unimportant for their own sake, although cast shadows underscored the concreteness of these subliminal images. Color was arbitrary, sometimes contradictory, but always poetic and pictorial.

Many Dada and Surrealist-related planar constructions may be considered in these terms: as concrete projections of a poetic and essentially pictorial imagery. Although this generalization may seem dubious in relation to Alexander Calder (see cat. nos. 73, 74), his works of the early 1930s, in their emphasis on line and painted two-dimensional elements, betray a pictorial inspiration traceable to his encounter with Miró in 1928 and his visit to Mondrian's studio two years later. Miró's paintings of 1927-28 were his most economical and abstract, showing elementary shapes and blots of color scattered over an open field. Mondrian's Paris studio walls were an organization of color-planes in real space.

One of Calder's early abstract constructions (cat. no. 72) is a constellation of colored disks which are staggered in relation to an invisible surface plane, spatially indicated by the isolated picture frame. Suddenly pictorial space has no meaning, either as surface or boundary. Calder's free-standing mobiles, developed at the same time, explode the frame, yet paradoxically they remain pictorial. From every perspective the brightly colored blade-like motifs align themselves in relation to an implied picture plane.[32]

Regardless of their professed attempts to appeal to the collective unconscious, many Surrealist artists developed repertoires of personalized forms. Should a single component be isolated from a Surrealist work (an Arp relief, a Calder mobile, a Miró construction), its author can usually be identified, because these are personal formal interpretations of archetypal experience. Artists who worked within the framework of Constructivism, as we shall see, sought a more objective, standardized, anonymous language. Because of his highly ambivalent nature, Kurt Schwitters appears to bridge the gap between these two idioms.

From the outset materials and medium dictated Schwitters' form and content. Despite his use of an underlying Cubist grid, this artist's juxtapositions of unexpected textures and tones generated a peculiar poetry. And it happened that his materials led Schwitters to a new understanding of spatial content.

Like his friend van Doesburg, Schwitters had a mind full of contradictions, prescribing disorder but always moving toward a more ordered statement. Although

his early works were somber, textured, sensuous in the disparate and time-worn materials combined, the production of the mid- to late twenties became brighter, more formalized, more controlled—an evolution related to the combined influence of *De Stijl* and Constructivism which reached Schwitters through his friendships with van Doesburg and Lissitzky. Schwitters' reliefs of this period have the poetic immediacy of the early collages, paradoxically implemented by Constructivist spatial solutions.

These constructions remain pictorial because the artist was working with a flat delimited surface, a figure-ground syntax, a Cubist grid. The forms are personal: uneven, hand-carved and painted. Every angle has an unexpected curve; shadow is important, accentuating dramatic spatial contrasts. But the reliefs are also architectural because the supports, although finite, imply the whole wall, the relief elements project into the viewer's space and they are of human (as opposed to miniature, monumental or arbitrary) scale. One could say that these are a kind of idiosyncratic *proun* or a relay between painting and architecture (see discussion pp. 28-29). Furthermore, the few free-standing objects by Schwitters' hand were conceived as fragments of an architectural whole, the artist's *Merzbau* (cat. nos. 81, 82).

The *Merzbau* (begun in 1923, destroyed in 1943) is the consummation of Schwitters' artistic progression. Sober and formalized on the outside, its inner space was expressionist and personal. Heavy cast shadows accentuated the jagged forms of the interior where an accumulation of almost fetishistic objects, many of them endowed with symbolic meanings, created a cluttered poetic intimacy. The *Merzbau* was a synthesis of intimate poetry and objective form, fantasy and reason, nonsense and sense.

In the early 1930s Arp, Calder and Schwitters belonged to the Paris-based but internationally oriented *Abstraction Création* group. Founded by van Doesburg shortly before his death, this group was devoted explicitly to the defense of non-representational art. But implicitly, and seemingly paradoxically because many of these artists were involved with Surrealism, they were taking a stand against dogmatic Surrealist doctrine. In an attempt to swell their ranks, the founding members opened their doors to a broad spectrum of artistic persuasions; with *abstraction* (from nature) at one extreme and *création* (from conceptually generated non-objective/geometric motifs) at the other. Their decision to embrace such widely diverse tendencies was motivated not only by practical considerations but must be attributed to a tacit acknowledgement that many Parisian artists of the period—sensitive to the appeals of both Surrealism and geometric art—were attempting to reconcile these two formal and conceptual opposites. For example, Arp, Herbin, Tutundjian, Gonzalez, Torres-García, Calder, Schwitters all became members of *Abstraction Création* at one time or another during its life

[32] See Rosalind E. Krauss, "Magician's Game: Decades of Transformation 1930-1950" in Whitney Museum of American Art, New York, *200 Years of American Sculpture*, Mar. 16-Sept. 26, 1976, pp. 174-175. Although her central thesis has a different orientation, Krauss arrives at these same conclusions.

which was brief (1931-1936), notwithstanding its wide-ranging approach. (Miró was invited but refused to join. Yet his art of the period 1930-32 was the most "concrete" of his whole career [see cat. nos. 70, 71].) Thus, the contradiction between these two poles of expression is not as irreconcilable as it is usually seen to be.

Although a growing social consciousness characterized the 1920s and early 1930s elsewhere in Europe, with the exception of Herbin (see discussion p. 85), the artists discussed above were remarkably innocent of any political coloration in their work. They were, furthermore, not interested in the ideological issues of technology. Generally their innovations were neither spatial nor structural. Archetypal images, unpretentious, even primitive materials, chance techniques, associative colors were their mediums. And their audience was the human collectivity, not the "new masses." In fact, it is highly symptomatic that, after 1932, many of these artists returned to easel painting.

IV *Constructivism but elegant*

During the 1920s Paris was a center of intense international activity dominated by Surrealism but leading, toward the end of that decade, to the counter-movements of *Cercle et Carré, Art concret* and *Abstraction Création.* Although these groups prescribed a form of "Constructivism," their intentions were restricted to a purification of artistic forms and content. In seeking to redefine the work of art, they did not aspire to "reconstruct the world."

Berlin was another important focal point of creativity during this decade. Because of the Soviet Union's geographical proximity, artists in Berlin were acutely conscious of the social transformations taking place around them. The presence in their midst of Soviet artists forced to emigrate by the October Revolution and its aftermath contributed to their awareness of the need for radically new art forms. This growing understanding of the vital role of art in the transformation of society set Berlin's artists at the opposite pole from the Parisian Surrealists.

Elsewhere in Europe, outside of France, the artist's relation to society was changing and his feeling of social responsibility was emerging. Artistic and intellectual communities were being formed which would work to create the harmoniously integrated environments of the new, ideal postwar society. The members of *De Stijl* in Holland, for example, although they did not live together, expressed a certain social commitment in all of their activities. Mondrian's paintings were meant to embody the ideal environment that the organization of his Parisian studio exemplified. Painters of the Bauhaus such as Baumeister, Schlemmer and Kandinsky ani-

mated public and private spaces with mural reliefs and motifs and sometimes designed entire rooms or environments. Art was to be the context of all human experience, not an object of delectation for a privileged few.

Thus, in the new integrated society, with its ideally integrated environment, the duality between aesthetic space and actual space was no longer valid. The easel painting, or even the discrete object, had no place. The walls and space of human life were the only aesthetic measure. They would be the context, the support, the visual ground for all artistic endeavor. Consequently, the plane, as the fundamental structural module of two-dimensional painting, then as a constituent part of spatialized objects, would gain new significance in relation to architecture and a certain autonomy within the new socio-spatial context. This evolution, from two-dimensional painted surface to constructed object to space, culminates in the work of three artists in Berlin during the period 1921-23: Erich Buchholz, El Lissitzky and László Peri.

Lissitzky's and Buchholz's spatial ideas developed in separate but not unrelated contexts—the Soviet Union and Berlin—and appear to have been motivated by somewhat comparable forces. Two texts, one by Buchholz, the other by Lissitzky, are striking in their analogies. Buchholz's essay describes his personal itinerary from figuration to abstraction to its final and inevitable culmination in architecture in 1921. That year he built his own house, designed the furniture and created planar assemblages for the walls (see cat. no. 96). These rooms, he explained, were spaces in which to "live," not only in which to "dwell." Paintings or abstract "things" on the walls would be superfluous.

Lissitzky's text of 1923 refers to his *Proun* exhibition space designed for the *Grossen Berliner Kunstausstellung* of the same year in similar terms.[33] For Lissitzky, this and other spaces were to be integrated environments, not walls hung with pictures, and they should be articulated to induce active participation.

Buchholz's painted wooden panels, initiated during the period 1921-22, were conceived as wall pieces to activate and animate space (see cat. nos. 93-95). He called this new venture (until then he had been engaged in a kind of religious figurative painting) "absolute abstraction." The latent mysticism of his writings, including references to the icon, encourage the conjecture that the thick wooden support, the frequent use of gold with

[33] El Lissitzky in Sophie Lissitzky-Küppers, *El Lissitzky: Life-Letters-Texts,* Greenwich, Conn., 1968 (first published Dresden, 1967), pp. 361-362. According to Buchholz, Lissitzky visited his Berlin studio at the time of the *Erste Russische Kunstausstellung* at the Galerie van Diemen in 1922. For several references to this, see Galerie Daedalus Berlin, Berlin-Charlottenburg, *Erich Buchholz,* May 15-June 20, 1971, n.p.

an otherwise severely limited but luminous palette and combinations of symbolic geometric forms constituted a non-orthodox translation of the icon's visual conventions. Furthermore, the icon, as an emblem affixed to a wall in a familiar (religious or domestic) setting represents a spiritual presence and has an important function in everyday life. Thus, these panels were architectural necessities in connection with a social and spiritual reality: they were icons for the new society.[34]

Buchholz's autobiography[35] suggests a friendship with László Peri prior to or simultaneous with this turning point in his art. Peri began working with concrete wall forms as early as 1920-21. However, too little is known about both artists to allow us to attribute the primacy of these ideas to one or the other.

Most of Lissitzky's multifaceted activity was directed toward reforming the visual (and eventually spiritual and emotional) expectations and responses of the "masses." Lissitzky conceived the *Proun* (an acronym for "project for the affirmation of the new") as a substitute for painting, an "interchange station between painting and architecture." The *Proun* paintings, begun in 1919, show the genesis of a concept of space which would reappear in the artist's later environmental work. The focal points of each canvas, the *Prouns* themselves, consist of tightly layered planar figures floating on a framed white or gray ground. Yet since these assembled forms do not acknowledge pictorial space (loosely defined as edge and surface), they are disquietingly scaleless, unnaturally positionless. They can only be understood as floating freely on the wall. Or to use Lissitzky's phrase, "the Proun assaults space."[36]

Lissitzky's approach to painting was formally and philosophically colored by Malevich's Suprematism. Although Malevich was not the first to defy traditional perspective, his solution was radical: his planimetric forms generated an unmeasurable, dematerialized, totally undetermined spatial milieu. By contrast, Lissitzky's abutting and overlapping planes, their eccentric positions and shifting axes defy both planimetric and perspectival laws and imply a space which is determined as multidimensional—extending forward, in depth and on all sides: "Emptiness, chaos, the unnatural, become space, that is: order, certainty, plastic form, when we introduce markers of a specific kind and in a specific relationship to each other. The structure and the scale of the group of markers give the space a specific tension. By changing the markers we alter the tension of the space, which is formed from one and the same emptiness."[37]

The 1923 *Proun* exhibition environment expressed Lissitzky's ultimate attempt to control space (see cat. no. 100). His objective was to model emptiness or rather to "construct" a space in which the viewer would be forced to participate actively with his whole self. The axes and thrusts of the diversified and spatialized wall motifs were to direct the viewer in his physical movements and emotional responses within an environment of real (human) scale, real substance (painted and natural textures) and real color (red, black, white and gray). The forms were positioned in different relations to the viewer's activity: flat to the wall, projecting toward him, guiding him according to vertical, diagonal, horizontal axes. Each axis or structural function was dictated by a material: wood was hung against the wall, color was applied flat to it. The colors obeyed a physiological and symbolic logic: black was used as an opaque plane, blotting out volume, red as a dynamic stimulus, white as infinite space.

Already in 1920, in his essay "Suprematism in World Construction," Lissitzky anticipated his later spatial environments: "We on the last stage of the path to Suprematism blasted aside the old work of art like a being of flesh and blood and turned it into a world floating in space. We carried both picture and viewer out beyond the confines of this sphere and in order to comprehend it fully the viewer must circle like a planet round the picture which remains immobile in the center."[38]

László Peri, a member of the Hungarian avant-garde, exhibited his "space constructions" (see cat. no. 99) at the same *Grossen Berliner Kunstausstellung* of 1923 where Lissitzky presented his *Proun* environment. These extraordinary free-floating planar elements were obviously intended to shape the viewer's experience in a manner similar to the *Proun* space. They appear, moreover, to have been the outcome of an analogous thought process. Since the total exhibition space was divided into cubicles or stalls which were assigned to the participating artists, it is probable that Peri knew the exact measurements of his alloted space and conceived his forms in proportion to the architecture. In fact, Peri made an annotated lithograph marked with wall measurements (fig. 17).

Peri's "space constructions" are unique. Molded in colored concrete, their dynamic non-objective shapes inhabited by contradictory tensions, their strong physical objecthood and human scale engage the viewer in a forceful dialogue. Unlike Lissitzky's *Proun* motifs, these forms were not linked together in a continuous circuit. But they were surely conceived as stations or moments of experience.

Thus, by 1921-23 human scale has become the prime referent for artistic form and meaning. Soviet artists

[34] Apparently Richard Huelsenbeck commented on their icon-like quality, *Ibid.*
[35] *Ibid.*
[36] Quoted in Lissitzky-Küppers, *El Lissitzky*, p. 343.
[37] *Ibid.*

[38] *Ibid.*, pp. 327-328.

and those touched by their influence were the most consistently conscious of space as the material of modern experience. Certain among them—Medunetsky, the Stenbergs, Joganson and members of the Moscow *Obmokhu* school for example—used space as their medium. These artists sought to express the essence of pure form with thin, dematerialized linear markers in real space (see cat. no. 90). Others, closer to Tatlin, were more concerned with the concept of *Faktura* as explicit substance and implicit structure; they attempted to develop an interaction between materials and space (fig. 18).

The importance of technology, evoked by the artists in their statements, is visible in the works of both groups. Modern technology represented the new age, and only through its use could the artist embody the open dynamics of a classless society. It was therefore ideologically important to supplant stability with instability, static form with dynamic form, solid mass with open planar or linear transparent structures, wood, canvas and paint with metal and glass.

Ironically, such materials and technology were lacking in postrevolutionary Russia. So these ambitious projects, inspired by the rhetoric of world revolution, were rarely carried beyond a tentative statement in cardboard, plywood, scraps of metal, wire, string, sheets of metal. For this reason and others, most of them have disappeared into oblivion.

A number of the sculptural objectives of the 1920s are embodied in the oeuvre of Katarzyna Kobro, who was born in Moscow but subsequently pursued her career in Poland and participated in the *Unism* group.

Her work is a synthesis of painting, sculpture and architecture (or surface, plane and actual space) designed for a new social context. Many of Kobro's contemporaries idealized their modestly scaled efforts into architectural projects; she, however, did not. Nevertheless, the premises developed in these unassuming but powerfully original spatial objects show a comprehensive understanding of basic architectural principles.

Kobro's early sculptures are indebted to Tatlin's "material culture" (cat. no. 109). Space, shaped with consummate understanding and skill, is unquestionably the substance of her mature work, which dates from after 1925 (cat. nos. 110-113). As her husband Wladyslaw Strzeminski wrote in 1928: "An imposing of limits upon a work of spatial plastic art is incompatible with its assumptions. What becomes spatial plastic art is the space, without any natural frontiers, unlimited by anything. A work of sculptural or architectonic art, placed in unlimited space, ought to be united with it as its inseparable part. . . . Fragments of space penetrating the consciously split up solid are interconnected with each other and at the same time they are tightly linked to the space as a whole."[39]

Kobro's mature sculptures are fluid but articulated assemblages of metal planes. She generally painted them white, but when she introduced color, her aims

[39] Wladyslaw Strzeminski and Szymon Syrkus, "The Present in Architecture and Painting" in Museum Folkwang Essen, *Constructivism in Poland 1923-1936: BLOK, Praesens, a.r.*, May 12-June 24, 1973, p. 106.

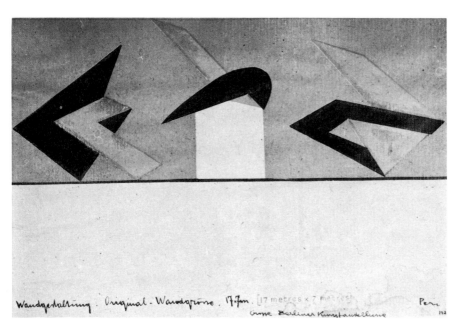

fig. 17
László Peri
Study for Three-Part Space Construction.
1923. Lithograph with painted additions,
12 x 18"
Collection Wulf Herzogenrath, Cologne

were specific: "The breaking of the shape of a solid is connected with its breaking as to the color, for a uniform shade, emphasizing the uniformity of a solid, cannot, quite naturally, befit a sculptural form. Color introduced into sculpture in all its fullness and richness saturates it with space, making up a spatio-temporal rhythm of colored shapes, shifting our attention from one to another with varying intensity dependent on the force of the shape and color. A spatial sculpture is an arrangement of infinitely reflected colors in space."[40] The plane as interpreted in this passage is not a boundary or shell but a diffuse zone of immaterial color-light, of the same substance as space itself.

Although Kobro's shapes were presumably chosen freely (this freedom was only relative, exercised within an established repertory of open forms), their sizes and relationships were not. Kobro organized her spaces in mathematical relationships to one another. For the artist sought to synthesize an architectonic order and an organic rhythm. The rhythm, based on a common denominator, not only creates a unity between all parts but is infinitely extendible in all directions.

Kobro designed no architecture. But she believed, particularly by the early 1930s, that her studies of fundamental spatial rhythms—based upon the interaction of space and time—should serve as blueprints for architects and urbanists of the future.

Kobro's ideals, objectives and small-scale models exemplify one of the most significant interpretations of the planar dimension in Europe in the 1930s. Metaphorically, the plane became the basic structural component of an open classless society. Aesthetically, it was a marker articulating a dynamic, rhythmic space. In both instances the plane lost its original value as a concrete surface area; in its ideal state, it would be infinitely penetrable, even invisible. Space was the substance of the new art.

In 1931-32, Alexander Dorner wrote: "Matter is dissolved into pure planes and lines, penetrating each other, devoid of mass and transparent. Thus instead of a space filled with solid mass, cubic, static and extended, a space appears as the criss-crossing of streams of movements and streams of events."[41] These observations are as true of painting as of sculpture and architecture today. It is worth considering that the assertion of open space which characterizes much twentieth-century art came about through the extension of two-dimensional surfaces, or a pictorial spatial concept, into actual space.

[40] *Ibid.*

[41] Alexander Dorner, "Die neue Raumgestaltung in der bildenden Kunst," *Museum der Gegenwart II*, 1931-32, p. 30 ff. Excerpts published and translated into English in Städtische Kunstsammlung Ludwigshafen, *Carl Buchheister*, May 25 - July 27, 1975, p. 19.

fig. 18
Alexander Rodchenko
Hanging Oval Construction (Rodchenko visible in background). 1920.
Painted wood and wire, 33 x 23 x 21"
Collection George Costakis

Many works representative of the planar dimension were not available to us. Some pieces were lost or destroyed, others were too fragile to travel; still more were inaccessible for a variety of other reasons. The following group of works can therefore not be considered to give a comprehensive view of all European experiments of this kind during the period 1912-32. Although we may regret the absence of certain key artists, we may, however, rejoice in the rich variety of examples which are presented here.

The catalogue of works is divided into four sections which correspond to the four chapters of the introductory text. An index of artists in alphabetical order is provided.

The information given for each work is all that was available to us. The bibliographical references were selected on the following basis: for a well-known artist, only references concerning his or her planar sculpture are given; for a lesser-known artist, we have cited texts on the artist's oeuvre as a whole.

*Indicates not in exhibition.

The following works are included in the exhibition but are not reproduced in the catalogue:

Jean Arp

118 *Hippic Bird.* 1916
(Oiseau hippique)
Painted wood, 6¾ x 6½ x 5″ (17.2 x 16.5 x 12.6 cm.)
Collection Mme Arp, Clamart, France

Georges Vantongerloo

119 *No. 2, The Hague: Construction in a Sphere.* 1917
Concrete, 12½ x 9⅞ x 9⅞″ (32 x 25 x 25 cm.)
Collection Vantongerloo Estate, Zürich

Georges Vantongerloo

120 *No. 60: $y = ax^2 + bx + 18$.* Paris, 1930
(authorized enlarged version, 1978-79)
Black lacquer on brass, 35⅜ x 21⅞ x 13″ (90 x 55.5 x 33 cm.)
Collection Max Bill, Zumikon

INDEX OF ARTISTS IN THE EXHIBITION

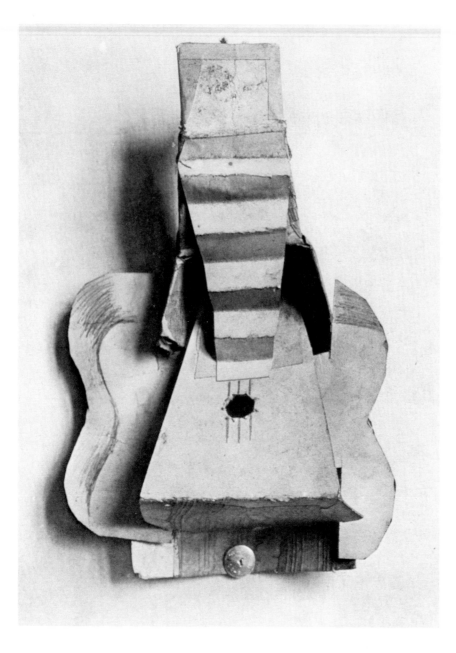

Pablo Picasso

Born 1881, Malaga
Died 1973, Mougins

*1 *Guitar.* 1912
(Guitare)

Colored papers, 9⅜ x 5½″ (24 x 14 cm.)

Succession Picasso

REFERENCES:

Christian Zervos, *Pablo Picasso:
oeuvres de 1912 à 1917*, vol. 2**, Paris,
1942, no. 779, pl. 339
William Tucker, "Four sculptors part 2:
Picasso cubist constructions," *Studio
International*, vol. 179, May 1970,
pp. 201-205
Alan Bowness, "Picasso's Sculpture,"
Picasso in Retrospect, New York, 1973,
pp. 130-133
Ronald Johnson, "Picasso's Musical
and Mallarmean Constructions," *Arts
Magazine*, vol. 51, Mar. 1977, pp.
121-127

see discussion p. 11 here

2 *Guitar.* 1912
(Guitare)

Sheet metal and wire, 30½ x 13⅞ x
7⅝″ (77.5 x 35.3 x 19.3 cm.)

Collection The Museum of Modern
Art, New York, Gift of the artist, 1971

REFERENCES:

Zervos, 1942, no. 773, pl. 337
William Rubin, *Picasso in the
Collection of The Museum of Modern
Art*, Greenwich, Conn., 1972, pp. 74-75,
repr., 207-208

see discussion p. 11 here

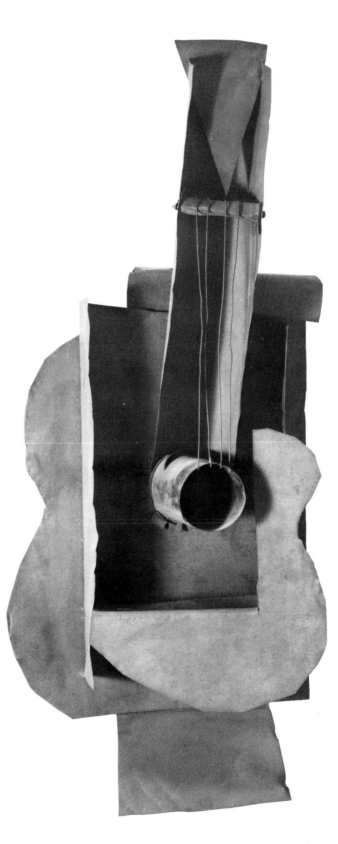

Pablo Picasso

3 *Still Life.* 1914
 (Nature morte)

Painted wood with upholstery fringe,
10 x 18 x 3⅝″ (25.4 x 45.7 x 9.5 cm.)

Lent by The Trustees of the Tate
Gallery, London

see discussion p. 11 here

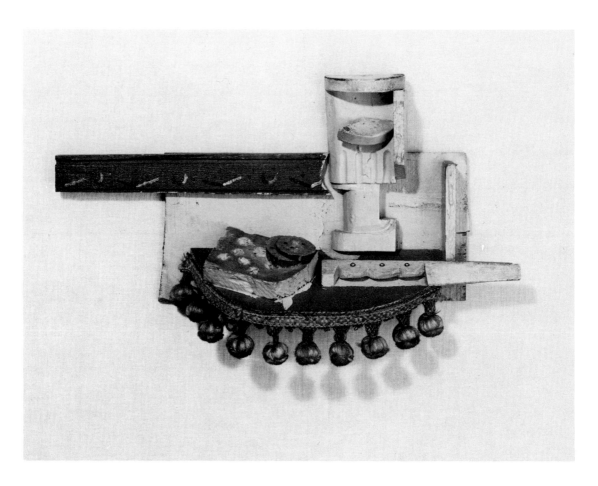

Pablo Picasso

*4 *Guitar.* 1914
(*Guitare*)

Painted sheet metal, 37 ⅞ x 26 x 7½"
(95 x 66 x 19 cm.)

Succession Picasso

REFERENCE:
Zervos, 1942, no. 580, pl. 267

see discussion p. 11 here

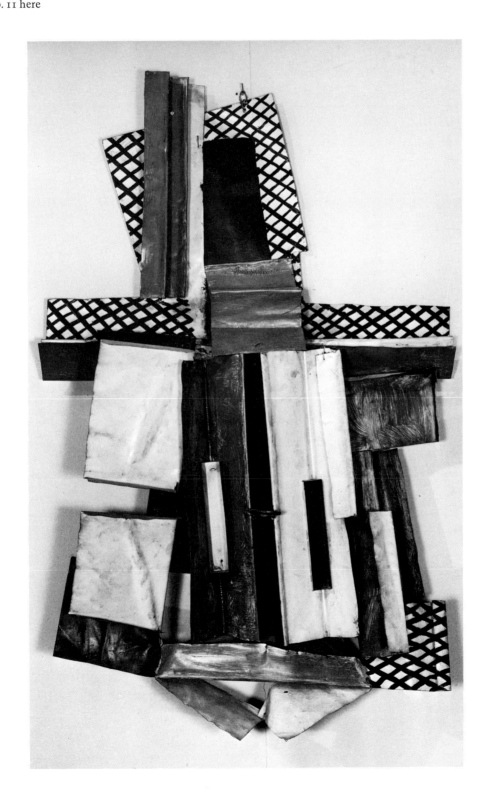

Pablo Picasso

*5 *Glass and Newspaper.* 1914
(*Verre et journal*)

Painted wood on wood panel,
5 ⅞ x 6 ⅝" (15 x 17 cm.)

Succession Picasso

REFERENCE:

Zervos, 1942, no. 846, pl. 360

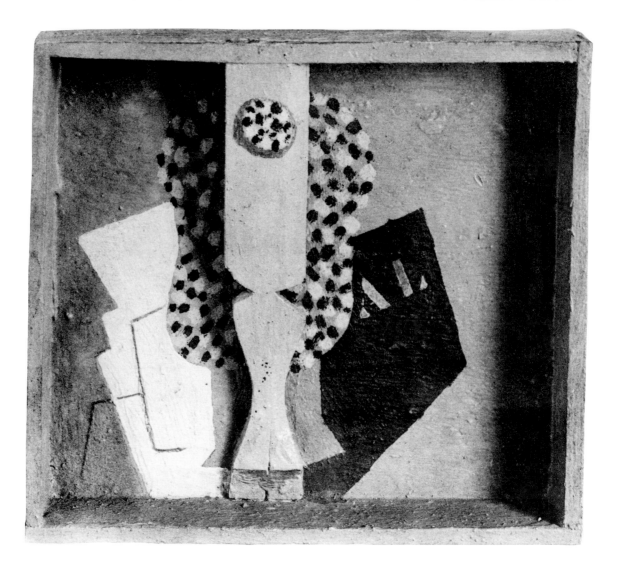

Pablo Picasso

*6 *Bottle of Bass, Glass and Newspaper.*
 1914
 (Bouteille de Bass, verre et journal)

Painted sheet metal, 7⅞″ (20 cm.) h.

Succession Picasso

REFERENCE:
Zervos, 1942, no. 849, pl. 361

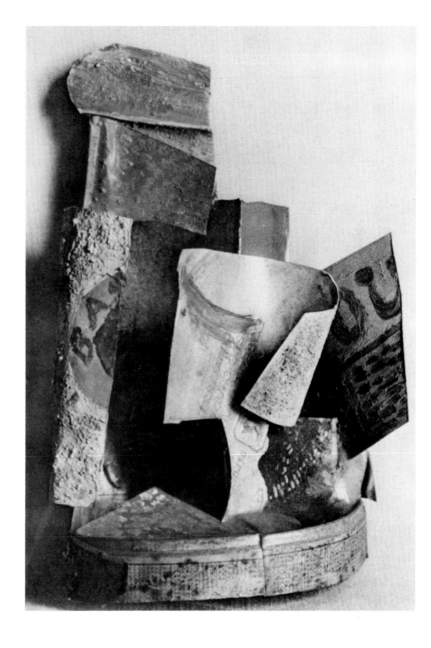

Pablo Picasso

*7 *Musical Instruments (Mandolin).* 1914
(Instruments de musique [Mandoline])

Painted wood, 23⅝″ (60 cm.) h.

Succession Picasso

REFERENCE:
Zervos, 1942, no. 853, pl. 363

see discussion p. 11 here

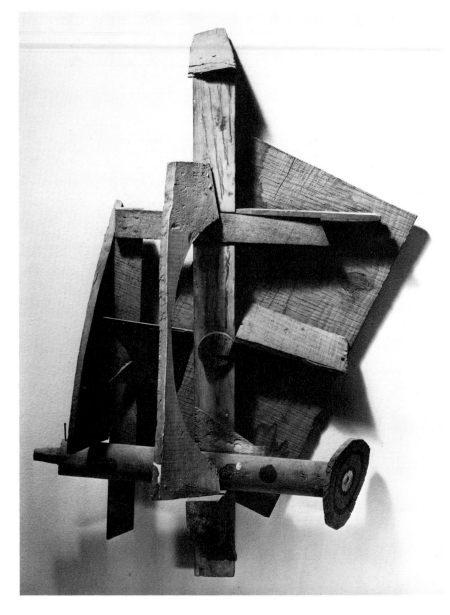

Henri Laurens

Born 1885, Paris
Died 1954, Paris

8 *Woman with Mantilla.* 1915
(Femme à la mantille)

Painted wood, 20⅞ x 14½ x 9⅞"
(53 x 37 x 25 cm.)

Private Collection

REFERENCES:

Christian Zervos, "Les 'Constructions'
de Laurens," *Cahiers d'Art*, 5e année,
no. 4, 1930, pp. 181-182, repr., 183-190

Marthe Laurens, *Henri Laurens:
sculpteur 1885-1954*, Paris, 1955, p. 23,
repr.

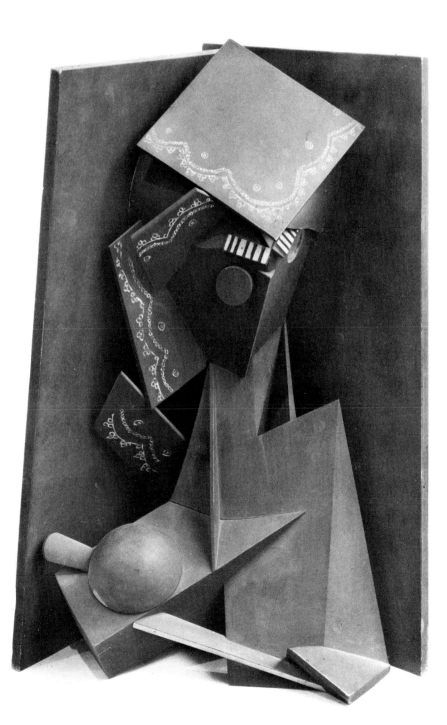

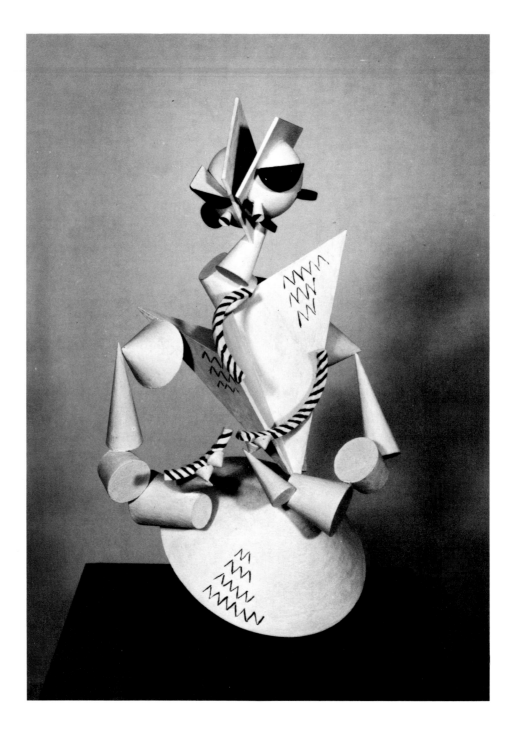

Henri Laurens

9 *Clown.* 1915

Painted wood, 20⅞ x 11⅝ x 9¼″
(53 x 29.5 x 23.5 cm.)

Signed and dated inside lower cone:
No. 1/LAURENS/1915

Collection Moderna Museet,
Stockholm

REFERENCES:

Zervos, 1930, p. 182, repr.

Laurens, 1955, p. 25, repr. (n.d.)

There exist two almost identical ver-
sions of this piece. The present location
of the other (ex-collection André
Lefebvre, Paris) is unknown.

10 *Head.* 1915
 (Tête)

Painted wood and metal, 5⅞ x 6⅞ x
4¼″ (15 x 17.5 x 11 cm.)

Collection Kunstmuseum Basel (Gift
of Marguerite Arp-Hagenbach, 1968)

REFERENCES:

Zervos, 1930, p. 184, repr. (*Portrait.*
1915)

Laurens, 1955, p. 29, repr.

The name given this piece by the Kunst-
museum Basel is *Sainte tête d'homme.*
However, there is no reference to this
title in the existing literature.

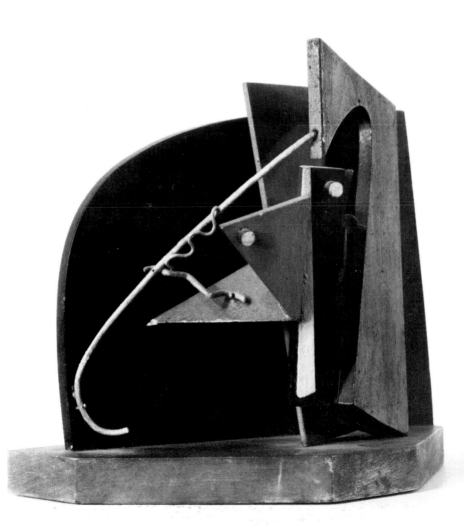

Henri Laurens

11 *Head.* 1915
(*Tête*)

Painted wood, 20 x 18¼″ (50.8 x
46.3 cm.)

Collection The Museum of Modern
Art, New York, van Gogh Purchase
Fund, 1937

REFERENCES:

Zervos, 1930, p. 183, repr.

Laurens, 1955, p. 28, repr.

This work and the preceding piece
present problems of dating because
later texts on the sculptor assign them
to 1918. However, according to
Laurens' family, the dates given by
Zervos should be respected as they
were arrived at in consultation with
the artist. Furthermore, the decorative
details relate these two works to
Laurens' earlier constructions.

Henri Laurens

12 *Bottle and Glass.* 1915
 (Bouteille et verre)

Painted wood and metal, 20 x 15¾ x
8⅝″ (51 x 40 x 22 cm.)

Collection Stedelijk Museum,
Amsterdam

REFERENCES:

Zervos, 1930, p. 185, repr. (*Nature
morte [Elements composés]. 1915*)

Laurens, 1955, p. 30, repr.

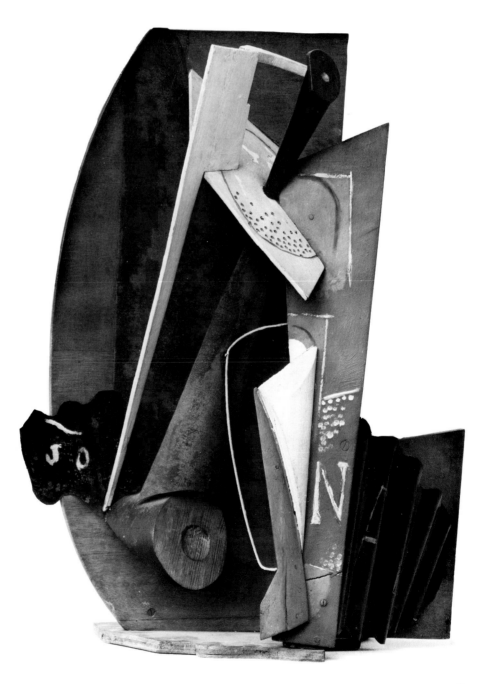

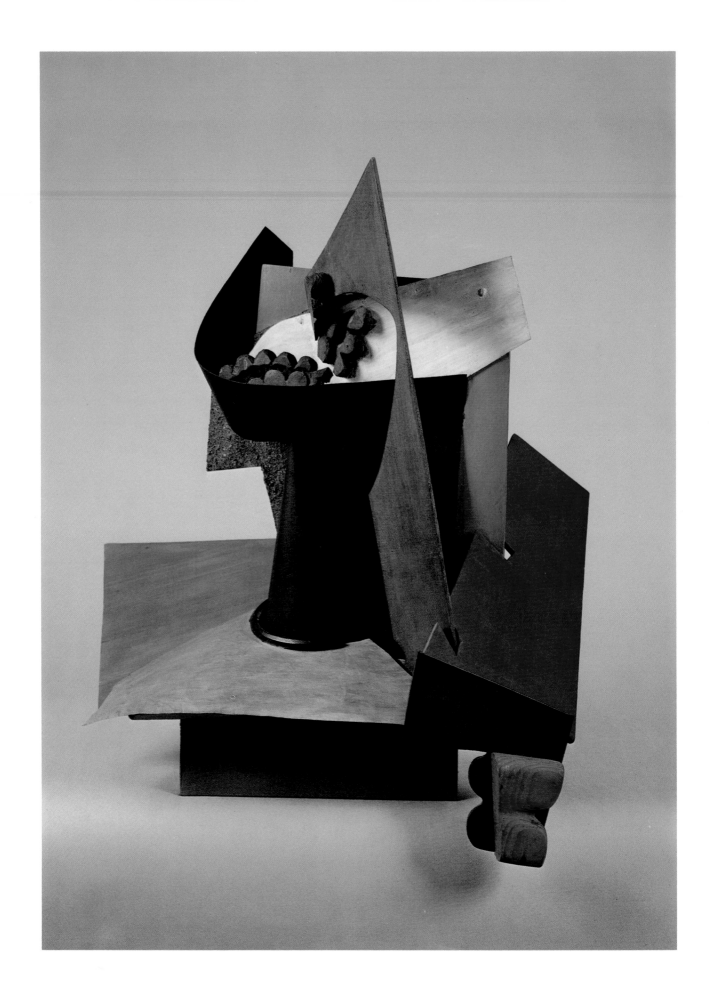

Henri Laurens

13 *Dish with Grapes.* 1916-18
 (Compotier de raisins)

Painted wood and sheet metal,
25½ x 24½ x 18″ (67.8 x 62.2 x 47 cm.)

Collection M. and Mme Claude
Laurens, Paris

REFERENCES:

Zervos, 1930, p. 190, repr. (*Le Compo-
tier.* 1918)

Laurens, 1955, p. 37, repr. (1918)

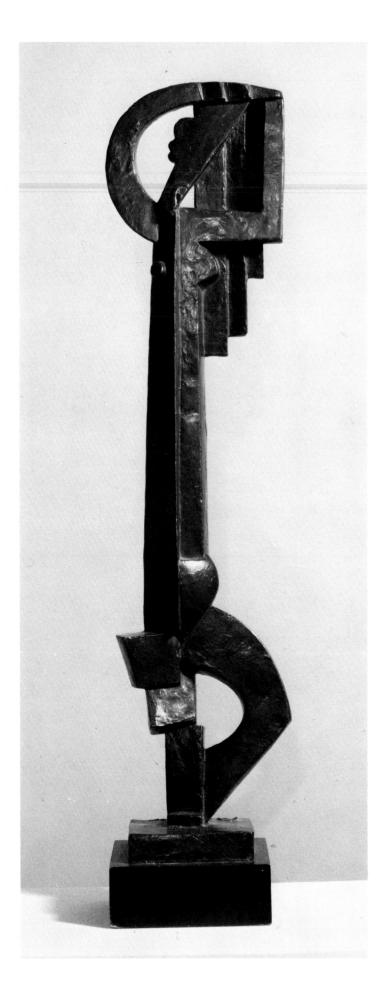

Jacques Lipchitz

Born 1891, Druskieniki, Lithuania
Died 1973, Capri

14 *Bather.* 1915
 (Baigneuse)

Bronze, 33⅝ x 7⅜ x 4⅜" (85.2 x 18.8 x
11.1 cm.)

Signed on top of base l. of c.:
2/7 J Lipchitz

Collection Hirshhorn Museum and
Sculpture Garden, Smithsonian
Institution, Washington, D.C.

REFERENCES:

Henry R. Hope, *The Sculpture of
Jacques Lipchitz*, New York, 1954,
pp. 10, 27, repr.

Jacques Lipchitz with H. H. Arnason,
My Life in Sculpture, New York, 1972,
pp. 22, fig. 17, 24-26

A. M. Hammacher, *Jacques Lipchitz*,
New York, 1975, pp. 11-36, fig. 28, 37-40

The *Bather* was identified by the artist
as the first of a series of works of 1915
reflecting a new approach. It was
originally made of clay. Although
related to Cubism, the interpretation
of the silhouette is visibly close to
Goncharova's bathers of 1912 which
she often depicted with arms raised
to their heads and busts in simul-
taneous frontal and profile views (see
fig.). Lipchitz visited Russia in 1913
where he met artists of the avant-garde.
Furthermore, Goncharova had a com-
prehensive exhibition at the Galerie
Paul Guillaume in Paris in 1914. These
are just two of a number of occasions
upon which Lipchitz could have seen
Goncharova's paintings. Nonetheless,
the translation of forms into three
dimensions is his own.

See further discussion p. 15 here.

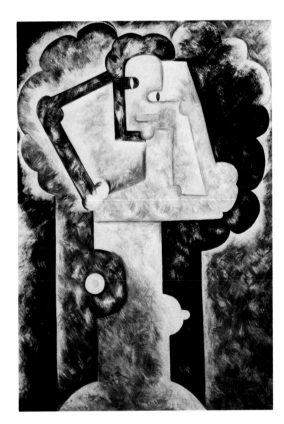

Goncharova, *Red Bather.* 1912. Oil on canvas
Leonard Hutton Galleries, New York

Jacques Lipchitz

15 *Detachable Figure (Dancer).* 1915
 (Figure démontable, danseuse)

Ebony and oak, 38⅝" (98.2 cm.) h.

Collection The Cleveland Museum of
Art, Gift of Mrs. Aye Simon

REFERENCE:
Lipchitz with Arnason, 1972, pp.
24-27, repr.

see discussion p. 15 here

16 *Detachable Figure (Dancer).* 1915
 (Figure démontable, danseuse)

Natural and painted wood, 34½ x 9 x
5½" (87.6 x 22.8 x 14 cm.)

Signed under base: *J Lipchitz*

Collection Yulla Lipchitz

see discussion p. 15 here

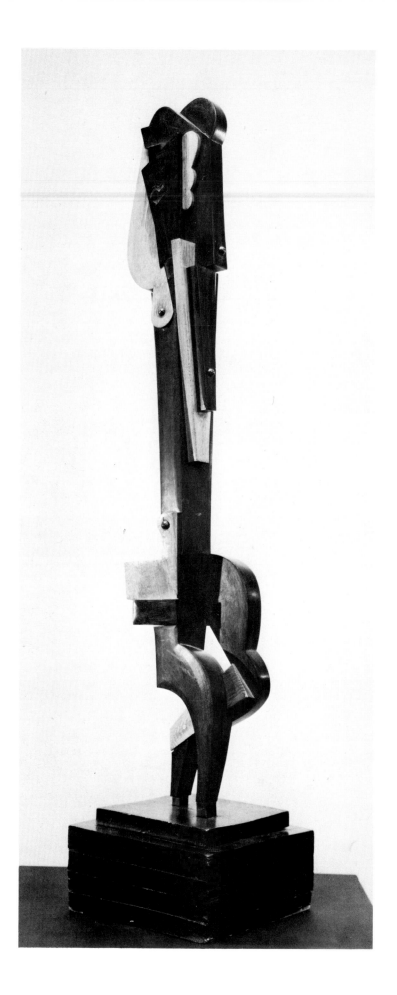

50

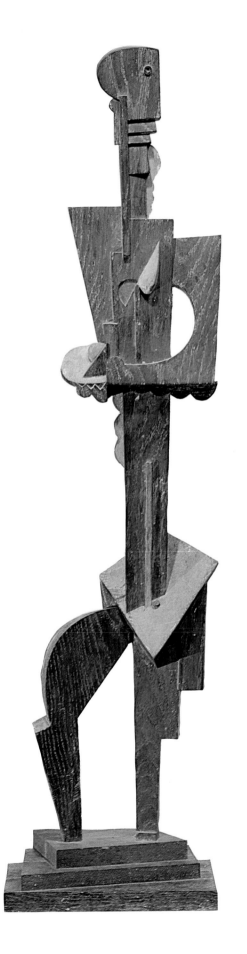
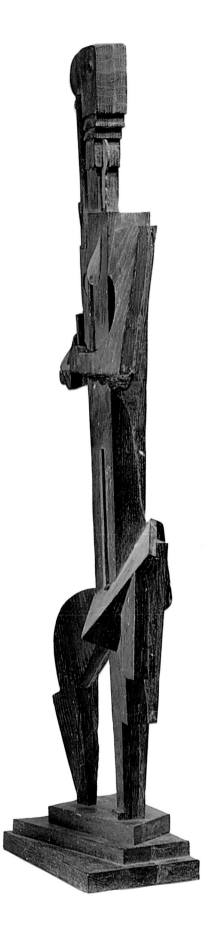

Jacques Lipchitz

17 *Detachable Figure (Seated Musician).*
 1915
 (Figure démontable, musicien)

Painted wood, 19¾ x 5¾ x 4½″
(50.2 x 14.6 x 11.4 cm.)

Signed under base: *J. Lipchitz*

Collection Yulla Lipchitz

REFERENCE:
Hammacher, 1975, fig. 66

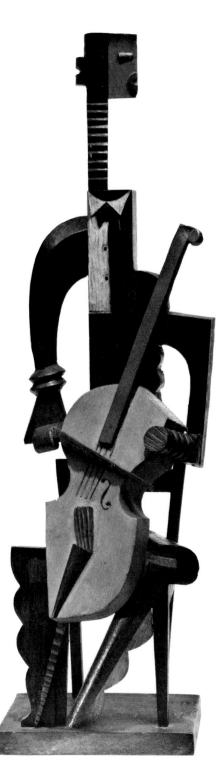

Jacques Lipchitz

18 *Detachable Figure (Pierrot).* 1915
 (Figure démontable, Pierrot)

Bronze, 27¼″ (69.2 cm.) h.

Collection Robert and Andrea Bollt,
New York

REFERENCE:
Lipchitz with Arnason, 1972, pp. 27,
fig. 19, 29

see discussion p. 15 here

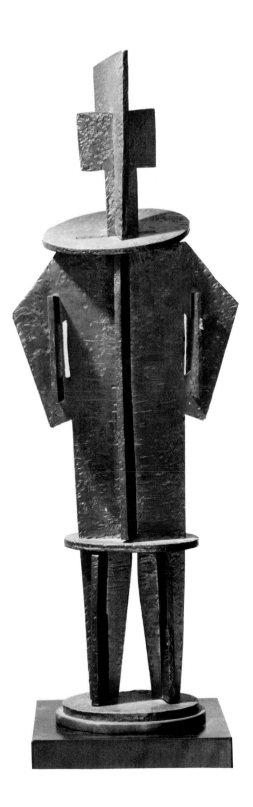

Giacomo Balla

Born 1871, Turin
Died 1953, Rome

19 *Fist of Boccioni; Force-Lines of the Fist
of Boccioni.* 1915
*(Pugno di Boccioni; Linee forze del
pugno di Boccioni)*

Painted wood and cardboard, 33 x 31 x
12½″ (83.8 x 78.7 x 31.8 cm.)

Signed and dated under base:
BALLA 1915

Lydia and Harry L. Winston Collection
(Dr. and Mrs. Barnett Malbin), New
York

REFERENCE:

The Solomon R. Guggenheim Museum,
New York, *Futurism: A Modern Focus.
The Lydia and Harry Lewis Winston
Collection, Dr. and Mrs. Barnett
Malbin*, Nov. 16, 1973-Feb. 3, 1974,
pp. 54, repr., 55, no. 19

see discussion p. 17 here

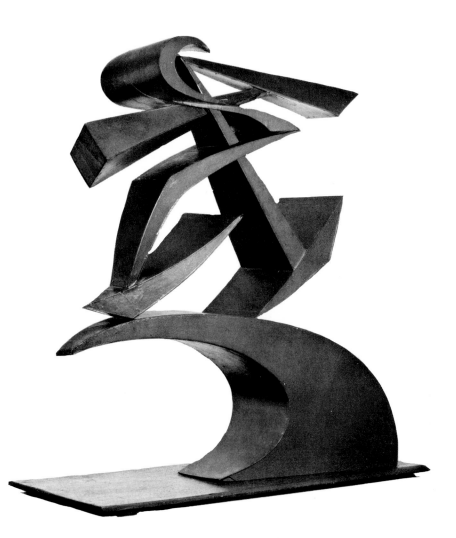

Giacomo Balla

20 *Tree.* ca. 1918
(*Albero*)

Painted wood, 12¾ x 10 x 10″
(32.4 x 25.4 x 25.4 cm.)

Signed (incised) l.l.: *BALLA*

Lydia and Harry L. Winston Collection
(Dr. and Mrs. Barnett Malbin), New
York

21 *Rose.* ca. 1918
(*Rosa*)

Painted wood, 13 x 7½ x 7½″
(33 x 19 x 19 cm.)

Signed (incised) l.r.: *BALLA*

Lydia and Harry L. Winston Collection
(Dr. and Mrs. Barnett Malbin), New
York

REFERENCE:

Virginia Dortch Dorazio, *Giacomo
Balla*, New York, n.d., figs. 187-190

Balla's trees and flowers were conceived for a completely artificial Futurist garden. They illustrate his and Depero's aspirations to "reconstruct the universe" (see discussion p. 17 here) by replacing natural forms with mechanical forms. Depero's theater work of the same period may have influenced them stylistically.

The "plants," made of flat, painted modular units, could be assembled and dismantled at will. Presumably the artist intended them for mass-production so that Futurist sculpture would be available to all.

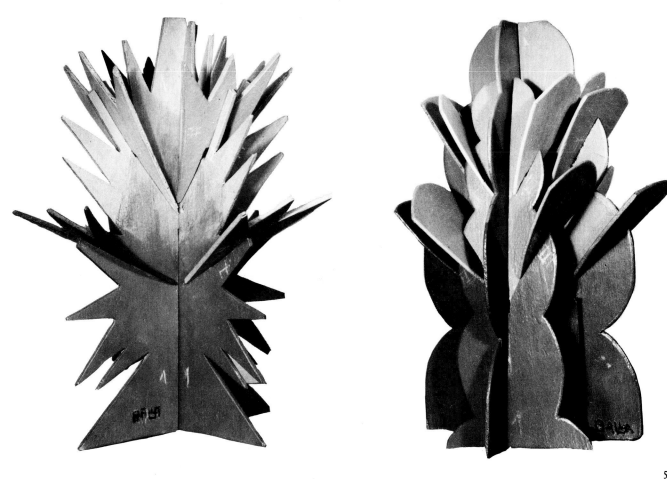

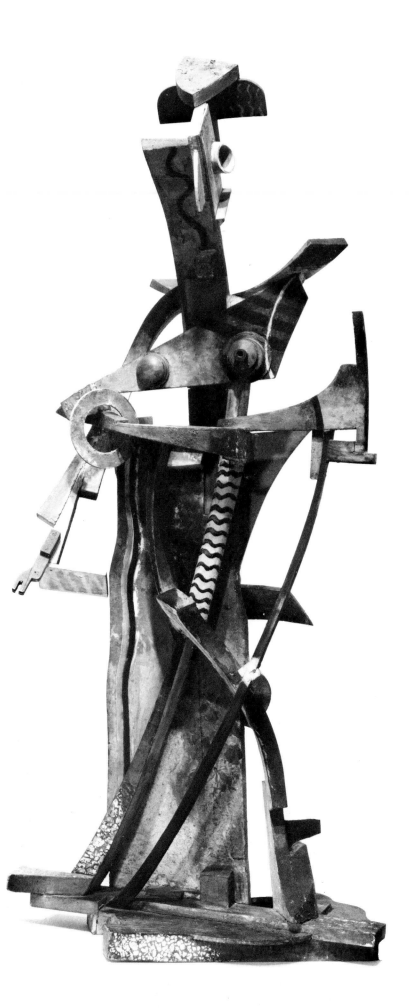

Vladimir Baranoff-Rossiné

Born 1888, Kherson, Ukraine, Russia
Died 1942, Paris

22 *Symphony Number 1.* 1913

Polychromed wood, cardboard and
crushed eggshells, 63¼ x 28½ x 25″
(161.1 x 72.2 x 63.4 cm.)

Collection The Museum of Modern
Art, New York, Katia Granoff Fund,
1972

REFERENCES:

Galerie Jean Chauvelin, Paris, *Vladimir
Baranoff-Rossiné*, Feb. 6-Mar. 6, 1970.
Text by Jean-Claude and Valentine
Marcadé

Musée National d'Art Moderne, Paris,
Vladimir Baranoff-Rossiné, Dec. 12,
1972-Jan. 29, 1973. Text by Michel Hoog

see discussion p. 20 here

Alexander Archipenko

Born 1887, Kiev, Ukraine, Russia
Died 1964, New York

23 *Médrano II.* 1913

Painted tin, wood, glass and oilcloth,
50″ (127 cm.) h.

Inscribed u.l.: *MÉDRANO;* signed and
dated l.r.: *A.Archipenko/1913 Paris*

Collection The Solomon R.
Guggenheim Museum, New York

REFERENCE:

Alexander Archipenko and others,
*Archipenko, Fifty Creative Years 1908-
1958*, New York, 1960, pp. 40-47

Médrano II was exhibited at the Paris
Salon des Indépendants in 1914 *(hors
catalogue)*. It is probably the only
remaining example of Archipenko's
mixed-media constructions of 1913,
which include *Médrano I, Woman in
front of a Mirror* and *Head.*

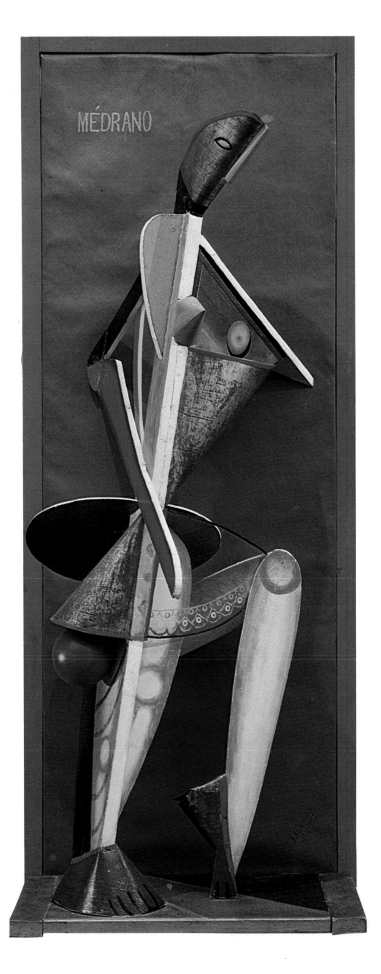

Alexander Archipenko

24 *Head of a Woman.* 1913-14
(Tête de femme)

Painted wood, sheet metal and found
objects, 17¾ x 13 x 14½" (45 x 33 x
37 cm.)

Collection Tel Aviv Museum, Eric
Goeritz Bequest

Although this piece does not reflect the
icon's structure, it evokes the primitive
force of the pre-Christian totemic
idols Archipenko admired during his
childhood in Kiev (see Yvon Taillandier,
"Conversation avec Archipenko," *XXe*
Siècle, xxxviie année, supplément au
no. 22, Christmas 1963, n.p.).

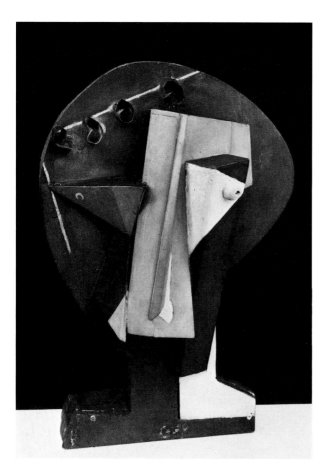 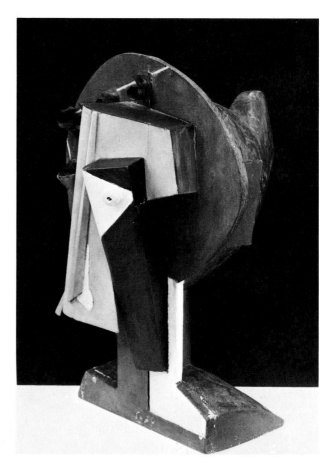

Alexander Archipenko

25 *Woman with a Fan.* 1914
(Femme à l'éventail)

Painted wood and canvas with funnel
and glass, 45½ x 24 x 5″ (108 x 61.5 x
13.5 cm.)

Signed and dated l.r.: *A. Archipenko/
1914.*

Collection Tel Aviv Museum, Eric
Goeritz Bequest

REFERENCE:

Yvon Taillandier, "Conversation avec
Archipenko," *XXe Siècle*, XXXVIIe
année, supplément au no. 22, Christ-
mas 1963, n.p.

Woman with a Fan provides the best
example for study of the icon's influ-
ence on the structure, space and
Faktura of Archipenko's 1913-15 works
(see discussion pp. 19-20 here). Part of
the ground is painted to resemble a
deep box-like frame within which the
figure is set as if it were a sacred image.
The coiffure of the elongated silhouette
is tipped like a halo into the canvas
background and its shadow reiterated
on that ground, accentuating the fig-
ure's frontal hieratic stance. The addi-
tion of found objects, including a metal
funnel and a glass bottle, produce a
visual tension between the presence of
the commonplace and an illusion of
the sacred, between concrete and
abstract forms.

This construction irresistably evokes
Picasso's 1908 *Woman with a Fan*
which was visible in the Shchukin
collection, Moscow, by 1909-10. Since
Archipenko went to Paris in 1908, he
may have seen this work before it was
sent to Moscow. However, it has not
been established whether Archipenko
knew Picasso's painting.

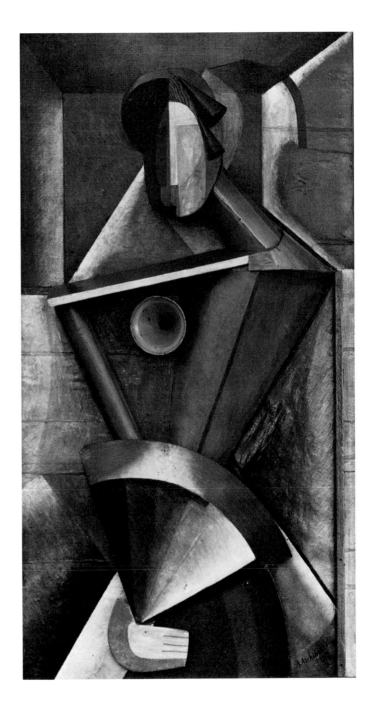

Alexander Archipenko

26 *Kneeling Woman.* 1914
 (Femme agenouillée)

Painted wood and found objects on
burlap, 35 x 18½ x 5½″
(89 x 47 x 14 cm.)

Signed l.l.: *Archipenko / Nice*

Collection Tel Aviv Museum, Eric
Goeritz Bequest

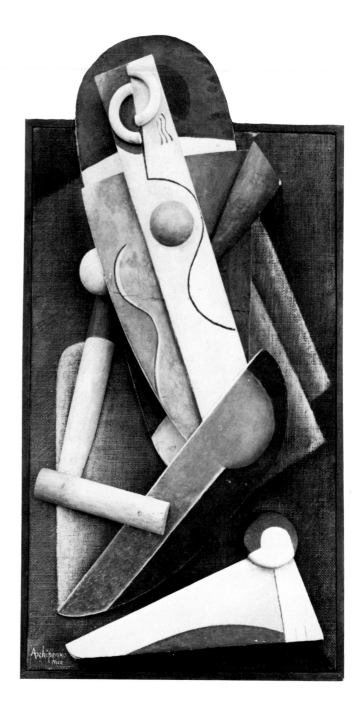

Alexander Archipenko

27 *The Bather.* 1915
 (Baigneuse)

Oil and pencil on paper, wood and
metal, 22 x 14″ (55.9 x 35.6 cm.)

Signed and dated l.l.: *A. Archipenko/
Nice 1915*

Philadelphia Museum of Art, The
Louise and Walter Arensberg
Collection

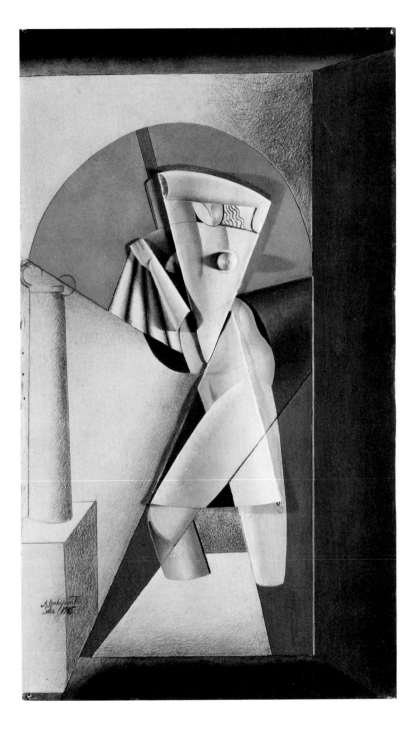

Alexander Archipenko

28 *Woman's Head and Still Life.* 1916
(*Tête de femme et table*)

Painted cement and plaster, 13¼ x
13⅝ x 8⅛" (33.7 x 34.5 x 20.5 cm.)

Signed l.l.: *Archipenko*

Collection Musée National d'Art
Moderne, Centre Georges Pompidou,
Paris

Archipenko executed this theme in
several formats and materials. Its alter-
nate title, *Española,* calls attention to
the woman's head (with mantilla) and
fan. One version, made of wood, metal
and canvas, was signed *Archipenko/
Nice* (present whereabouts unknown).
An edition of painted bronzes dated
1918, but cast in the 1950s, also exists
(see Donald Karshan, ed., *Archipenko:
International Visionary,* Washington,
D.C., 1969, p. 45, color repr.).

The tilted tabletop is a clear reference
to Cubist painting. From this date
forward Archipenko would execute
several still lifes, a subject not found
in his earlier work. This particular
relief has recently emerged from the
Raymond Duchamp-Villon estate.

Iwan Puni (Jean Pougny)

Born 1892, Kouokkala, Finland
Died 1956, Paris

29 *Still Life—Relief with Hammer.*
1920s reconstruction of 1914 original
(*Nature morte—Relief au marteau*)

Gouache on cardboard with hammer,
31⅝ x 25¾ x 3½" (80.5 x 65.5 x 9 cm.)

Collection Mr. and Mrs. Herman
Berninger, Zürich

REFERENCE:

Herman Berninger and Jean-Albert
Cartier, *Pougny: Catalogue de l'oeuvre,*
tome I, *Les Années d'avant-garde,
Russie-Berlin, 1910-1923,* Tübingen,
1972, pp. 45-46, 196, no. 100, repr.

According to Herman Berninger, Puni's
biographer and loyal supporter, when
the artist and his wife emigrated to
Berlin in 1919, most of his reliefs
executed between 1914 and 1916 in
Russia were left behind and sub-
sequently lost. However, a few that had
been left at the family dacha in
Kouokkala were eventually recovered.
The Russian constructions were
mostly small works which were never
produced beyond the model stage.

1920 in Berlin Puni reconstructed
some of these reliefs, many of them in
a larger format. The reconstruction of
Relief with Hammer presumably dates
from that time. It was sold to Ernst
Fritsch and then to the present owner.

In later years in Paris the artist and his
wife continued to reconstruct, re-
assemble and replace missing ele-
ments in the reliefs. The dates of
assemblage of the other works ex-
hibited here remain unclear.

The original *Relief with Hammer* was
shown in the *Tramway V* exhibition in
Moscow in 1915 (cat. no. 57) and was
mentioned unsympathetically by the
press.

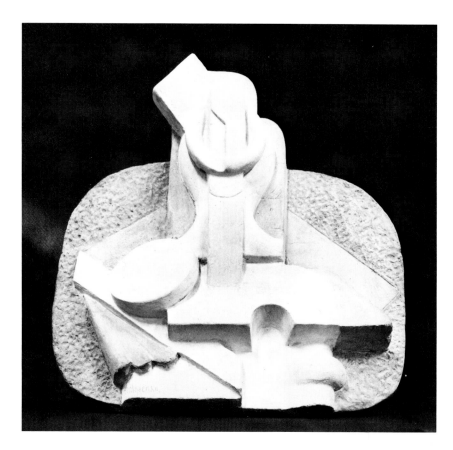

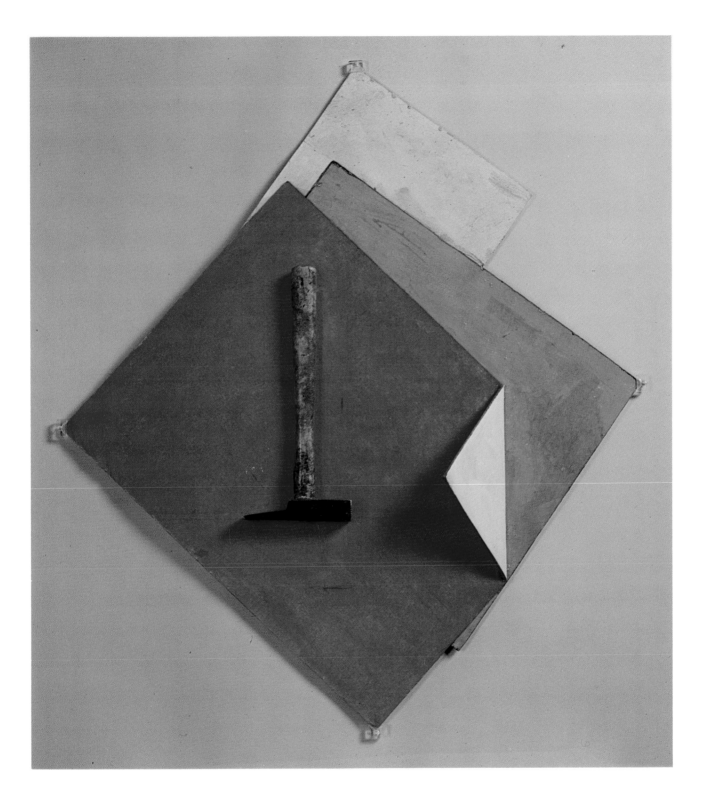

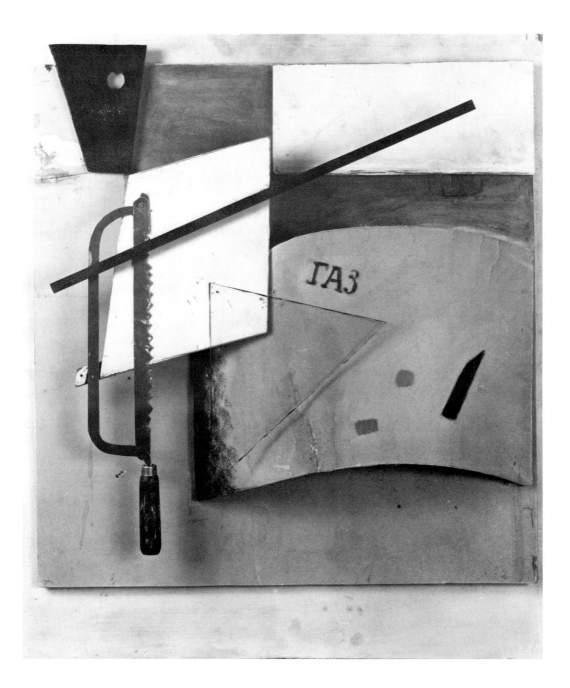

Iwan Puni (Jean Pougny)

30 *Sculpture—Relief with Saw.* Reconstruction from 1916 drawing of 1915 original
(*Sculpture—Relief à la scie*)

Partially painted wood, sheet iron, glass and cardboard with saw, 28½ x 25⅝ x 4¾" (72.5 x 65 x 12 cm.)

Collection Mr. and Mrs. Herman Berninger, Zürich

REFERENCE:
Berninger and Cartier, 1972, pp. 70, 198, no. 108, repr. See also pp. 82, 203, no. 127, for related drawing dated 1916

31 *Sculpture.* Reconstruction from 1916 drawing of 1915 original

Partially painted wood, tin and cardboard, 30¼ x 19⅝ x 3⅛" (77 x 50 x 8 cm.)

Collection Musée National d'Art Moderne, Centre Georges Pompidou, Paris

REFERENCE:
Berninger and Cartier, 1972, p. 198, no. 109, repr. See also p. 204, no. 128, for related drawing dated 1916

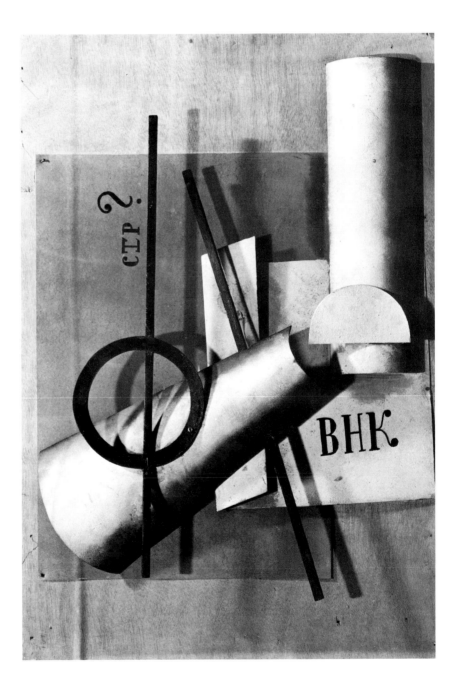

Iwan Puni (Jean Pougny)

32 *Cubo-Sculpture*. Reconstruction of
1915 original

Partially painted wood, sheet metal,
cardboard and plaster, 27½ x 21⅜ x
4¾" (70 x 54.4 x 12 cm.)

Collection Mr. and Mrs. Herman
Berninger, Zürich

REFERENCE:

Berninger and Cartier, 1972, p. 199, no.
111. See also pp. 83, 201, no. 118, for
related drawing dated 1915

The employment here of lines which
suggest perspective or depth is an
unusual compositional device for
Puni: the grounds in his other reliefs
are more open and spatially un-
inflected. This tighter framework
serves to accentuate the contradiction
between surface and depth and also
introduces a note of austere iconic
structure.

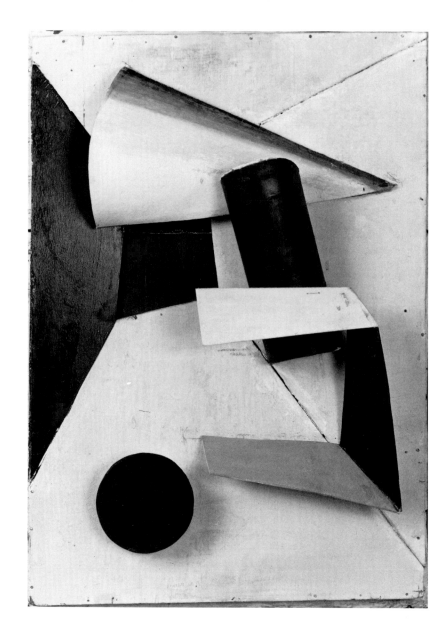

Liubov Popova

Born 1889, near Moscow
Died 1924, Moscow

33 *Relief.* 1915

Painted papers on cardboard, 26⅛ x 19⅛" (66.3 x 48.5 cm.)

Museum Ludwig, Cologne (Ludwig Collection)

REFERENCE:

John E. Bowlt, "From Surface to Space: The Art of Liubov Popova," *The Structurist*, Saskatoon, Canada, no. 15/16, 1975/76, pp. 80-88

In 1912 Popova studied in Paris under Le Fauconnier, Metzinger and Segonzac. The influence of Cubism (particularly of the kind practiced by these artists and Gleizes) is visible in her paintings of 1912-15. Upon Popova's return to Moscow in 1913, she studied with Tatlin. Her interest in architectonic form and in extending the painted surface into space probably dates from this period. Reliefs such as this one (another is housed at the Tretiakov Gallery, Moscow) reflect both the influences of Cubism and Tatlin.

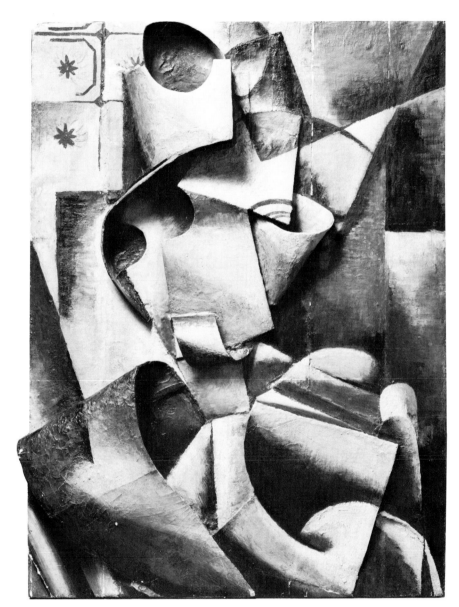

Vladimir Tatlin

Born 1885, Moscow
Died 1953, Moscow

34 *Counter Relief (Corner)*. 1966-70
reconstruction from photographs by
Martyn Chalk of 1915 original

Iron, zinc and aluminum, 31 x 60 x
30″ (78.7 x 152.4 x 76.2 cm.)

Lent by Annely Juda Fine Art, London

REFERENCE:

Moderna Museet, Stockholm, *Vladimir
Tatlin*, July-Sept. 1968, p. 42, repr.
(original). Texts by Troels Andersen,
El Lissitzky, Kazimir Malevich, Nikolai
Punin, the artist and others. Traveled
to Kunstverein München, Jan. 22-
Mar. 8, 1970

see discussion pp. 20-22 here

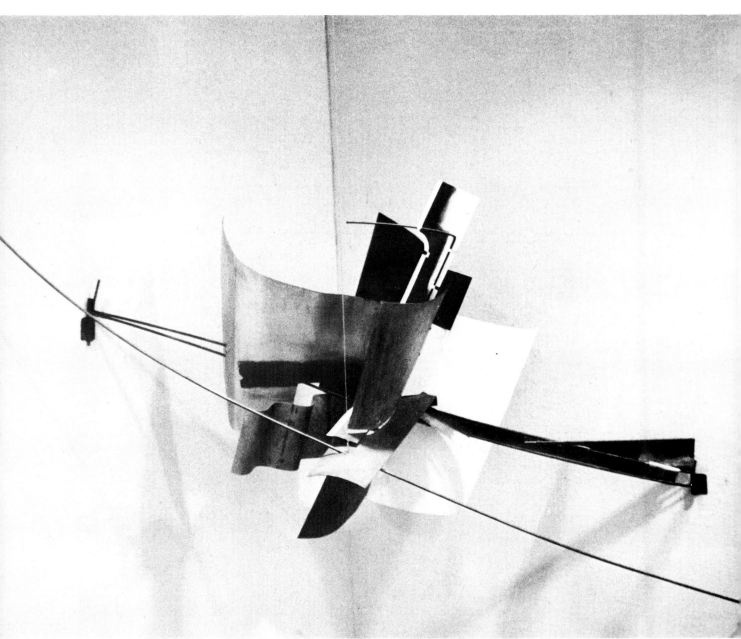

Vladimir Tatlin

35 *Counter Relief.* 1966-70 reconstruction
 from photographs by Martyn Chalk
 of 1915 original

Wood and metal, 27 x 32¾ x 31″
(68.6 x 83.2 x 71.7 cm.)

Lent by Annely Juda Fine Art, London

reference:

Moderna Museet, 1968, p. 43 repr.
(original)

see discussion pp. 20-22 here

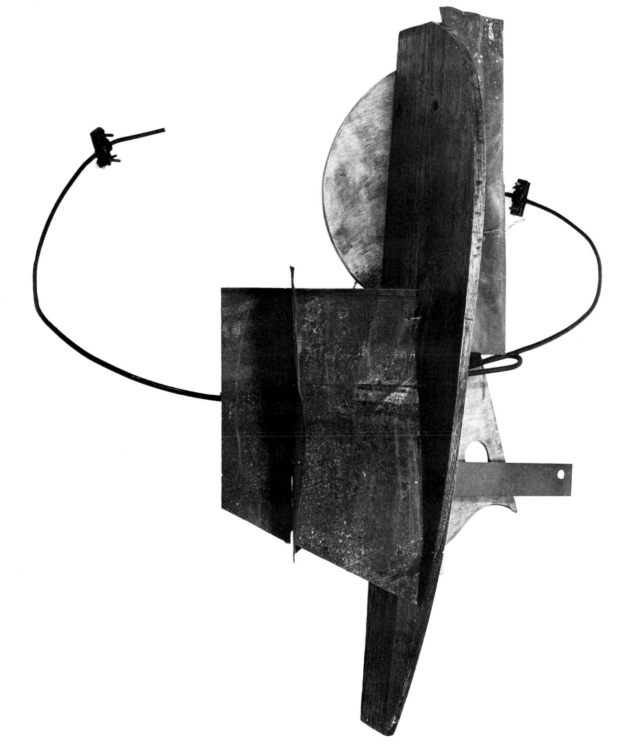

Naum Gabo

Born Naum Gabo Pevsner, 1890,
Briansk, Russia
Died 1977, Middlebury, Conn.

36 *Constructed Head No. 2.* early 1950s
replica of 1916 galvanized iron original

Bronze, 17¾″ (45.1 cm.) h.; base, 14″
(35.5 cm) h.

Collection Miriam Gabo

REFERENCE:

Herbert Read and Leslie Martin, *Gabo*,
London, 1957

Constructed Head No. 1, made in Nor-
way in 1915 (now lost), was a thin
cellular structure of planes of wood.
The original version of *Constructed
Head No. 2* consisted of galvanized
sheet-iron plates covered with yellow
ochre paint and measured 17¾ inches
high. It was exhibited in Moscow in
1917 and in Berlin and Holland in
1922-23. After the latter exhibition it
was mistakenly returned to the Soviet
Union, while Gabo remained in Berlin.
He would not see it again until the
early 1950s, when it was sent to him
from Russia in pieces. Gabo stripped
the paint, reassembled the work and
subsequently made six replicas: a
bronze, original size (this catalogue
entry); a celluloid, original size (Collec-
tion Miriam Gabo); a bronze, three feet
high (Oslo University); three large-
scale works, each six feet high, one in
corten steel (Tate Gallery, London) and
two in stainless steel (Collection Miriam
Gabo). The artist apparently considered
the large-scale versions the best transla-
tion of his original objectives.

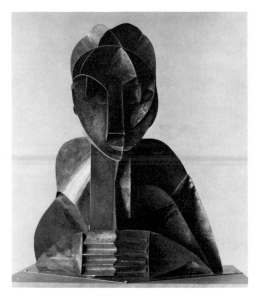

Constructed Head No. 2. 1916. Galvanized iron
Collection Miriam Gabo

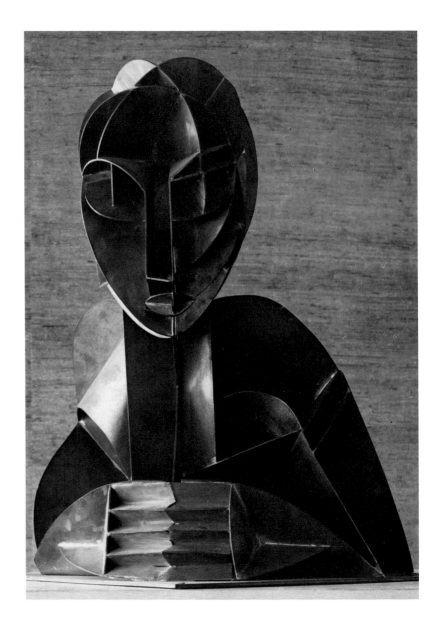

Naum Gabo

37 *Head of a Woman.* 1917-20 replica of
1916 original

Celluloid and metal, 24½ x 19¼"
(62.2 x 48.9 cm.)

Signed l.r.: *Gabo*

Collection The Museum of Modern
Art, New York, Purchase, 1938

The original version of *Head of a
Woman*, called *Head No. 3*, was iron.
Gabo made *Head No. 3*, like the present
piece, in Norway; it is now in the
collection of the artist's widow. The
iron *Head* was included in the Moscow
Open Air Exhibition in August 1920.
The celluloid replica was shown at the
Erste Russische Kunstausstellung at the
Galerie van Diemen, Berlin, in 1922,
and at the Galerie Percier, Paris, in
1924, in the exhibition *Constructivistes
russes.* It was purchased by Alfred Barr
for The Museum of Modern Art in
1938 from the Galerie Jos. Hessel, Paris.

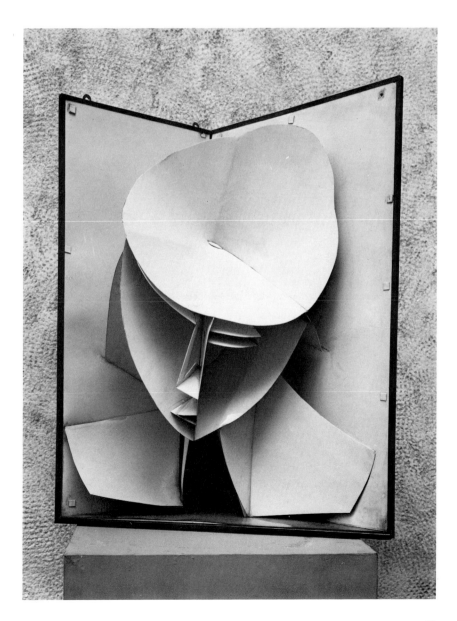

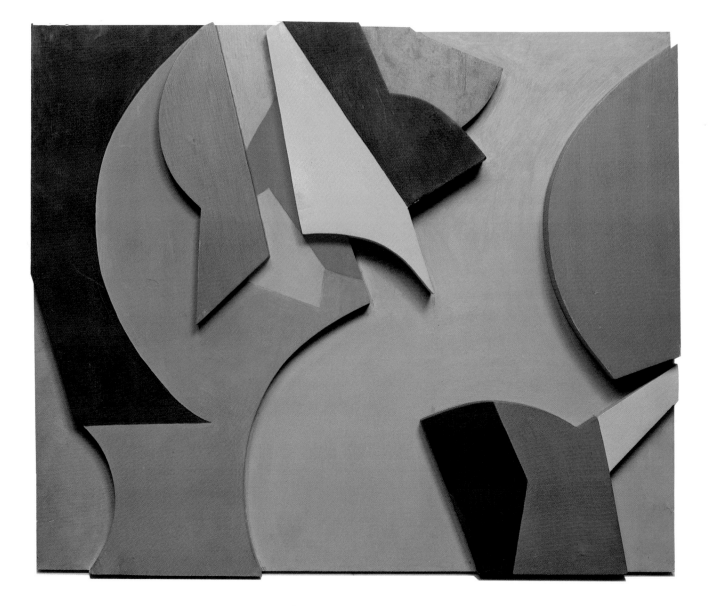

Jean Arp

Born 1886, Strasbourg
Died 1966, Basel

*38 *Abstract Configuration.* 1915
(Composition abstraite)

Painted wood, 29¼ x 35½″ (74 x
90 cm.)

Collection Tehran Museum of Contemporary Art

REFERENCES:

James Thrall Soby, ed., *Arp*, New York,
1958. See particularly texts by Carola
Giedion-Welcker and Robert Melville,
pp. 20-33.

The University of California at Los
Angeles Art Galleries, *Jean Arp (1886-
1966): A Retrospective Exhibition*,
Nov. 10-Dec. 5, 1968. Traveled to: Des
Moines Art Center, Iowa, Jan. 11-Feb.
16, 1969; Dallas Museum of Fine Arts,
Mar. 12-Apr. 6; The Solomon R.
Guggenheim Museum, New York, May
16-June 29. Catalogue published as
Herbert Read, *The Art of Jean Arp*,
New York, 1968. See particularly pp.
66-67, repr., 68-84.

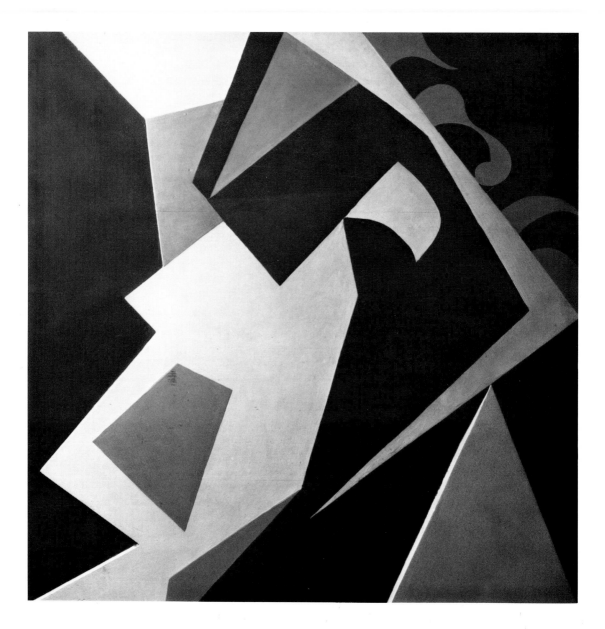

Jean Arp

39 *Crucifixion.* 1915
 (Le Crucifié)

Painted wood, 48 x 47½ x 1⅜"
(122 x 120 x 3.5 cm.)

Collection Musée d'Art Moderne,
Strasbourg

REFERENCES:

Musée National d'Art Moderne, Paris,
Arp, Feb. 21-Apr. 2, 1962, p. 37, no. 20
Musée d'Art et d'Industrie, Saint-
Etienne, *Jean Arp—Reliefs*, Nov.-Dec.
1978, frontispiece, p. 19, no. 1

Although Arp's first reliefs are some-
times dated 1914, the artist's 1958 text
"Looking" (see Soby, 1958, p. 12) indi-
cates that they are from 1915. *Abstract
Configuration* and *Crucifixion* are
among his earliest sculptures in this
form. The early pieces are singularly
abstract compared to Arp's other reliefs
and seem to be conceived, like applied
art, to fill a given space. Possibly they
were influenced by Sophie Taeuber-
Arp's work in the decorative arts. Some
were even reinterpreted as rugs, em-
broideries and tapestries (see Read,
1968, p. 20 for a rug on the theme of
Crucifixion and p. 28 for an embroi-
dered rendering of *Abstract Configura-
tion*.) Paradoxically, the motifs in the
later reliefs, although still schematized,
would become increasingly legible as
Arp shifts his emphasis to the poetic
connotations of form.

40 *Forest.* 1916
 (Forêt)

Painted wood, 12⅞ x 7¾ x 3"
(32.7 x 19.7 x 7.6 cm.)

Collection National Gallery, Washing-
ton, D.C., Andrew W. Mellon Fund,
1977.

REFERENCES:

Soby, 1958, pp. 35, repr., 121, no. 34
Read, 1968, pp. 31-33, color repr., 202,
no. 21
Musée National d'Art Moderne, Centre
Georges Pompidou, Paris, *Paris-New
York*, June 1-Sept. 19, 1977, p. 459, repr.

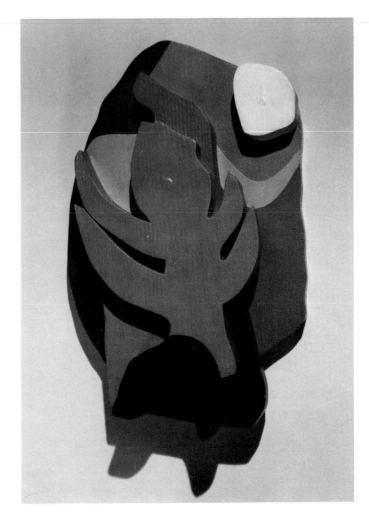

Jean Arp

41 *Dada Relief.* 1916
 (Relief Dada)

Painted wood, 9½ x 7¼ x 3⅞"
(24 x 18.5 x 10 cm.)

Collection Kunstmuseum Basel (Gift
Marguerite Arp-Hagenbach, 1968)

REFERENCES:

Read, 1968, pp. 32, repr., 202, no. 20
(First Dada Relief)

Rijksmuseum Kröller-Müller, Otterlo,
*Verzameling Marguerite Arp-Hagen-
bach,* June 28-Aug. 16, 1970, n.p., no. 9,
repr.

Dada Relief is related to the larger relief
of the same year entitled *Portrait of
Tzara.*

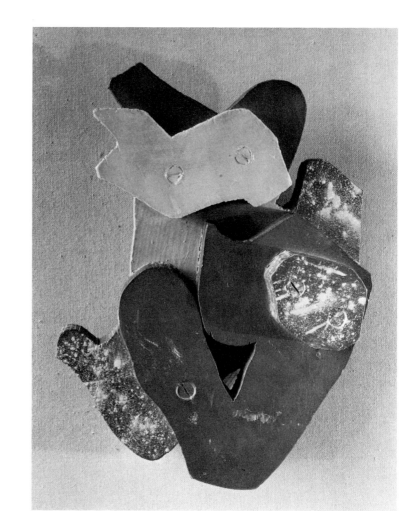

Jean Arp

42 *Plant Hammer.* 1916-17
(Fleur marteau)

Painted wood, 24¾ x 19⅝ x 3⅛"
(62.8 x 49.8 x 7.9 cm.)

Private Collection

REFERENCE:
Soby, 1958, pp. 30, 36, repr., 121, no. 35

Plant Hammer was executed in two
almost identical versions, the present
sculpture and another in the collection
of the Gemeentemuseum, The Hague.
Apparently when Arp particularly liked
a work, he made more than one version
and kept one for himself.

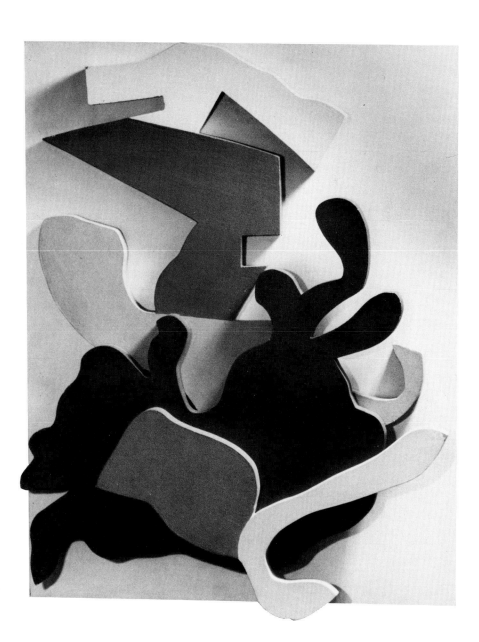

Jean Arp

43 *Forest Tables.* 1926
(*Tables-forêts*)

Oak, 16½ x 24⅜″ (24.1 x 61.9 cm.)

Collection I.M.A.

This is one of the earliest, if not the
first, free-standing sculptures made by
the artist, according to his niece Ruth
Tillard-Arp.

44 *Vase-Bust.* 1930
(*Vase buste*)

Painted wood, 12⅛ x 9½ x 2½″
(31.7 x 24.1 x 6.3 cm.)

Philadelphia Museum of Art, A. E.
Gallatin Collection

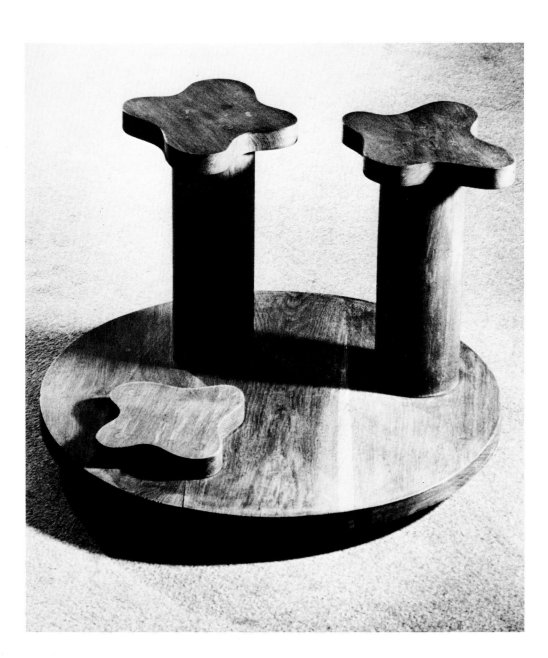

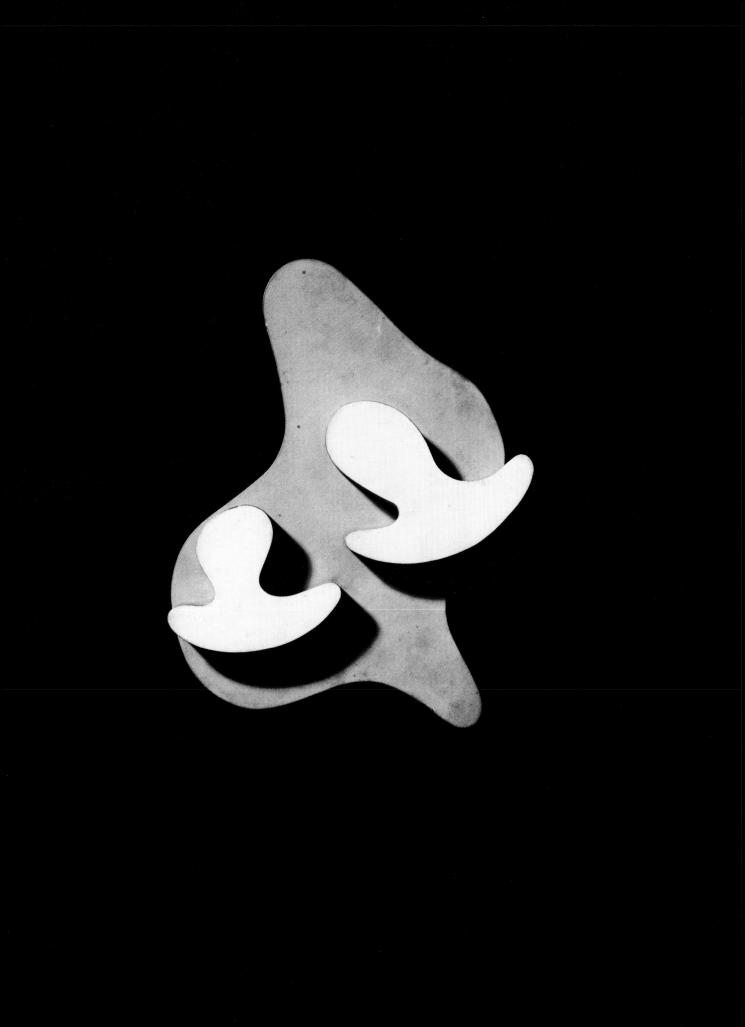

Jean Arp

45 *Constellation with Five White Forms
and Two Black, Variation III.* 1932
*(Constellation avec cinq formes
blanches et deux noires, variante III)*

Painted wood, 23⅝ x 29⅝ x 1½″
(60 x 75.3 x 3.8 cm.)

Collection The Solomon R. Guggen-
heim Museum, New York

REFERENCE:

Margit Rowell, ed., *Selections from The
Guggenheim Museum Collection:
1900-1970*, New York, 1970, pp. 24-25,
repr.

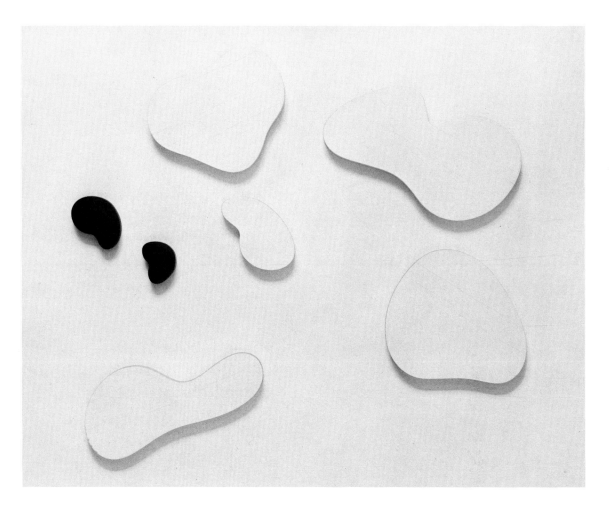

Max Ernst

Born 1891, Brühl, Germany
Died 1976, Paris

46 *Bird.* 1916-20

Wood, 40⅛ x 8¼ x 11⅞″
(102 x 21 x 30.2 cm.)

Private Collection

REFERENCES:

The Museum of Modern Art, New
York, *Dada, Surrealism, and Their Heritage*, Mar. 27 - June 9, 1968, p. 49, no.
89, fig. 61. Text by William Rubin.
Traveled to: Los Angeles County Museum of Art, July 16 - Sept. 8; The Art
Institute of Chicago, Oct. 19 - Dec. 8

Werner Spies, Sigrid and Günter
Metken, *Max Ernst Oeuvre-Katalog:
Werke 1906-1925*, Cologne, 1975, p. 350,
no. 672, repr. (ca. 1924)

Bird is one of Ernst's earliest sculptures
and perhaps his only free-standing
Dada work. The humorous, mechanical and finely articulated silhouette
echoes the artist's collages of the Cologne Dada period. Indeed, this laminated assemblage of found objects
(wooden slats) was probably inspired
by the collage technique.

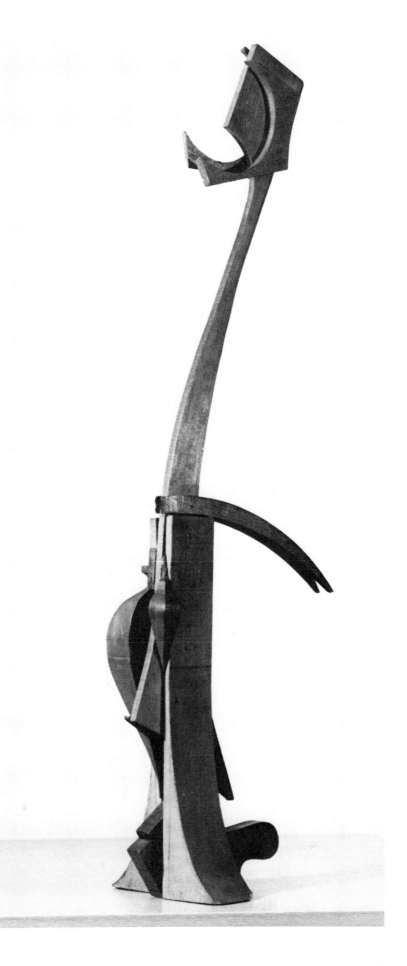

Vilhelm Lundstrøm

Born 1893, Copenhagen
Died 1950, Copenhagen

47 *Lattice Picture.* 1917

Painted wood and metal, 50⅜ x 24″
(128 x 61 cm.)

Collection Louisiana Museum, Humlebaek, Denmark

REFERENCES:

Moderna Museet, Stockholm, *Vilhelm Lundstrøm*, Feb. 25 - Apr. 2, 1978, pp. 3, repr., 10

Herta Wescher, *Collage*, New York, n.d. (first published Cologne, 1968), pp. 48-50, fig. 41, p. 54, color pl. 9

Lundstrøm was a painter most of his life. However, during the period 1917-18 he made a series of reliefs, including the present work, in which simple geometric forms are fashioned from waste material. Although these constructions evoke Constructivist art in the truest sense of the term (whereby the innate qualities of the materials dictate structure and form), it is more correct to relate them in spirit to Dada reliefs and collage.

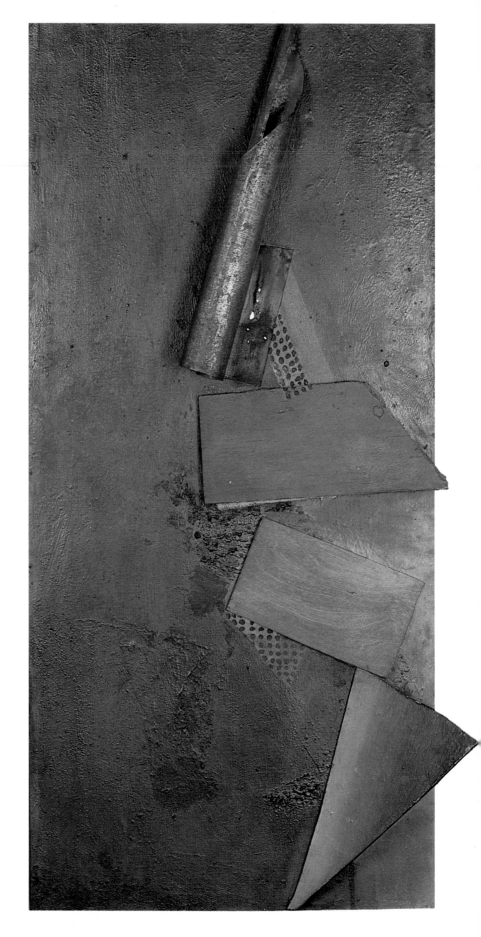

Christian Schad

Born 1894, Miesbach, Germany
Lives in Keilberg im Spessart, Germany

48 *Image of a Woman.* 1920
(*L'Image d'une femme*)

Painted wood and appliqué, 25⅝ x
11⅞ x 4⅛" (60 x 30 x 10.5 cm.)

Signed and dated l.r.: *SCHAD 20*

Lent by the artist

REFERENCES:

Palazzo Reale, Milan, *Christian Schad,*
Oct. 26 - Nov. 19, 1972. Text by Roberto
Tassi

Carl Lazlo, ed., *Christian Schad,* Basel,
1972, p. 117, color repr.

Schad's Dada activity in Zürich and
Geneva is mostly remembered for his
invention of "Schadography" in 1918
and a series of curious reliefs of 1920 of
which approximately six are known.
Schadography, so named by Tzara, was
a technique of photography without a
camera, whereby objects were placed
on sensitized paper and exposed to
light. It was the acknowledged prede-
cessor of Man Ray's rayograms. The
artist's aim in the Schadographs was to
capture "magical" images from "magi-
cal" organizations of his materials.

Many of the enigmatic shapes in the
Schadographs are found again in the
slightly later reliefs. It therefore seems
possible that these wooden forms were
originally fashioned to block out light
and create mysterious configurations in
the photographs. The reliefs translate
that mystery into the concrete terms of
almost fetish-like objects.

By 1921 Schad had returned to figura-
tive painting (primarily people and
portraits) and by 1925 he had reached
his mature style of *Neue Sachlichkeit*
(New Objectivity), the idiom for which
he is best known.

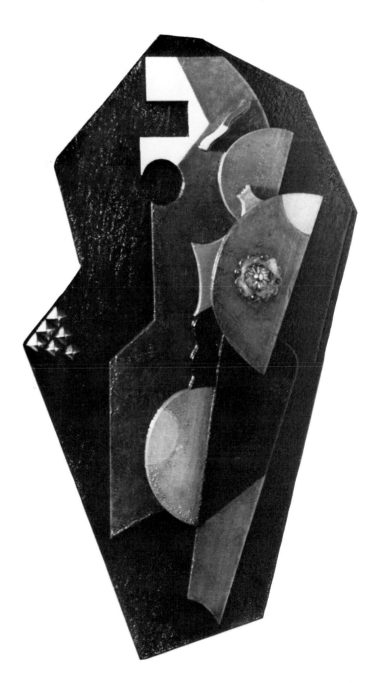

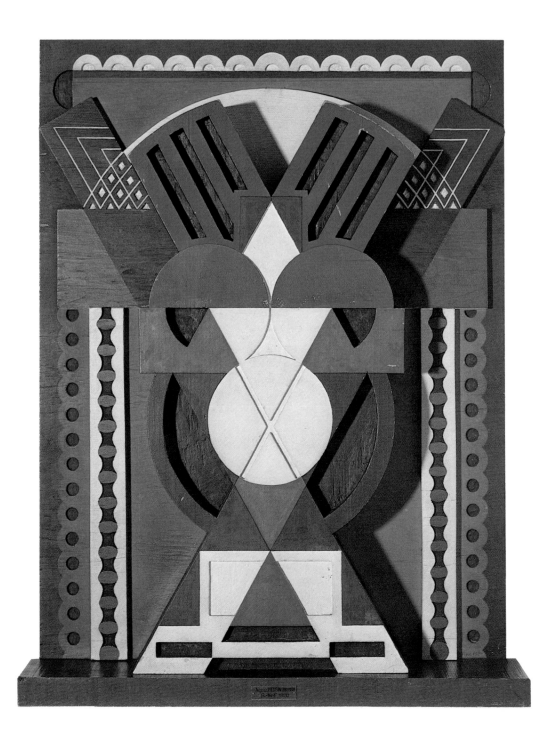

Auguste Herbin

Born 1882, Quiévy, France
Died 1960, Paris

49 *Wood Relief.* 1920
(Bois sculpté)

Painted wood, 34⅞″ (88.5 cm.) h.

Signed l.l.: *Herbin*; dated l.r.: *Nov. 1920*

Collection Musée d'Art Moderne de la
Ville de Paris

REFERENCE:

Anatole Jakovski, *Auguste Herbin*,
Paris, 1933, pp. 27, repr., 32-38

In 1920 Herbin began making what
he would later call "concrete objects,"
wood and cement reliefs and free-
standing forms such as those seen here.
At the same time he referred in his cor-
respondence to "monumental art" and
its relationship to architecture and to
Communism, in which he firmly be-
lieved: *"Notre art ne peut être que*
monumental *et je crois que nous n'au-*
rons de vrai communisme que lorsque
nous aurons cet art monumental. *Le*
monument qui sera la foi de tous, le
rayonnement qui sera l'égalité absolue.
Le monument qui contiendra toutes les
formes d'art, tous les artistes et artisans
(véritable art populaire) où les hommes
reviendront au contraire *puiser des*
joies sans mélange . . ." (Undated letter
from Herbin, probably 1920, GC Ar-
chive, Paris). ("Our art must be monu-
mental and I believe that we will not
have true communism until we have
that monumental art. The monument
which represents the faith of all, its
radiance which represents absolute
equality. The monument which con-
tains all forms of art, all artists and ar-
tisans [truly popular art], where men
will come to obtain unmitigated plea-
sure.")

These wooden reliefs corresponded to
an attempt to formulate a simplified
repertory of forms for a decorative art
which could be structurally integrated
into architecture, an idea which was
uncommon in France. Herbin was a
founding member of *Abstraction*
Création and remained a participant
in the group until it disbanded. Jakov-
ski's monograph (see reference) was
published under the auspices of
Abstraction Création.

Auguste Herbin

50 *Wood Relief.* 1921
(*Bois sculpté*)

Painted wood, 38½ x 18⅞ x 11¾″
(98.7 x 48.3 x 29.8 cm.)

Private Collection

REFERENCE:
Jakovski, 1933, p. 28, repr.

51 *Wood Relief.* 1921
(*Bois sculpté*)

Painted wood, 39⅜ x 28⅞ x 1⅛″
(100 x 76 x 4 cm.)

Private Collection, Paris

REFERENCE:
Galerie Denise René, New York, *Masters of Early Constructive Abstract Art*, Oct. 1971, cover, color repr.

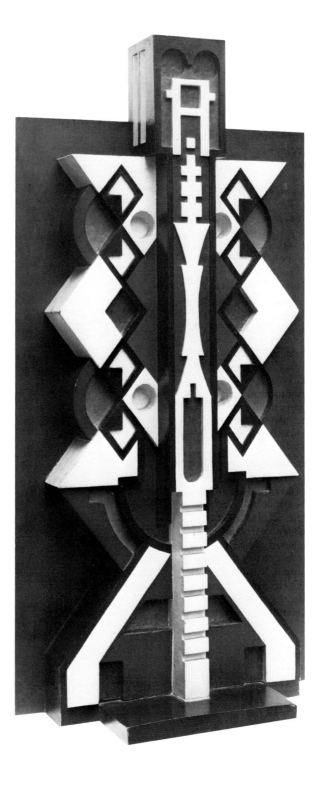

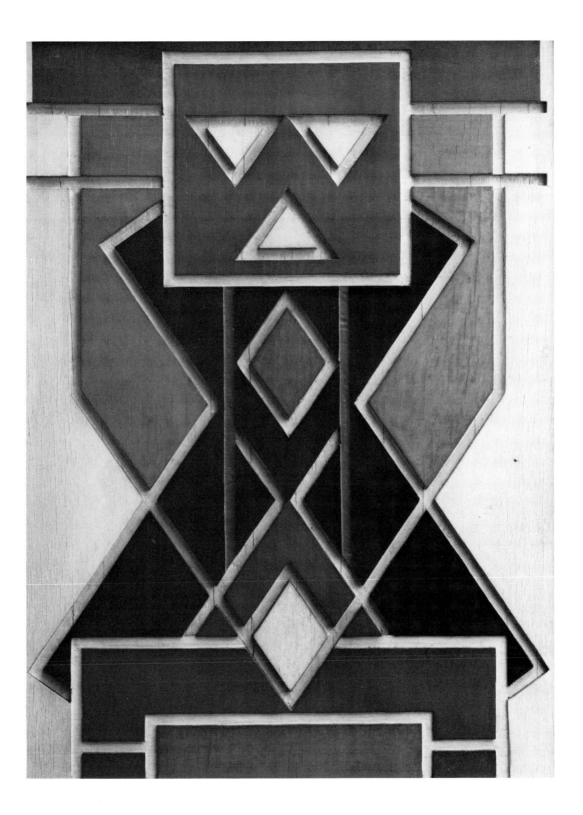

Man Ray

Born 1890, Philadelphia
Died 1976, Paris

52 *Lampshade.* 1921

Painted metal and wood, 45¼″
(114.9 cm.) h.

Signed and dated on base: *Man Ray
N.Y. 1921/Lampshade*

Yale University Art Gallery, New
Haven, Gift from the Estate of Kath-
erine S. Dreier

REFERENCES:

Man Ray, *Self Portrait,* Boston, 1963,
pp. 92, 96-97

William S. Rubin, *Dada and Surrealist
Art,* New York, 1968, p. 62

Man Ray's singular form of creativity
can be described as "the invention of
the useless," according to Hans Richter
(in *Dada: Art and Anti-Art,* New York,
1965, p. 96). "The Uselessness Effect
shows us objects from what one might
call their human side. It sets them free.
It was precisely because these things
were useless that we found them mov-
ing and lyrical. The humour of the use-
less machine is Man Ray's discovery."
This passage is pertinent to the *Lamp-
shade* and other objects of the same pe-
riod, perhaps the best known of which
is *Gift,* 1921, a flatiron studded with
nails on its sole.

Man Ray was one of the founders of
the *Société Anonyme,* along with Mar-
cel Duchamp and Katherine Dreier.
The first *Lampshade,* made of paper,
was exhibited in the first *Société An-
onyme* exhibition in 1920. Apparently
the piece was accidentally destroyed,
and, in January 1921, Dreier suggested
to the artist that he remake it in "tin."
She bought this version from Man Ray
sometime later that year (information
from Robert L. Herbert, 1978).

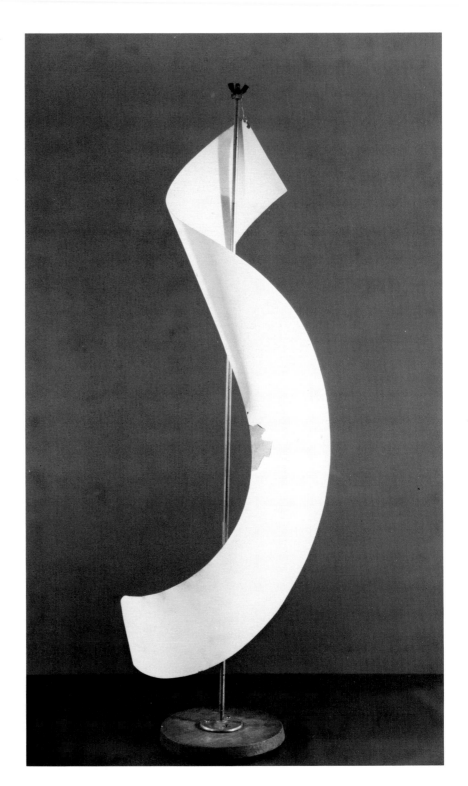

Marc Eemans

Born 1907, Dendermonde, Belgium
Lives in Brussels

53 *Kallomorphose IV.* 1924
Painted wood, 24¾ x 20⅞" (63 x 53 cm.)

Signed and dated l.r.: *MARC EEMANS/ XXIV*

Collection Carl Laszlo

REFERENCE:
Serge Goyens de Heusch, *"7 Arts" Bruxelles 1922-29*, Brussels, 1976, pp. 116-117, 148-155

54 *Kallomorphose V.* 1924
Painted wood, 28⅞ x 23⅝"
(73.5 x 60 cm.)

Signed and dated l.r.: *MARC EEMANS/ XXIV*

Collection Mr. Neirynck, Sint-Martens-Latem, Belgium

At an early age, in late 1922, Eemans associated himself with the Brussels group 7 *Arts* and contributed critical articles to their weekly magazine (published from 1922-29). This group defended "pure plasticism" (*la plastique pure*) as the style most appropriate to the social role of art and to the sensibility and technology of the new industrial age. In 1924 Eemans executed a series of about ten paintings on wood panels in which his relation to 7 *Arts*, its defense of reason in the arts and its understanding of painting as close to if not subordinate to architecture is visible. "Kallomorphose" is a term invented by Eemans, "created by analogy with 'metamorphose,' and 'anamorphose,' 'kallos' being the Greek word for beauty" (letter from Eemans to the author, Oct. 9, 1978).

By 1925 the Surrealist movement was a real threat to the aesthetic of rationalism in Belgium, and the 7 *Arts* review published texts strongly critical of the expression of the subconscious in art (see Goyens de Heusch, 1976, p. 47). But by 1926 Eemans had turned to Surrealism, claiming that pure plasticism did not permit him to express the strong poetic and mythical dimension of his sensibility (see interview with the artist, Goyens de Heusch, p. 419). He remains a Surrealist to this day.

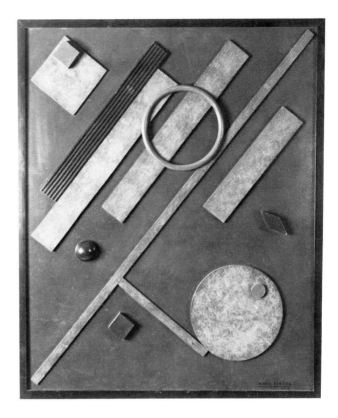

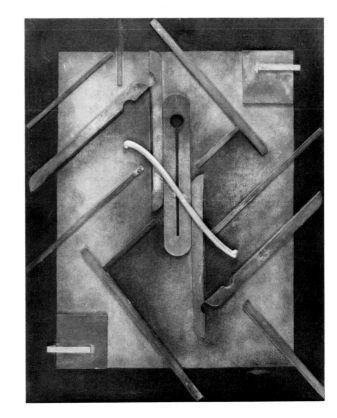

Jean Peyrissac

Born 1895, Cahors, France
Died 1974, Sorges par Savignac les
Eglises

55 *Harlequin's Eye.* 1924
(*L'Oeil d'arlequin*)

Painted wood, metal and string, 18⅞ x
14½ x 2½″ (48 x 37 x 6.5 cm.)

Signed and dated l.l.: *Peyrissac/mai
1924*

Lent by N. Seroussi, Galerie Quincam-
poix, Paris

REFERENCES:

Michel Seuphor, *La sculpture de ce
siècle: dictionnaire de la sculpture
moderne,* Neuchâtel, 1959, pp. 316-318

Sylvain Lecombre, "Peyrissac," *Canal,*
Paris, no. 9, 1/30 Nov. 1977, p. 7

Peyrissac was a self-taught artist who
lived most of his life in Algeria (1920-57)
and actively participated in no main-
stream European movement. Most of
his painting during the time of his Al-
gerian residence shows a Surrealist col-
oring, although he has denied any close
contact with that group. After his re-
turn to France he devoted his energies
to extremely personal cast-iron sculp-
ture.

His constructions of mixed materials
date from two periods. The first reliefs,
from the 1920s, were made of planar
forms which, although geometric, re-
lated to the Surrealist imagery of his
paintings. Furthermore, the layered
spaces, tight box-like frames and the
heavy shadows emphasize a magical
ambience.

In the second group of works, executed
in the mid 1940s, the artist introduced
movement into more open wire forms.

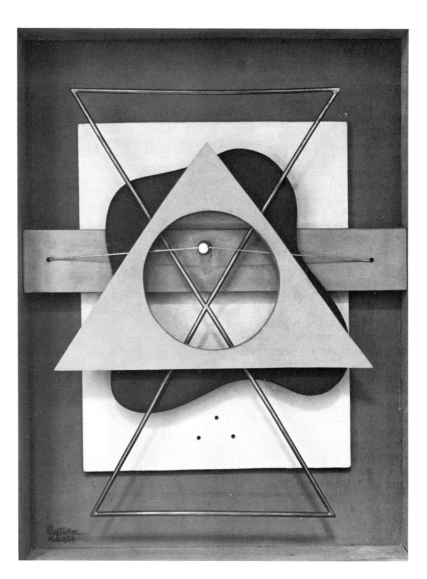

Jean Peyrissac

56 *Construction.* 1925

Painted wood, metal and string, 48⅜ x
27⅞ x 5⅝" (123 x 71 x 14.5 cm.)

Signed and dated on reverse: *Peyrissac
1925*

Private Collection, Paris

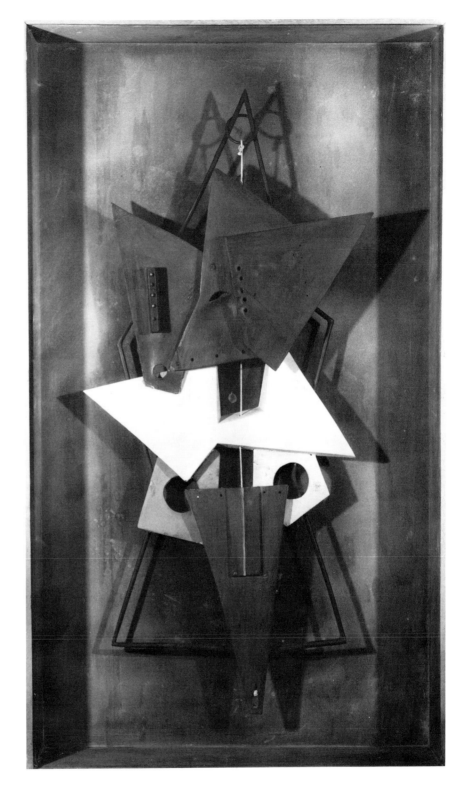

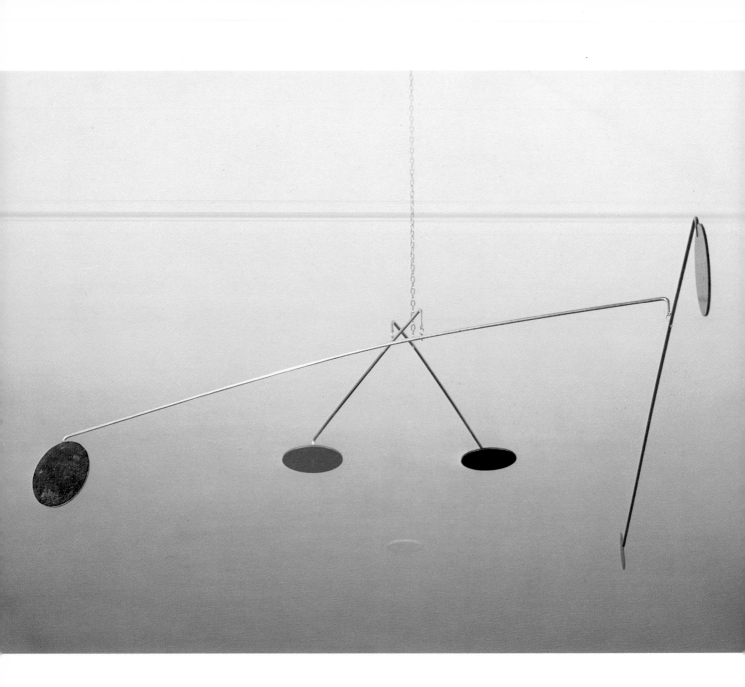

Jean Peyrissac

57 *Mobile.* 1930 (?)

Painted iron, 17¾ x 82½″ (45 x 210 cm.)

Lent by Henkel KGaA, Düsseldorf

REFERENCE:

Derrière le miroir, no. 8, Mar. 1948

In 1928 Peyrissac visited the Bauhaus
in Dessau where he was impressed by
Klee and Kandinsky. Apparently his
first "mobiles" date from shortly after
that visit but were not directly related
to it. Since most of Peyrissac's earliest
constructions with moving forms are
not dated, it is difficult to ascertain
whether he or Calder was the first to
work in this direction.

This is the only hanging construction
with disks in Peyrissac's oeuvre.
Although undated, it can be placed
around 1930, as it is closer stylistically
to the assemblages of flat planes char-
acteristic of his 1920s constructions
than to the more complex spiral con-
figurations with moving parts of the
1940s. The latter sculptures were ex-
hibited in Paris at the Galerie Maeght
in 1948.

Julio Gonzalez

Born 1876, Barcelona
Died 1942, Arcueil, France

58 *Harlequin.* 1929
 (Arlequin)

Iron, 16½″ (42 cm.) h.

Signed l.r.: *j.G*

Collection Kunsthaus Zürich, Vereini-
gung Zürcher Kunstfreunde

REFERENCE:

Josephine Withers, *Julio Gonzalez.
Sculpture in Iron*, New York, 1978, pp.
39-40, fig. 17, 41-42, 159, no. 33

According to Withers, the *Harlequin*,
usually dated 1929, was probably fin-
ished in 1930. It was exhibited in Paris
and Brussels in 1931. The same author
relates it to Picasso's paintings of the
period 1926-30 on this theme: "The
subject itself, the alternation of the
opaque and transparent forms, the syn-
copated rhythms of the arclike forms
and the counterpoint of graphic, linear
forms against flat, geometrically-shaped
planes all suggest that this sculpture is
an imaginative transposition or recrea-
tion of Picasso's paintings of the same
period." (p. 42) When Gonzalez com-
pleted *Harlequin,* he had just finished
collaborating with Picasso on the wire
constructions of 1928 and 1929.

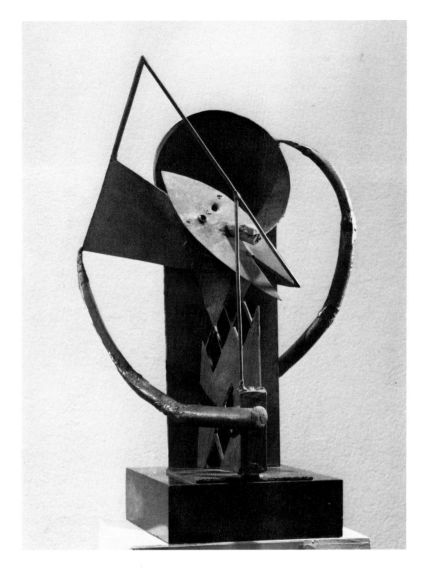

Julio Gonzalez

59 *The Kiss.* 1930
(*Le Baiser*)

Iron, 10½ x 11¼ x 3"
(26.7 x 28.5 x 7.6 cm.)

Signed and dated on reverse u.l.:
J. Gonzalez/1930

Lydia and Harry L. Winston Collection
(Dr. and Mrs. Barnett Malbin), New
York

REFERENCES:

The Solomon R. Guggenheim Museum,
New York, *Futurism: A Modern Focus.
The Lydia and Harry Lewis Winston
Collection, Dr. and Mrs. Barnett Mal-
bin*, Nov. 16, 1973-Feb. 3, 1974, pp. 100-
101, repr.

Withers, 1978, pp. 42, 44, 51, repr., 159,
no. 34

This is one of Gonzalez's earliest ab-
stract sculptures. It was exhibited in
Paris at the Galerie de France in 1931
and reproduced in an advertisement for
the gallery in *Cahiers d'Art* that same
year (6ᵉ année, no. 1, n.p.). It was also
shown in Brussels in 1931. *The Kiss* be-
longed to the artist Mario Tozzi from
the early 1930s to 1958, when it came
into the present collection. No bronze
castings have been made.

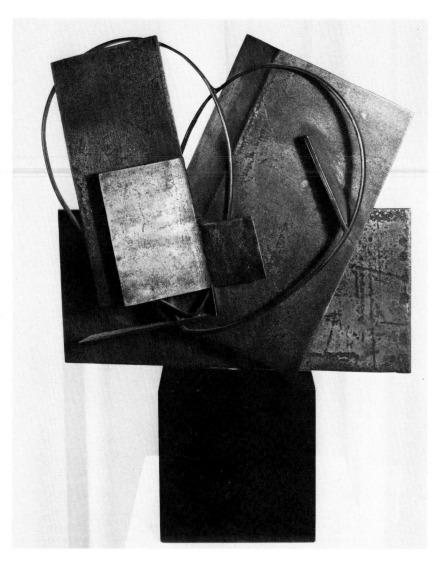

Julio Gonzalez

60 *Head of a Harlequin.* 1932
(Tête d'arlequin)

Iron, 10½ x 6 ⅞ x 5½"
(26.7 x 17.4 x 14 cm.)

Signed and dated l.r.: *J. Gonzalez / 1932*

Collection Cecilia Torres-García, New
York

Gonzalez undertook his earliest experi-
ments with the encircled or enclosed
void in approximately 1930, as exem-
plified in *Harlequin* (cat. no. 58). His
objectives are more explicit in this
small *Head of a Harlequin,* a gift from
the sculptor to his friend Torres-
García. The irregular geometric shape
cut out of the frontal surface recalls the
Cubist practice of cutting away planes
in constructions to indicate transpar-
ency. Thus, the inner spaces are visible
and are emphasized by the play of light
and shadow. Although relatively rare
in Gonzalez's work, this kind of styl-
ized opening on the front plane occurs
again in *The Lovers II* of 1933 (Artist's
Estate; see Withers, 1978, p. 58, fig. 46).
It leads to *Head ("The Tunnel")* of
1933-34 (Tate Gallery, London), where
the open-closed relationship is reversed.

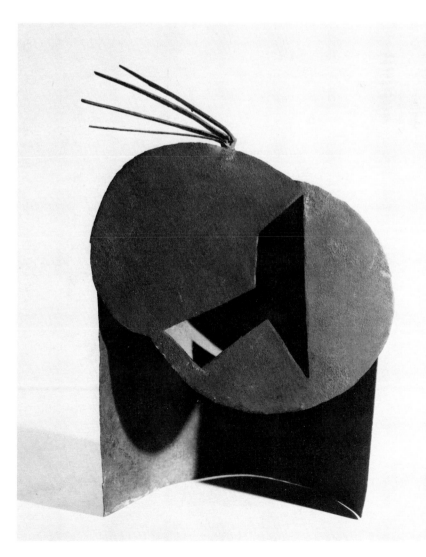

Joaquín Torres-García

Born 1874, Montevideo
Died 1949, Montevideo

61 *Superimposed White Form Like a Mask in Profile.* Paris 1929
(*Forma Blanca Superpuesta en Forma de Mascara de Perfil*)

Painted wood, 10⅛ x 6½ x 1¾"
(25.7 x 16.5 x 4.5 cm.)

Signed and dated on reverse: *J. Torres-García*/29

Private Collection, New York

REFERENCES:

Joaquín Torres-García, "Vouloir construire," *Cercle et Carré*, Paris, no. 1, Mar. 15, 1930, n.p.

Museum of Art, Rhode Island School of Design, Providence (organizer), *Joaquín Torres-García: 1874-1949.* Text by Daniel Robbins. Traveled to: The National Gallery of Canada, Ottawa, Oct. 2 - Nov. 1, 1970; The Solomon R. Guggenheim Museum, New York, Dec. 12, 1970-Jan. 31, 1971; Museum of Art, Rhode Island School of Design, Feb. 16 - Mar. 31

Enric Jardi, *Torres-García*, New York, 1973 (first published Barcelona, 1973)

Torres-García's relief or free-standing constructions date from his Paris period (1926-32). The more interesting ones, in which he used detached abstract forms and accentuated shadow, were executed between 1929 and 1931, after he met van Doesburg and Mondrian. The year 1929 marks the turning point in Torres-García's painting: his rather primitive figurative style was replaced by "universal constructivism," as he called it. In this unique idiom cryptographic symbols are organized according to an irregular (and therefore dynamic) grid structure. Torres-García attempted to create a balance between art and nature through the rectilinear grid, the symbols and natural colors.

In some paintings where shading makes the signs seem to be positioned in shallow space, an effect of relief is created. The constructions appear as an extension of this imagery in which the relation between form or symbol and plane is examined. More precisely, however, these objects reflect the notions of concrete art developed in Paris at that time in opposition to the Surrealist movement. In 1930 Torres-García was a founding member of the group *Cercle et Carré*, a short-lived predecessor of *Abstraction Création* (see discussion pp. 27-28 here). In his essay "Vouloir construire," published in the first issue of the *Cercle et Carré* magazine, Torres-García defined his understanding of

"construction": a work of art must not represent nature but exist as the concrete embodiment of an idea. It must be self-contained, defined by its own order and inner rhythms, and refer to nothing outside itself.

Torres-García had carved wooden toys in earlier years, so that this technique was easy and natural for him. And wood was the medium of some forms of primitive art to which he referred in "Vouloir construire." Presumably, these constructions of free-standing elements did not completely satisfy him since he did no more experimental works of this kind after 1931, although he made a few sculptures.

Joaquín Torres-García

62 *Construction in White.* 1930
 (Constructivo en Blanco)

Painted wood, 20¾ x 14 ¼″
(52.7 x 36.1 cm.)

Private Collection, New York

REFERENCE:

Museum of Art, Rhode Island School of
Design, 1970, p. 106, no. 76, repr.

Joaquín Torres-García

63 *Wood Construction.* 1931
 (Constructivo en Madera)

 Painted wood, 13½″ (34.2 cm.) h.

 Signed and dated on reverse: *J.Torres-GARCIA/31*

 Philadelphia Museum of Art, A. E. Gallatin Collection

 REFERENCE:

 Museum of Art, Rhode Island School of Design, 1970, p. 107, no. 78, repr.

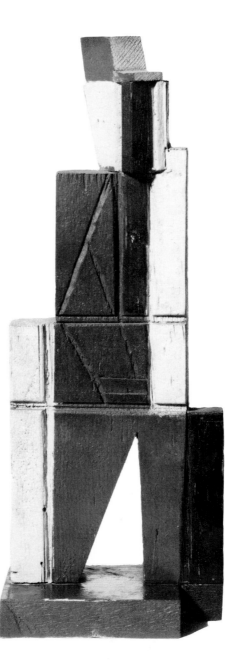

Joaquín Torres-García

64 *Wood in Form of a Red T.* ca. 1931
 (Madera en Forma de T Roja con Signos)

Painted wood, without base, 11 x 7 x ¾″
(28 x 17.8 x 1.9 cm.)

Private Collection

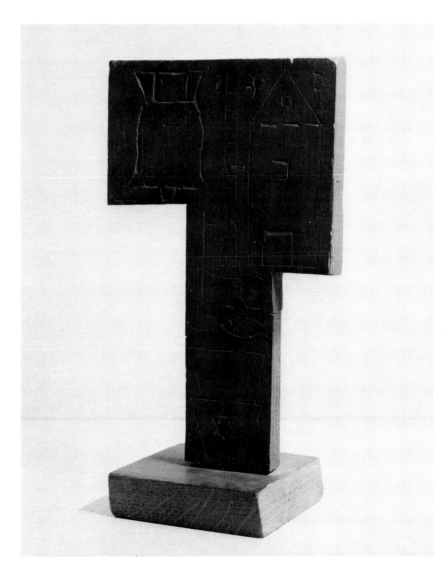

Joaquín Torres-García

65 *Form.* 1931
 (Forma)

Painted wood, 15¼ x 4⅛ x
1½″ (38.7 x 10.5 x 3.8 cm.)

Signed and dated on reverse: *J.Torres-*
GARCIA/31

Private Collection

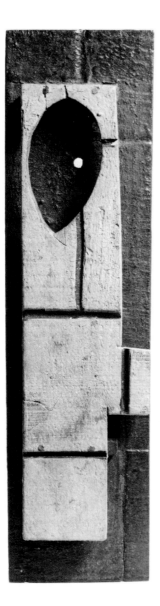

Joaquín Torres-García

66 *"Constructivo" with Curved Forms.*
1931
(Constructivo con Formas Curvas)
Painted wood, 19 x 16″ (48.3 x 40.6 cm.)
Private Collection

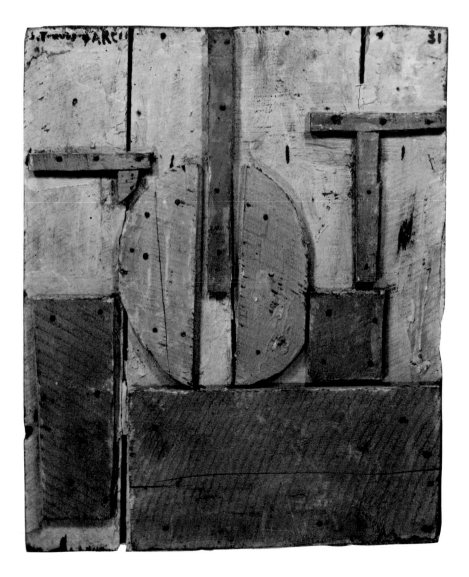

Léon Tutundjian

Born 1905, Amassia, Armenia
Died 1968, Paris

67 *Relief.* 1929

Painted wood and metal, 12⅞ x 10⅝ x
2⅜″ (32.7 x 27 x 6 cm.)

Signed and dated l.r.: *L.H. tutundjian/
1929*

Collection M. Bricheteau, Paris

REFERENCES:

Westfälisches Landesmuseum, Mün-
ster, *Abstraction Création 1931-1936,*
Apr. 2 - June 4, 1978, see particularly
pp. 4, 268-270. Text by Gladys C. Fabre.
Traveled to Musée d'Art Moderne de la
Ville de Paris, June 15 - Oct. 1, 1978

Herta Wescher, *Collage,* New York, n.d.
(first published Cologne, 1968,) pp.
44-46

Tutundjian moved to Paris in 1923.
After preliminary activity as a Surreal-
ist, in 1930 he became a member of *Art
concret.* This short-lived group, which
included van Doesburg, Carlsund, Hé-
lion, Wantz and Schwab, asserted that
art should relate only to itself, without
figurative, associative or extra-pictorial
subject matter. After the demise of *Art
concret* Tutundjian helped organize
Abstraction Création in 1931, a group
based on similar premises but broader
in its scope (see discussion pp. 27-28
here).

According to Hélion (letter to Tutund-
jian, May 13, 1958), Calder was among
those who were influenced by Tutund-
jian's constructions of 1929-31 with
their *"rapports aigus des boules pleines
et des lignes fines"* (quoted in Fabre,
1978, p. 39, fn. 19). ("acute relationships
between full spheres and fine lines")

Ironically, by 1932 Tutundjian had re-
turned to a Surreal figural style. In fact,
despite his theoretical pronounce-
ments, he had never totally abandoned
Surrealism, as many of the drawings of
his *Art concret* and *Abstraction Créa-
tion* period prove.

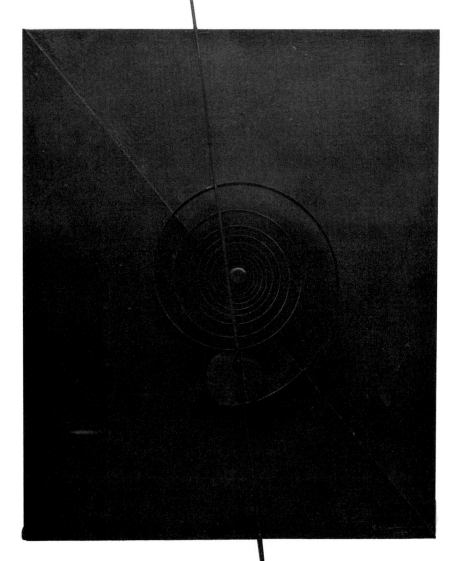

Léon Tutundjian

68 *Gray Relief.* 1929
 (Relief gris)

Painted wood and metal, 14⅛ x 14⅜″
(36 x 36.5 cm.)

Signed and dated l.r.: *L.H. tutundjian
1929*

Lent by N. Seroussi, Galerie Quincam-
poix, Paris

REFERENCE:
Westfälisches Landesmuseum,
1978, p. 269, no. 1, repr. (on side)

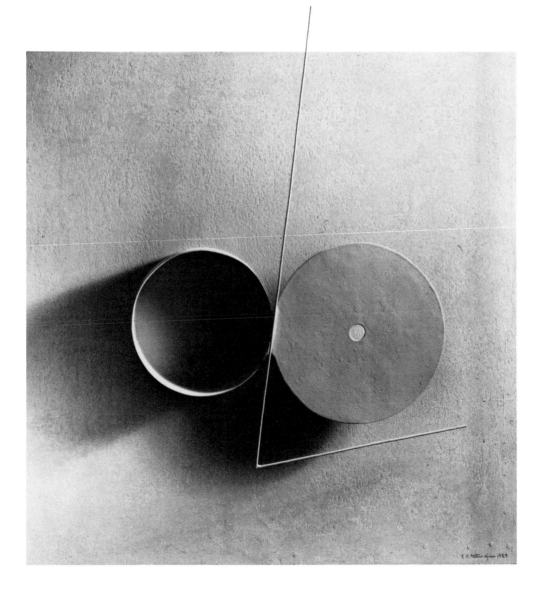

Léon Tutundjian

69 *Relief with Lattice.* 1929
(Relief au treillis)

Painted wood, metal and cardboard,
13⅜ x 10⅝ x ¾" (34 x 27 x 2 cm.)

Collection Gladys C. Fabre, Paris

Joan Miró

Born 1893, Barcelona
Lives in Palma de Mallorca

70 *Relief Construction.* 1930

Painted wood and metal on wood
panel, 35⅞ x 27⅝" (91.1 x 70.2 cm.)

Signed and dated on reverse: *Joan
Miró/1930*

Collection The Museum of Modern
Art, New York, Purchase, 1937

REFERENCES:

Jacques Dupin, *Joan Miró: Life and
Work*, New York, 1962, pp. 242-244

William Rubin, *Miró in the Collection
of The Museum of Modern Art*, Green-
wich, Conn., 1973, pp. 52, 53, repr.,
122-123

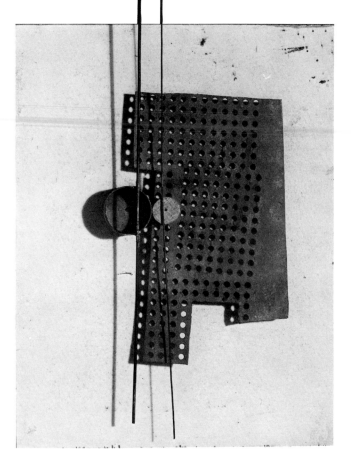

During the summer of 1930 in Mon-
troig Miró executed a number of con-
structions, his first attempts to deal
with three-dimensional space. Most of
them were assemblages of discarded
materials, and the emphasis was usual-
ly on the combinations of textures and
natural forms (shells, bones, driftwood,
cork picked up by the artist on the
beach). A few of these works, including
the present relief, contain elements
which Miró designed himself and had
cut out by a carpenter.

Miró's objective in these experimental
constructions was to control his expres-
sion: the resistance of the materials dis-
ciplined his forms and palette. These
constructions are usually considered a
spatialized form of collage. They will
lead the artist to the clearer, crisper
formal idiom of his paintings of the
early to mid-thirties.

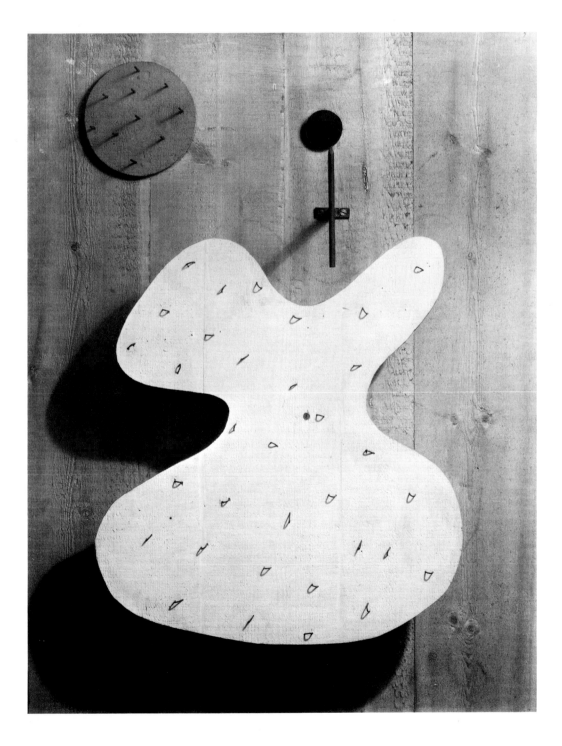

Joan Miró

71 *Construction.* 1930

Painted wood and iron on wood panel,
35¾ x 28 x 14½" (91 x 71 x 37 cm.)

Lent by Galerie Tronche, Paris

REFERENCES:

Georges Hugnet, "Joan Miró ou
l'enfance de l'art," *Cahiers d'Art*, 6e
année, no. 7-8, 1931, pp. 335-336, repr.,
337-340

Dupin, 1962, pp. 242-244

Even in a relief such as this one, the
artist did not seek abstraction. In 1931
Miró was approached to join the group
Abstraction Création (see discussion
pp. 27-28 here), but he declined the
invitation.

*Avez-vous jamais entendu parler
d'une sottise plus considérable que
l'"abstraction-création"? Et ils m'invi-
tent dans leur maison déserte, comme
si les signes que je transcris sur une
toile . . . ne possédaient pas une
profonde réalité, ne faisaient pas
partie du réel! J'attache d'ailleurs . . .
à la matière de mes oeuvres, une
importance de plus en plus grande
Ainsi la poésie, plastiquement expri-
mée,parle-t-elle son propre langage.
Dans ces conditions, je ne peux com-
prendre—et tiens pour une insulte—
qu'on me range dans la catégorie des
peintres "abstraits"* (Quoted in Georges
Duthuit, "Où allez-vous Miró?,"
Cahiers d'Art, 11e année, no. 8-10, 1936,
p. 261). (Have you ever heard of any-
thing as silly as "abstraction-création"?
And they invite me to their deserted
house, as though the signs that I tran-
scribe on a canvas did not have a pro-
found reality, do not partake of the
real! Moreover, I attach . . . more and
more importance to materials in my
work. Thus poetry, plastically ex-
pressed, speaks its own language. This
being so I cannot understand—and take
as an insult—my being placed in the
category of "abstract" painters.)

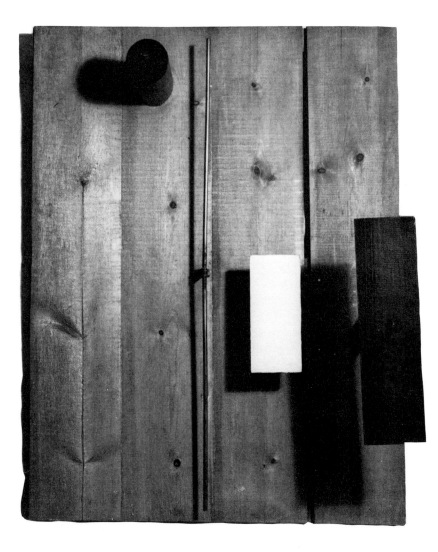

Alexander Calder

Born 1898, Lawnton, Pa.
Died 1976, New York City

72 *Construction.* 1932

Painted wood and metal, 30¼ x 35 x
26½″ (76.9 x 88.9 x 67.3 cm.)

Philadelphia Museum of Art, A. E.
Gallatin Collection

REFERENCE:

Whitney Museum of American Art,
New York, *200 Years of American
Sculpture,* Mar. 16 - Sept. 26, 1976. Text
by Rosalind E. Krauss, pp. 161-162,
174-176

see discussion p. 27 here

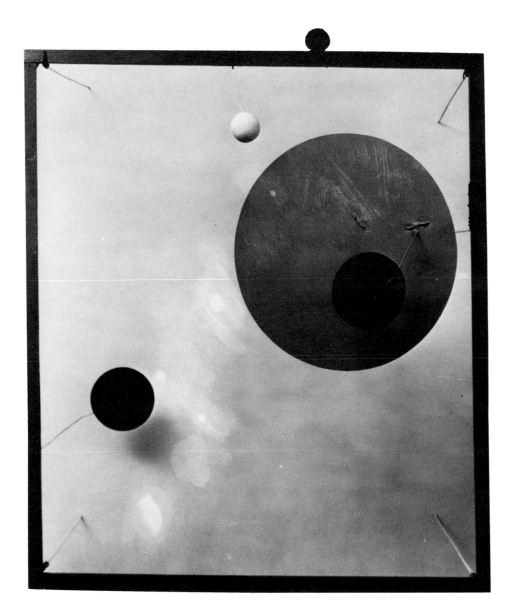

Alexander Calder

73 *Helicoidal Mobile-Stabile.* ca. 1932

Painted sheet metal and wire, 30¼ x
29″ (76.8 x 73.6 cm.)

The Phillips Collection, Washington,
D.C., Katherine S. Dreier Bequest

74 *Calderberry Bush.* 1932

Painted sheet metal, wood, wire and
metal rod, 84″ (213.4 cm.) h.

Collection Mr. and Mrs. James Johnson
Sweeney

REFERENCE:

Whitney Museum of American Art,
1976, pp. 44, color repr., 169, 175-176

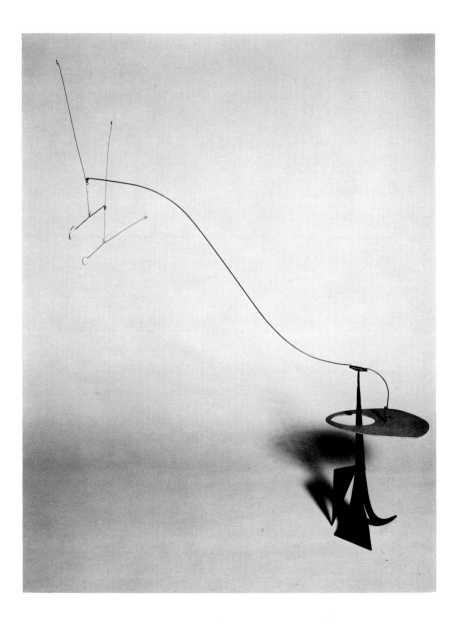

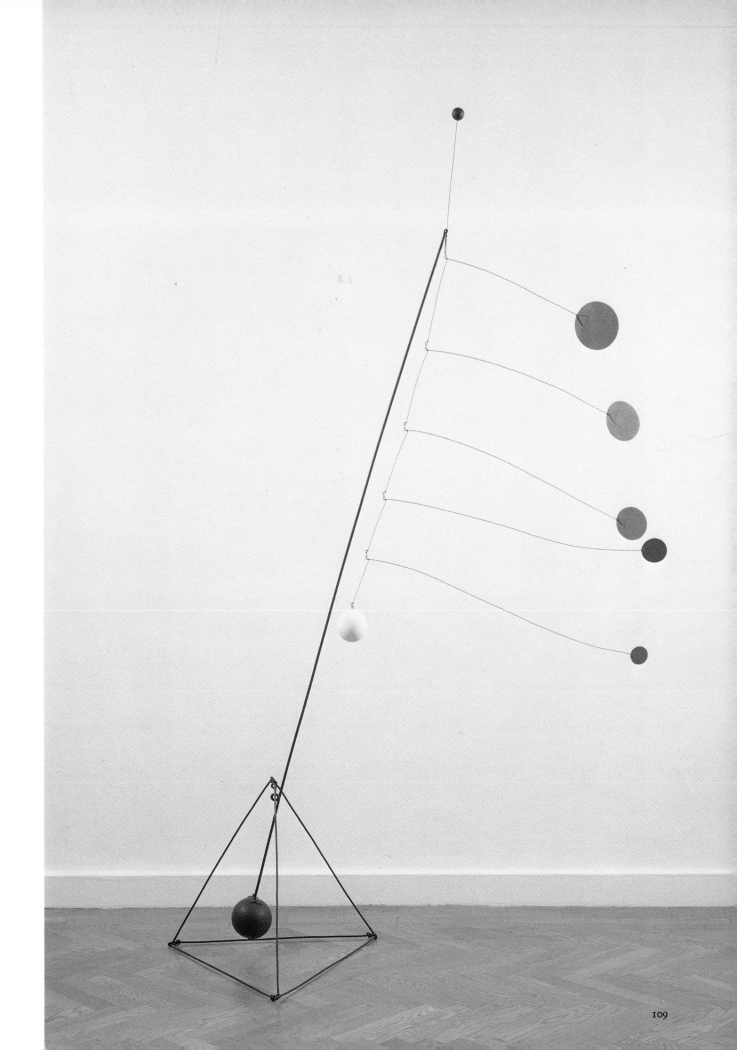

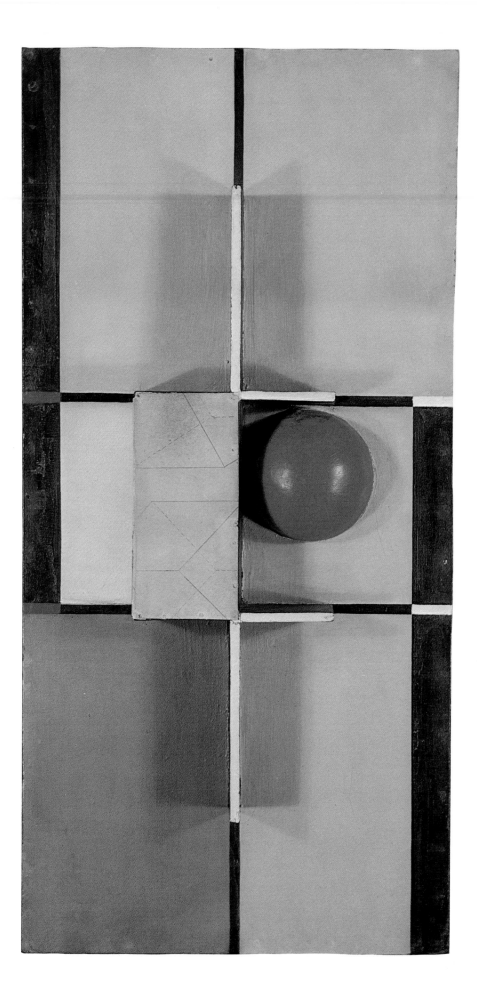

Kurt Schwitters

Born 1887, Hannover
Died 1948, Kendal, near Ambleside,
England

75 *Merz 1924, 1. Relief with Cross and
Sphere.* 1924
*(Merz 1924, 1. Relief mit Kreuz und
Kugel)*

Painted wood and cardboard on board,
27⅛ x 13½″ (69 x 34.2 cm.)

Lent by Marlborough Fine Art
(London), Ltd.

REFERENCES:

Werner Schmalenbach, *Kurt Schwitters*,
Cologne, 1967, pp. 48-52 and pl. 126

Dallas Museum of Fine Arts, *berlin/
hanover: the 1920s*, Jan. 26-Mar. 13, 1977

Galerie Gmurzynska, Cologne, *Kurt
Schwitters*, Oct.-Dec. 1978, pp. 104,
repr., 159, no. 25

The influence of the Dutch *De Stijl*
group begins to be seen in Schwitters'
work in 1924. This is one of the artist's
rare reliefs in an extremely pure,
refined geometric style with an explicit
rectilinear grid format.

76 *Oval Construction.* 1925

Painted wood on board, 45 x 30″
(114.3 x 76.2 cm.)

Yale University Art Gallery, New
Haven, Gift of Collection Société
Anonyme

REFERENCES:

Brooklyn Museum, New York, *An
International Exhibition of Modern Art
Assembled by the Société Anonyme*,
Nov. 19, 1926-Jan. 1, 1927, no. 100

Schmalenbach, 1967, no. 126, repr.
(Untitled)

This relief and others of 1925-26 are
characterized by a more disciplined,
almost Constructivist syntax compared
to Schwitters' earlier oeuvre. Yet an
irrational, poetic subjectivity is never-
theless maintained in them. The
unexpected thickness of the ground
and superimposed components, the
crudely carved shapes and unorthodox
colors are far removed from the
anonymity of forms and materials
which were essential to the orthodox
expression of Constructivist faith. The
dichotomy within these works by
Schwitters endows them with a pro-
foundly human dimension.

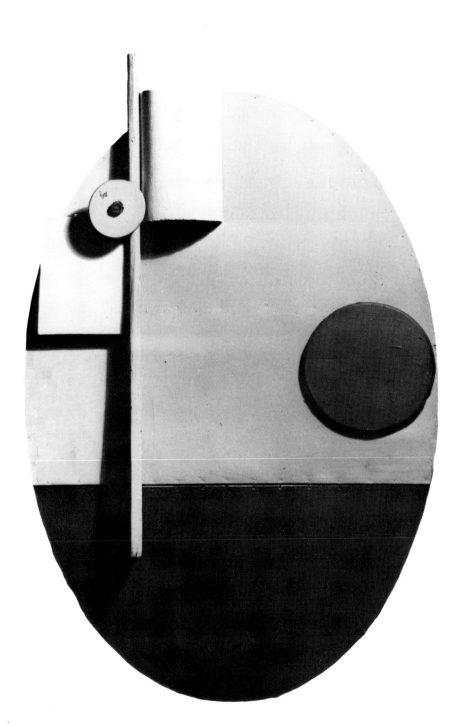

Kurt Schwitters

77 *Blue.* 1923-26
 (Blau)

 Painted wood, 20⅞ x 16¾″ (53 x
 42.5 cm.)

 Inscribed on reverse by the artist:
 BLAU

 Lent by Galerie Gmurzynska, Cologne

REFERENCES:
Schmalenbach, 1967, no. 121, repr.
Galerie Gmurzynska, Cologne, 1978,
pp. 89, color repr., 158, no. 22

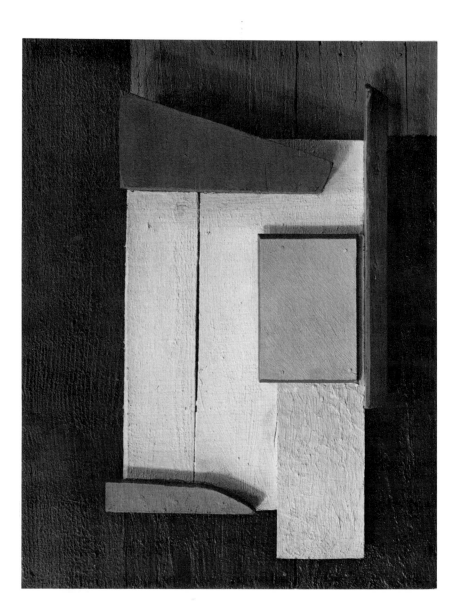

Kurt Schwitters

78 *Merzbild with Yellow Block.* 1926
 (Merzbild mit gelbem Klotz)

Painted wood, 25½ x 22" (65 x 56 cm.)

Signed and dated l.r.: *KS/26*

Collection Dr. and Mrs. André F.
Essellier, Zürich

REFERENCES:

Schmalenbach, 1972, p. 195, color repr.

Musée National d'Art Moderne, Centre
Georges Pompidou, Paris, *Paris-Berlin:
1900-1933*, July 12-Nov. 6, 1978, pp. 161,
color repr. 12 (annexe), no. 360

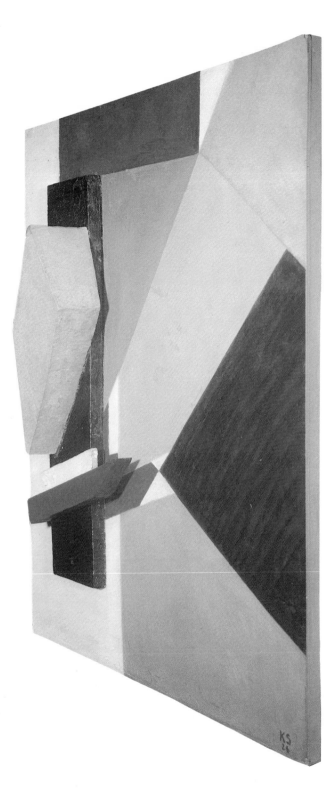

Kurt Schwitters

79 *Merz 1926, 3. Cicero.* 1926

Painted wood and plaster, 26¾ x 19½″
(68.1 x 49.6 cm.)

Inscribed on reverse by the artist:
MERZ 1926, 3. Cicero

Private Collection

REFERENCES:

Abstraction création art non-figuratif,
Paris, no. 1, 1932, p. 33, repr.
Schmalenbach, 1967, p. 185, color repr.

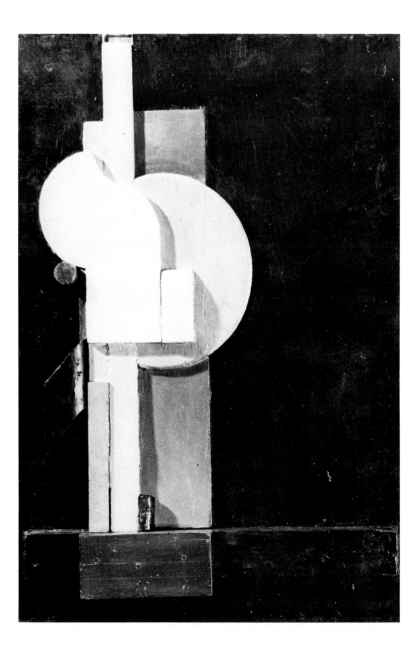

Kurt Schwitters

80 *Relief with Yellow Rectangle.* 1928
 (Relief mit gelbem Viereck)

Painted wood, 24 x 18¼″ (61 x 46.4 cm.)

Signed and dated l.r.: *KS/28*

Private Collection, Rheinland

REFERENCES:
Schmalenbach, 1967, no. 129, repr.
Galerie Gmurzynska, Cologne, 1978,
pp. 70, repr., 160, no. 32

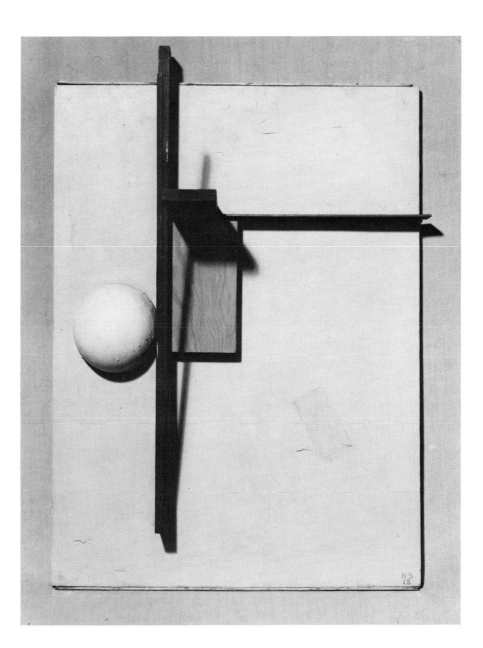

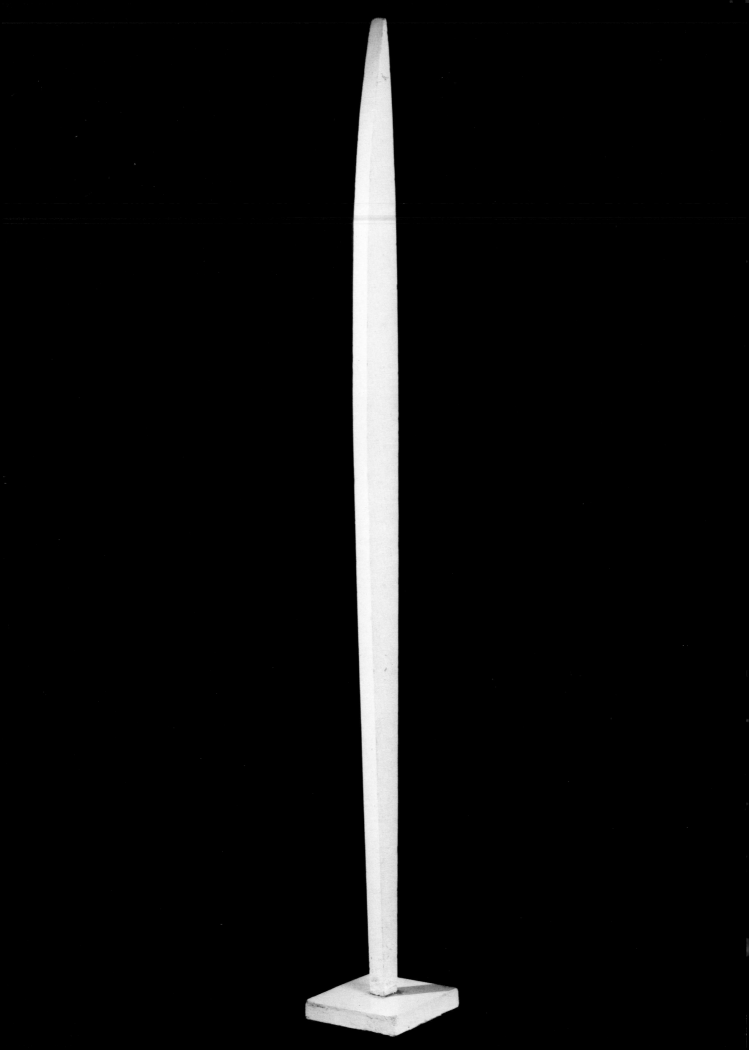

Kurt Schwitters

81 *Sword.* ca. 1930(?)
(Schwert)

Painted wood, 32½″ (82.5 cm.) h.

Signed and inscribed under base: *Kurt Schwitters #16 Schwert*

Lent by Lords Gallery, London

see discussion p. 27 here

82 *Slim Angle.* ca. 1930(?)
(Schlanker Winkel)

Painted wood, 19″ (48.2 cm.) h.

Signed and inscribed under base: *Kurt Schwitters No. 15 Schlanker Winkel*

Lent by Lords Gallery, London

REFERENCE:
Dallas Museum of Fine Arts, 1977, n.p., no. 41, repr.

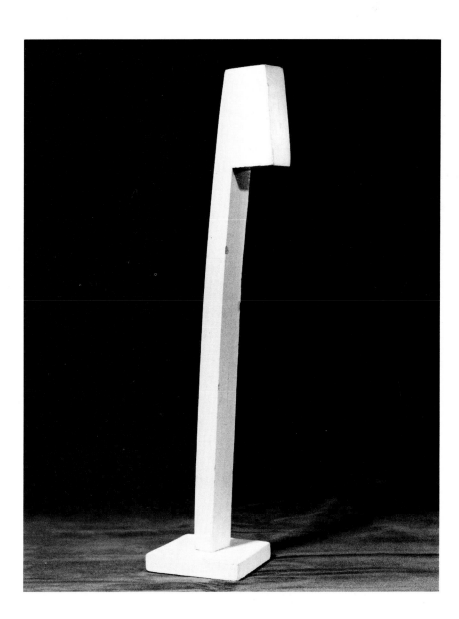

Yurii Annenkov

Born 1889, Petropavlovsk, Russia
Died 1974, Paris

83 *Cathedral of Amiens.* 1919
 (La Cathédrale d'Amiens)

Wood, cardboard and wire on paper-
board, 28 x 20½″ (71 x 52 cm.)

Signed (in Cyrillic alphabet) and dated
l.r.: *Y. Annenkov 1919*

Lent by Leonard Hutton Galleries,
New York

REFERENCE:

Galerie Gmurzynska, Cologne, *Die 20er
Jahre in Osteuropa,* June 3-mid Sept.
1975, p. 38

84 *Relief Collage.* 1919

India ink, sackcloth and board on
cardboard, 13 x 9½″ (33 x 24.1 cm.)

Signed (in Cyrillic alphabet) and dated
l.l.: *Y. Annenkov 1919*

Collection McCrory Corporation,
New York

Nathan Altman

Born 1889, Vinnitsa, Russia
Died 1970, Leningrad

85 *Untitled.* 1916(?)

Painted wood and metal, 20⅞ x
16⅝ x 2″ (53 x 42.6 x 5.1 cm.)

Collection Mr. and Mrs. Joseph Ascher

86 *Relief.* 1922

Painted wood with rakes, 17¾ x 20⅞″
(44 x 53 cm.)

Lent by Galerie Jean Chauvelin, Paris

REFERENCES:

Galerie Jean Chauvelin, Paris, *The
Non-Objective World: 1924-1939*, June
1-30, 1971, pp. 14-15, repr. Traveled to:
Annely Juda Fine Art, London, July 7-
Sept. 30; Galleria Milano, Milan, Oct.
15-Nov. 15

*Erwerbungen 1971 aus dem Jahrbuch
der Hamburger Kunstsammlungen,*
Hamburger Kunsthalle, Band 17, 1972,
p. 169

Russian artists in the early twentieth-
century often introduced utilitarian
objects into their painted works. These
objects, stripped of their functions,
were selected on the basis of their
textural and formal attributes, thereby
enhancing the concrete reality of the
work. They were intended neither to
shock the viewer nor to introduce
another level of reality, as in Cubist
collage. The relief elements in this
work are two rakes.

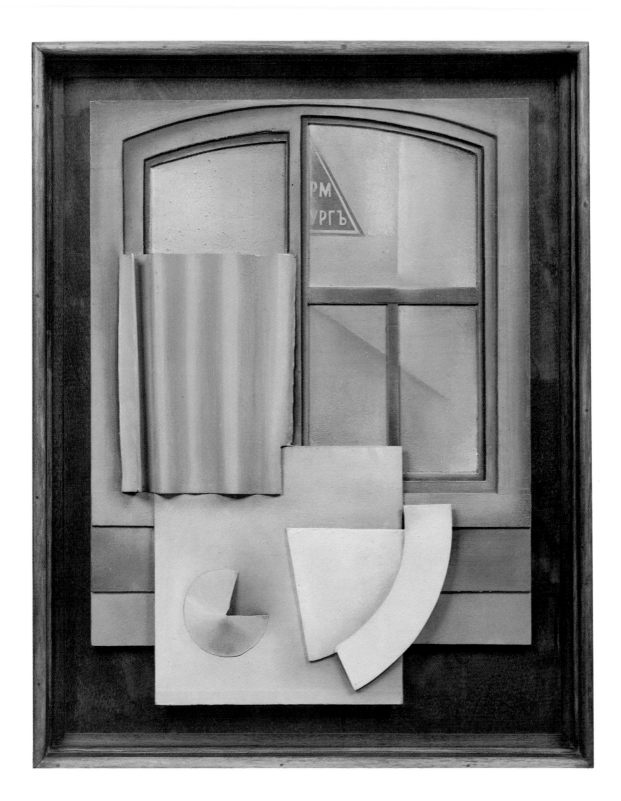

Wassily Ermilov

Born 1894, Kharkov, Ukraine, Russia
Died 1968, Kharkov

87 *Window.* 1922

Painted wood, metal, masonite and canvas, 27½ x 20¾" (70 x 52.7 cm.)

Private Collection

REFERENCES:

Fischer Fine Art Ltd., London, *Tatlin's Dream: Russian Suprematist and Constructivist Art 1910-1923*, Nov. 1973 - Jan. 1974, frontispiece, color repr., p. 61, no. 15

Zinovy Fogel, *Ermilov*, Moscow, 1975, p. 87, repr. *(Experimental Construction with Window)*

Ermilov was a member of the Kharkov Constructivist School which bloomed later and longer than the Constructivism of Moscow. He studied in Moscow, and his early work showed Cubo-Futurist tendencies. After a brief Suprematist period he turned to relief constructions in wood and metal, calling them "Experimental Compositions." The slightly arched form of the window in this Experimental Composition is that of the artist's own window in his Kharkov apartment (compare reprs., Fogel, pp. 70, 87). Some of the other motifs are reminiscent of those in Puni's more Suprematist reliefs. Here, the specific forms engendered by specific materials are important, even though the lush color brushed throughout tends to negate the particular textural characteristics of each. Other reliefs of this period by Ermilov (see for example *Oval Composition*, ca. 1923, Albright-Knox Art Gallery, Buffalo) also express this contradiction between concrete structure and illusionistic modeling.

Wassily Ermilov

88 *Self Portrait.* 1922

Painted wood and metal, 31½ x 16⅞"
(80 x 43 cm.)

Lent by Galerie Bargera, Cologne

REFERENCES:

Fischer Fine Art Ltd., 1973-74, pp. 60-61

Galerie Bargera, Cologne, *Russische
Avantgarde 1910-1930*, May 31-Sept. 30,
1978, pp. 45-47, no. 15, color repr., 48-51,
123-124

Reliefs such as this one, although later,
are not without analogies to Archi-
penko's constructions; it is unlikely,
however, that Ermilov would have seen
Archipenko's work except in reproduc-
tions. The iconic reference is clear, and,
true to the tenets of Constructivism, the
technical, structural potential of the
materials is respected.

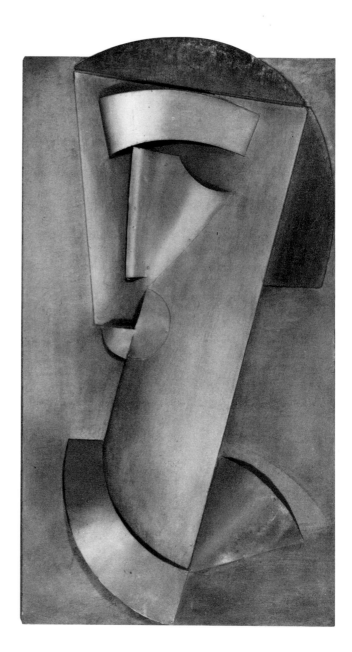

Wassily Ermilov

89 *Composition No. 3.* 1923

Painted wood and brass, 32 x 17″
(81.2 x 43.2 cm.)

Collection McCrory Corporation,
New York

REFERENCE:

Willy Rotzler, *Constructive Concepts*,
Zürich, 1977, pp. 51, repr., 265, no. 151

By 1923 Ermilov was working a great
deal with exhibition and graphic
design. Perhaps this helps to explain
the increased structural purification of
his forms. Here, only the frame, the
icon-influenced juxtaposition of
materials and the slanted composition
(which he used quite frequently)
remain.

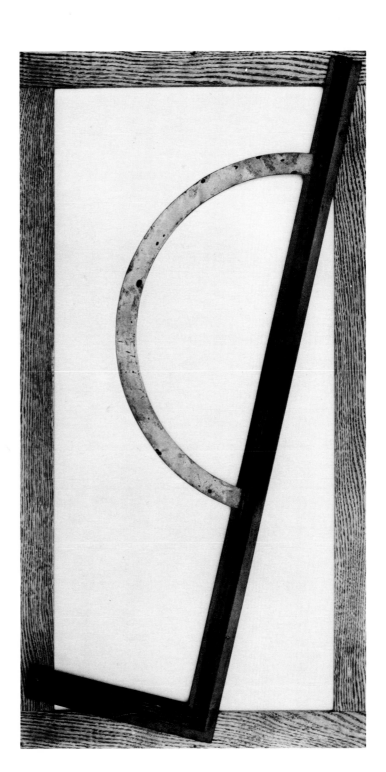

Konstantin Medunetsky

Born 1899, Moscow
Died ca. 1936, Moscow

90 *Construction No. 557.* 1919

Tin, brass and iron, 10⅞″ (27.6 cm.) h.;
base, painted metal, 7 x 7 x 7″
(17.8 x 17.8 x 17.8 cm.)

Signed (in Cyrillic alphabet) on base
l.r.: *K. Medunetsky*

Yale University Art Gallery, New
Haven, Gift of Collection Société
Anonyme

REFERENCES:

Galerie van Diemen & Co., *Erste
Russische Kunstausstellung*, Oct. 1922,
no. 556, repr. (*Raumkonstruktion*)

Yale University Art Gallery, New
Haven, *Collection of the Société
Anonyme: Museum of Modern Art
1920*, 1950, pp. 19, repr., 20 (Kasimir
Meduniezky)

Medunetsky belonged to the *Obmokhu*
group of Moscow artists who around
1920 were experimenting with the
interaction of forms and space. Unlike
Tatlin, who was profoundly concerned
with materials or *Faktura,* this group
(which counted Rodchenko, Joganson
and the Stenberg brothers among its
participants) sought to attain the
essence of pure forms in space. The
present piece was included in an
Obmokhu exhibition in 1921 in Mos-
cow: it appears in an installation pho-
tograph in *Westch-Gegendstand-Objet,*
no. 1-2, Berlin, 1922. It was also shown
in the *Erste Russische Kunstausstellung*
in Berlin, 1922, where it was purchased
by Katherine Dreier.

The explicit use of line and plane, as
well as the contrasts between the red
paint and different neutral tones of
metal, make this work a unique exam-
ple of Suprematist painting translated
into three-dimensional spatial terms.

László Moholy-Nagy

Born 1895, Borsod, Hungary
Died 1946, Chicago

91 *Nickel Construction.* 1921

Nickel-plated iron, 14⅛″ (35.6 cm.) h.;
base, 6⅞ x 9⅜″ (17.5 x 23.8 cm.)

Collection The Museum of Modern
Art, New York, Gift of Mrs. Sibyl
Moholy-Nagy, 1956

REFERENCES:

Sibyl Moholy-Nagy, *Moholy-Nagy,
Experiment in Totality*, New York,
1950

The Museum of Modern Art, New
York, *The Machine as Seen at the End
of the Mechanical Age*, Nov. 25, 1968-
Feb. 8, 1969, p. 136, repr. Text by K. G.
Pontus Hultén. Traveled to: University
of St. Thomas, Houston, Mar. 25-May
18; San Francisco Museum of Art,
June 23-Aug. 24

By the 1920s Moholy-Nagy was in con-
tact with the Russian avant-garde and
impressed by their spatial experiments
(see discussion pp. 29-30 here). The
Nickel Construction, conceived as a
statement of balance between dynamic
and static forms, may be related to
Russian experiments with pure forms
in space. Moholy-Nagy himself des-
cribed this piece as a "completely per-
forated, completely broken through,
piece of sculpture which demands on
the one hand a developed technical
knowledge, and on the other hand a
mind that works abstractly; a freeing
of material from its own weight, a
passing beyond expressional ends"
(Quoted in The Museum of Modern
Art, 1968, p. 136).

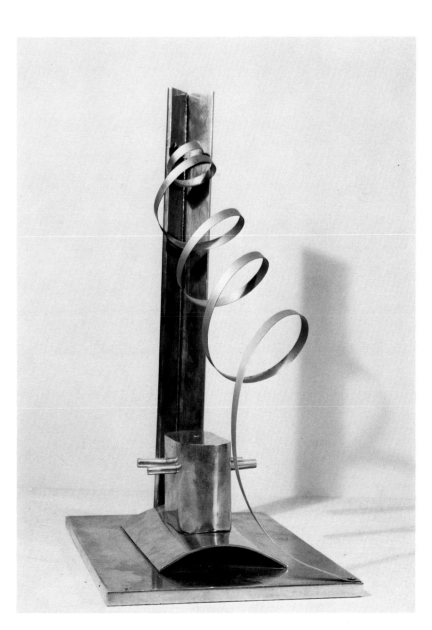

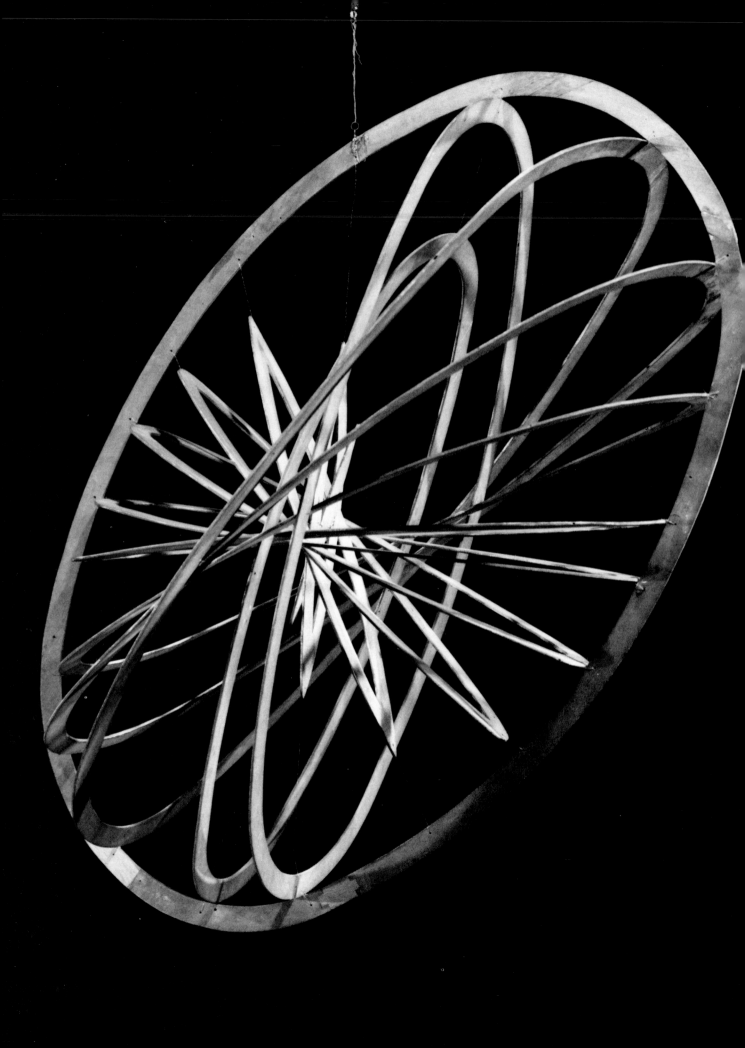

Alexander Rodchenko

Born 1891, St. Petersburg
Died 1956, Moscow

92 *Hanging Oval Construction.* 1920

Painted plywood and wire, 33 x 23 x
21″ (83.5 x 58.5 x 53.3 cm.)

Collection George Costakis

REFERENCES:

Galerie Gmurzynska, Cologne, *Von der
Fläche zum Raum: Russland 1916-24,*
Sept. 18-end of Nov. 1974. See particu-
larly texts by John E. Bowlt and
Szymon Bojko, pp. 4-25

G. Karginov, *Rodcsenko,* Budapest,
1975

John E. Bowlt, "Rodchenko and Chai-
kov," *Art and Artists,* vol. 11, Oct. 1976,
pp. 28-33

Between 1918 and 1920 Rodchenko
made spatial constructions, few of
which survive today. John Bowlt notes,
"in the second half of 1918 he . . . made
seven non-objective freestanding sculp-
tures—based on the manipulation
and integration of diverse geometric
forms" (Galerie Gmurzynska, 1974,
p. 9). According to the same source,
in 1919-20 the artist made "six
spatial constructions and three other
free-standing constructions
Rodchenko was . . . interested in
the essence of form and attained a re-
markable lightness and simplicity of
design in his constructions based on
the repetition of a single form. . . .
It was in this economy of form that
Rodchenko succeeded . . . in attaining
a perfect balance between material
and space."

This oval construction was exhibited
in Moscow at the *Obmokhu* exhibition
in May 1921. George Costakis, who
acquired it from the artist, says it is
probably the only hanging spatial con-
struction still in existence.

Erich Buchholz

Born 1891, Bromberg, Germany
Died 1972, Berlin

93 *Circle of Ascent I.* 1922
 (Kreis des Aufgangs I)

Oil paint and bronze powder on wood,
22 x 14⅛″ (56 x 36 cm.)

Signed, dated and inscribed on reverse:
Erich Buchholz 22/holzbilt

Private Collection

REFERENCES:
Eau de Cologne, Cologne, no. 1, 1968.
(Special issue devoted to Buchholz's
activity of 1919-25)

Galerie Daedalus Berlin, Berlin- Char-
lottenburg, *Erich Buchholz,* May 15-
June 20, 1971. Autobiographical text

Städtisches Kunstmuseum, Düsseldorf,
Erich Buchholz, opened Dec. 17, 1978,
p. 136, no. 131, repr. Traveled to: West-
fälisches Landesmuseum für Kunst und
Kulturgeschichte, Münster; Wilhelm-
Hack-Museum, Ludwigshafen; Ulmer
Museum; Kunstmuseum Hannover mit
Sammlung Sprengel

see discussion pp. 28-29 here

Erich Buchholz

94 *Red Circle in Gold Circle.* 1922
(Roter Kreis im Goldkreis)

Oil paint and bronze powder on wood,
28½ x 20⅝″ (71.5 x 52.5 cm.)

Signed on reverse: *Erich Buchholz*

Private Collection, Rheinland

REFERENCE:

Städtisches Kunstmuseum, Düsseldorf,
1978, pp. 48, repr., 99, color repr.

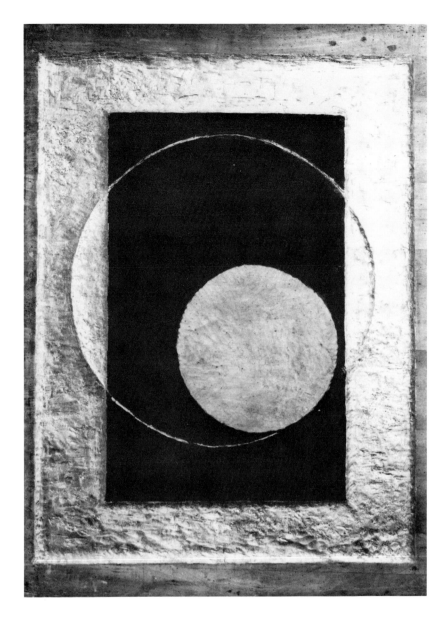

Erich Buchholz

95 *Gold Square with Beaming Rays.* 1922
*(Gold Quadrat mit auslaufenden
Strahlen)*

Oil paint and bronze powder on wood,
26 x 20¼″ (66 x 51.5 cm.)

Private Collection

96 *Three-Part Maquette for the Studio at
Herkulesufer 15.* 1971 model of 1922
studio

Painted board, left, 17¾ x 30½″ (45 x 80
cm); center 17¾ x 23⅝″ (45 x 60 cm);
right, 17¾ x 30½″ (45 x 80 cm.); ratio of
model to studio, 1:10

Private Collection

REFERENCE:
Eau de Cologne, Cologne, no. 1, 1968,
pp. 16-17

see discussion p. 28 here

László Peri

Born 1889, Budapest
Died 1967, London

97 *Space Construction VI.* 1922-23
(Raumkonstruktion VI)

Painted concrete, 24⅜ x 33⅞″
(62 x 86 cm.)

Dated on reverse: *1922*

Collection Carl Laszlo

REFERENCES:

Kölnischer Kunstverein, *László Peri:
Werke 1920-1924 und das Problem des
Shaped Canvas,* May 5-31, 1973. Text
by Wulf Herzogenrath

Wulf Herzogenrath, *Oskar Schlemmer:
die Wandgestaltung der neuen Archi-
tektur,* Munich, 1973. See particularly
pp. 63-88

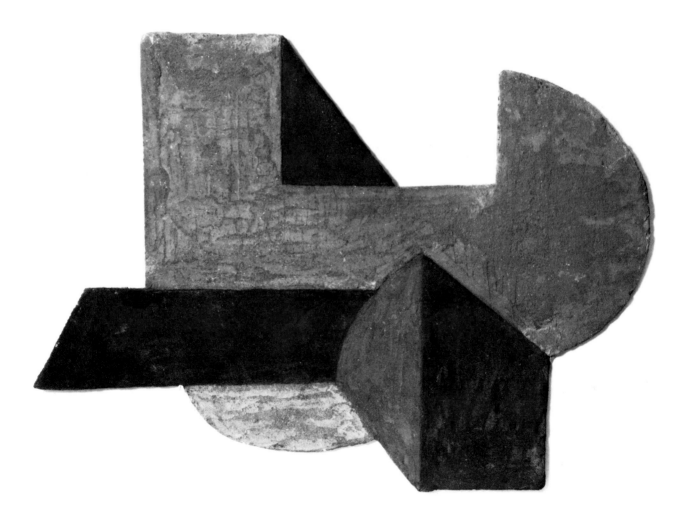

László Peri

98 *Space Construction VIII.* 1922-23
(Raumkonstruktion VIII)

Painted concrete, 21⅝ x 30¾"
(55 x 78 cm.)

Dated on reverse: 1923

Collection Carl Laszlo

REFERENCE:

Galerie von Bartha, Basel, *Ungarische Avantgarde*, June 1976, cover, color repr., n.p., color repr., biography

Peri emigrated to Berlin from his native Budapest in 1919-20. Prior to this he had studied sculpture and received training as a stonemason; he had also been exposed to Russian Constructivism. His first non-objective cement pieces date from 1921 and were presumably motivated by a desire to break away from "bourgeois" art and to formulate a new symbolic language for revolutionary thought (see Kölnischer Kunstverein, 1973, p. 5).

Peri was highly regarded not only by artists but by connoisseurs and critics of his time, including Herwarth Walden, Alfred Kemeny, Alexander Dorner, Ernst Kállai and Adolf Behne. Katherine Dreier purchased two examples of his work in 1922 at Der Sturm and exhibited them in 1923, 1924, 1926 and 1930. Lissitzky and Arp reproduced a *Space Construction* in their 1925 *Die Kunstismen*.

After 1924 Peri turned to architecture, believing it a better means than sculpture to express his socialistic commitment. Nonetheless, the *Space Constructions* of 1921-23 were themselves architectural statements, conceived to articulate the viewer's total experience of space (see discussion p. 29 here).

Alexander Dorner wrote in 1949: "These artists were geniuses because they visualized behind the modern machine the opening of a heretofore unknown world of energies which set the very framework of space in motion. Peri's early compositions do just that, and they are unique among the work of the abstract artists, insofar as they achieve that aim through a simplicity which cannot be surpassed" (quoted in Yale University Art Gallery, New Haven, *Collection of the Société Anonyme: Museum of Modern Art 1920*, 1950, p. 20).

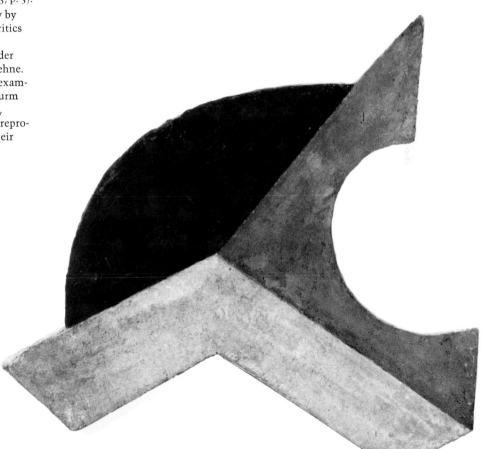

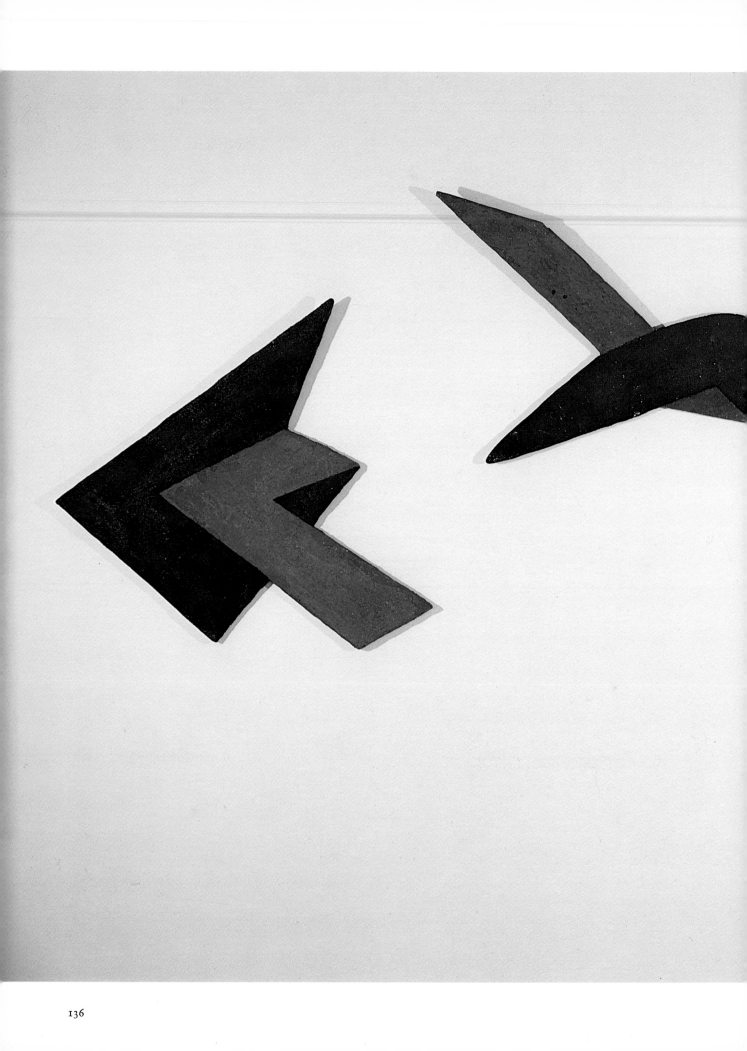

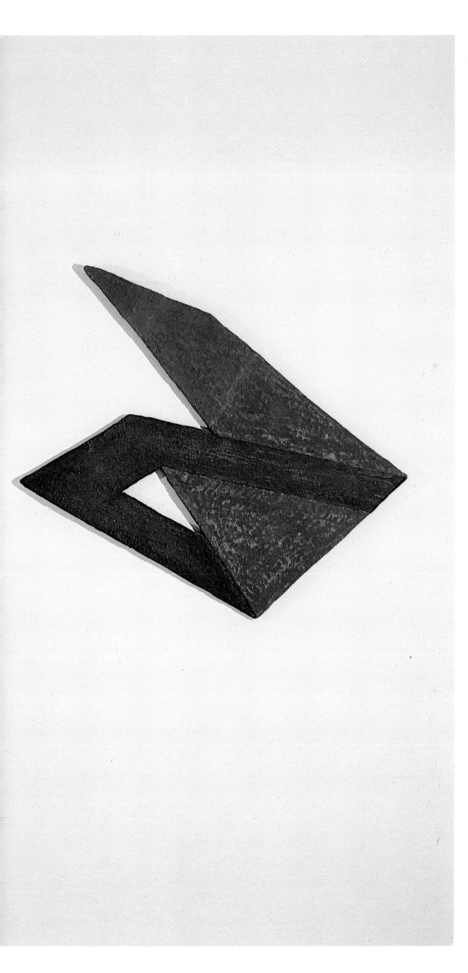

László Peri

99 *Three-Part Space Construction.* 1923
*(Raumkonstruktionen, Betonreliefs zur
Wandgestaltung auf der "Grossen
Berliner Kunstausstellung" 1923)*

Painted concrete, part 1, 23⅝ x 26¾"
(60 x 68 cm.); part 2, 21⅞ x 27½"
(55.5 x 70 cm.); part 3, 22¾ x 26¾"
(58 x 68 cm.)

Signed, dated and inscribed on reverse:
part 1, *Raumgestaltung, 1924, 1. Teil
Peri;* part 2, *Wandgestaltung, 1924,
Peri 2;* part 3, *Wandgestaltung, 1924,
Peri 3. Teil*

Lent by Kunsthandel Wolfgang Werner
KG, Bremen

REFERENCE:

Graphisches Kabinett Kunsthandel
Wolfgang Werner KG, Bremen, *12
Bildhauer in Deutschland 1900-1933,*
May 11-July 15, 1978, n.p., biography,
no. 41, repr.

This three-part *Space Construction* was
conceived and executed for the *Grossen
Berliner Kunstausstellung* of 1923. It
was exhibited in the *Novembergruppe*
section of the presentation (cat. no.
1303) alongside a three-part wall paint-
ing by van Doesburg and Lissitzky's
Proun Space. The pieces of the *Space
Construction* were later mistakenly
dated 1924 by Peri. Peri's sketch (see
fig. 17) indicates the exact measure-
ments of the walls at the *Kunstaus-
stellung,* which suggests that he de-
signed these constructions in relation
to the given space. This of course
underlines the artist's architectural
concerns and his desire to articulate the
viewer's vital space.

see further discussion p. 29 here

Lazar (El) Lissitzky

Born 1890, Polshinok, Russia
Died 1941, Moscow

100 *Proun Space.* 1965 reconstruction of
1923 original
(*Prounenraum*)

Painted wood, 118⅛ x 118⅛ x 102⅜"
(300 x 300 x 260 cm.)

Collection Stedelijk van Abbemuseum,
Eindhoven, The Netherlands

REFERENCES:

Stedelijk van Abbemuseum, Eind-
hoven, The Netherlands, *El Lissitzky*,
Dec. 3, 1965-Jan. 16, 1966. Text by Jan
Leering. Traveled to: Kunsthalle Basel,
Jan. 27-Mar. 6; Kestner-Gesellschaft,
Hannover, Mar. 22-Apr. 17 (The
present reconstruction was made for
this exhibition.)

Sophie Lissitzky-Küppers, *El Lissitzky:
Life-Letters-Texts*, Greenwich, Conn.,
1968 (first published Dresden, 1967).
See particularly texts by the artist,
"Proun Not world visions BUT—world
reality 1920," pp. 343-344 (first pub-
lished in *De Stijl*, Year V, no. 6, Amster-
dam, 1922); "Proun Room, Great Berlin
Art Exhibition 1923," p. 361 (first pub-
lished in *G*, vol. 1, Berlin, July 1923)

Alan C. Birnholz, " 'For the New Art:'
El Lissitzky's Prouns," part I, *Artforum*,
vol. VIII, Oct. 1969, pp. 65-70; part II,
vol. VIII, Nov. 1969, pp. 68-73

Dallas Museum of Fine Arts, *berlin/
hanover: the 1920s*, Jan. 26-Mar. 13,
1977. Text by John E. Bowlt. See par-
ticularly ch. "Lissitzky's Proun Room,
Berlin, 1923," n.p.

see discussion pp. 28-29 here

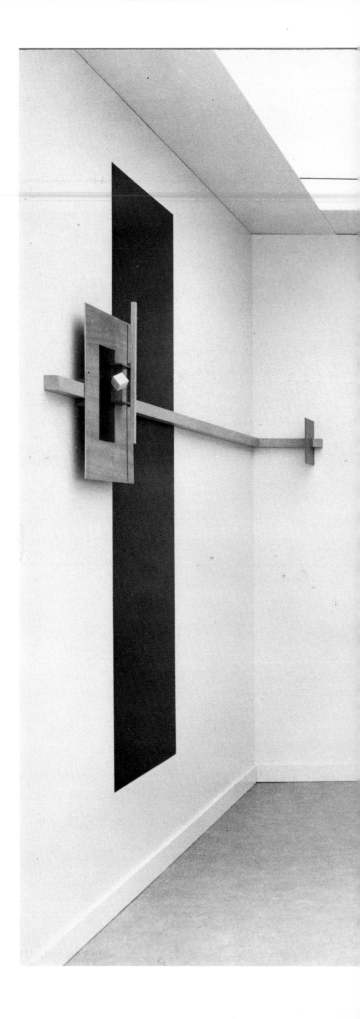

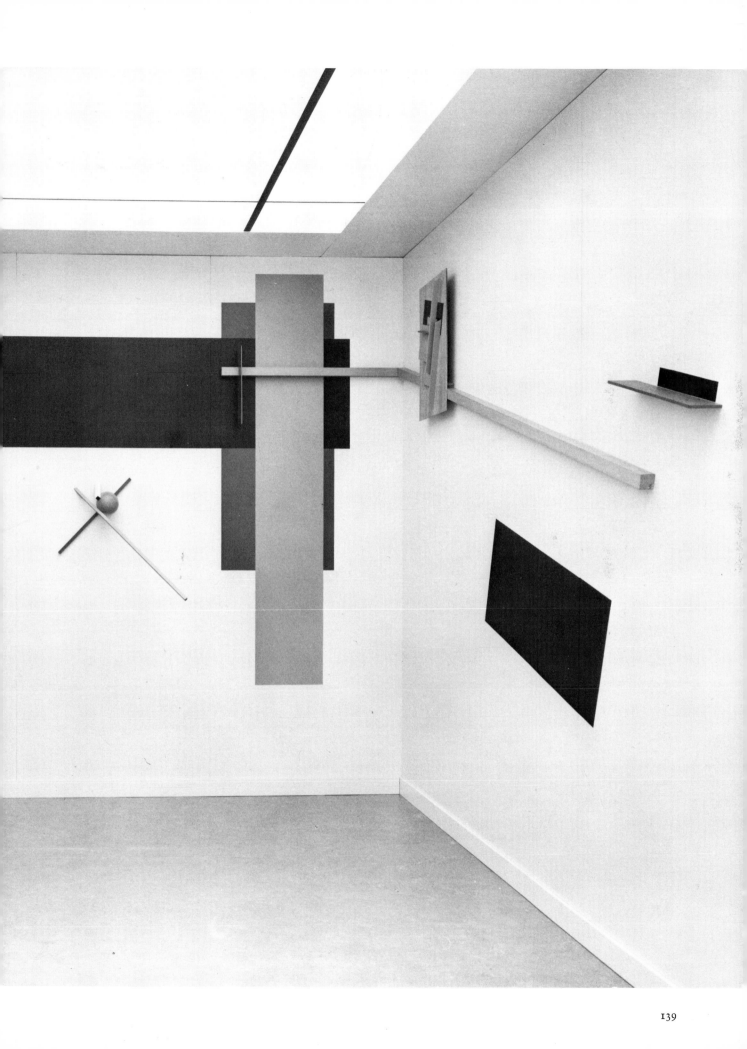

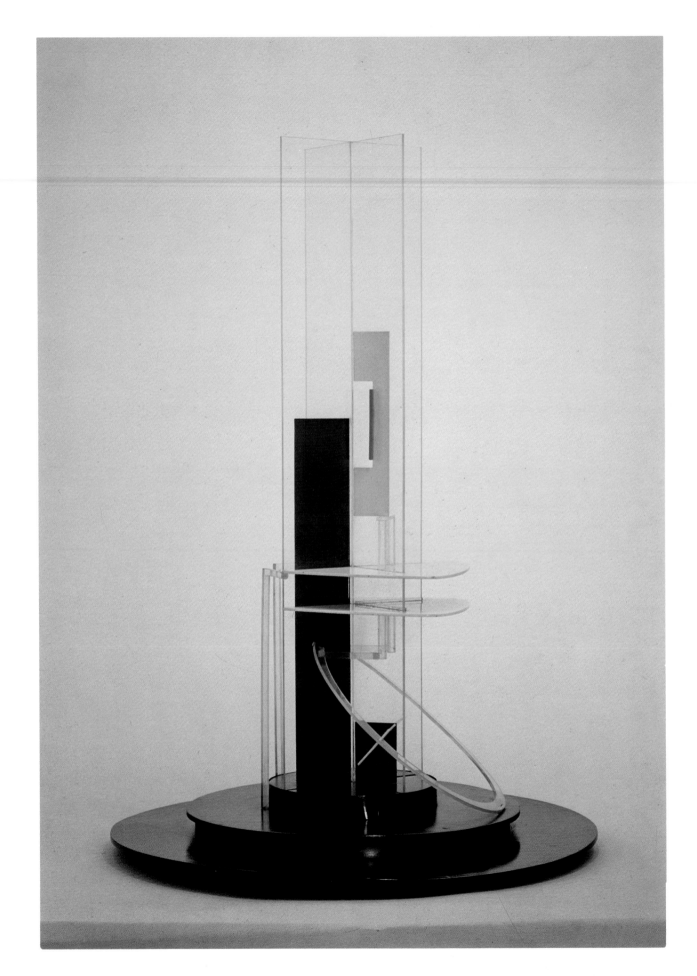

Naum Gabo

101 *Column.* mid 1930s reconstruction of 1923 original

Perspex, wood, metal and glass, 41½ x 29 x 29″ (105.3 x 73.6 x 73.6 cm.)

Collection The Solomon R. Guggenheim Museum, New York

REFERENCES:

Herbert Read and Leslie Martin, *Gabo*, London, 1957, p. 9

Margit Rowell, ed., *Selections from The Guggenheim Museum Collection: 1900-1970*, New York, 1970, pp. 124-125, color repr.

The original small celluloid model, now in the Tate Gallery, London, was probably made in Berlin around 1923. The dates of the other versions are difficult to determine with certainty. Three small celluloid versions were executed in London, probably in the mid-thirties but before 1936, when Gabo first used perspex. After that date Gabo replaced many of the celluloid parts in his constructions with perspex. The Guggenheim piece dates from the mid-thirties. It has not been possible to establish whether this sculpture originally included celluloid parts which were then replaced with perspex, or whether it was made with perspex from the start (information from Angelica Zander Rudenstine, The Solomon R. Guggenheim Museum).

Gabo always thought of this work in relation to architecture. In a letter to Bartlett Hayes, Jr. of the Addison Gallery of American Art, Andover, Massachusetts, dated March 13, 1949, he wrote: "It is one of my works of which I am proudest, knowing now how much it contributed to the contemporary spirit in architecture."

Alfred Barr wrote in *Cubism and Abstract Art*, "Some of Gabo's constructions (*Column, Monument for an Airport*) have in fact been projects for semi-architectural monuments..." (1936, p. 138).

102 *Construction in Space with Balance on Two Points.* 1960s replica of 1925 original

Celluloid, 10¼″ (26 cm.) h.

Private Collection

REFERENCE:

Musée National d'Art Moderne, Centre Georges Pompidou, Paris, *Paris-Berlin: 1900-1933*, July 12-Nov. 6, 1978, pp. 229, repr., 5 (annexe), no. 116

The work is one of two known replicas of this piece: both probably date from the 1960s. The other, approximately the same size, is in the Busch-Reisinger Museum, Harvard University, Cambridge, Massachusetts (ex-collection Alexander Dorner).

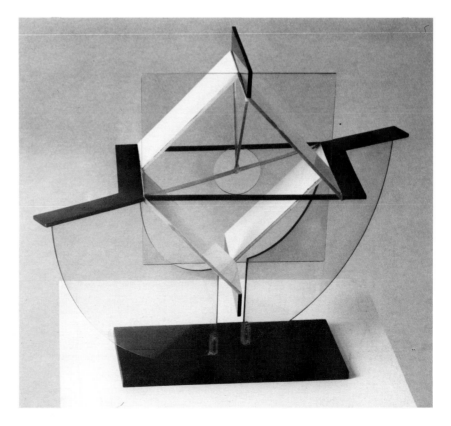

Antoine Pevsner

Born 1884, Orel, Russia
Died 1962, Paris

103 *Bust.* 1923-24

Metal and celluloid on plywood panel,
20⅞ x 23⅜″ (53 x 59.4 cm.)

Signed r. of c.: *Pevsner:* on panel l.r.:
Pevsner

Collection The Museum of Modern
Art, New York, Purchase, 1938

REFERENCE:

Pierre Peissi, Carola Giedion-Welcker,
Antoine Pevsner, Neuchâtel, 1961,
no. 47, repr.

104 *Bas Relief.* 1929

Celluloid on bakelite panel, 35 x 23 x
7¾″ (88.9 x 58.4 x 19.7 cm.)

Signed and dated (incised) on panel l.r.:
PEVSNER/1929-X

The Phillips Collection, Washington,
D.C., Katherine S. Dreier Bequest

REFERENCES:

René Massat, *Antoine Pevsner et le
constructivisme*, Paris, 1956, n.p., repr.
(1927)

Musée National d'Art Moderne, Paris,
Antoine Pevsner, Dec. 21, 1956-Mar. 10,
1957, p. 18, no. 25, n.p., pl. VI

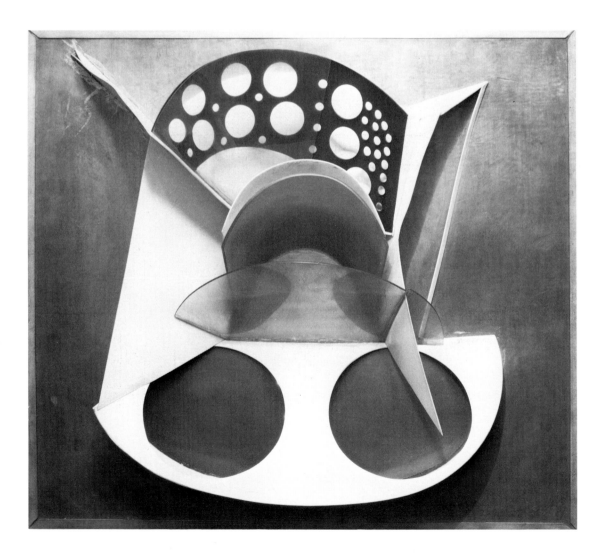

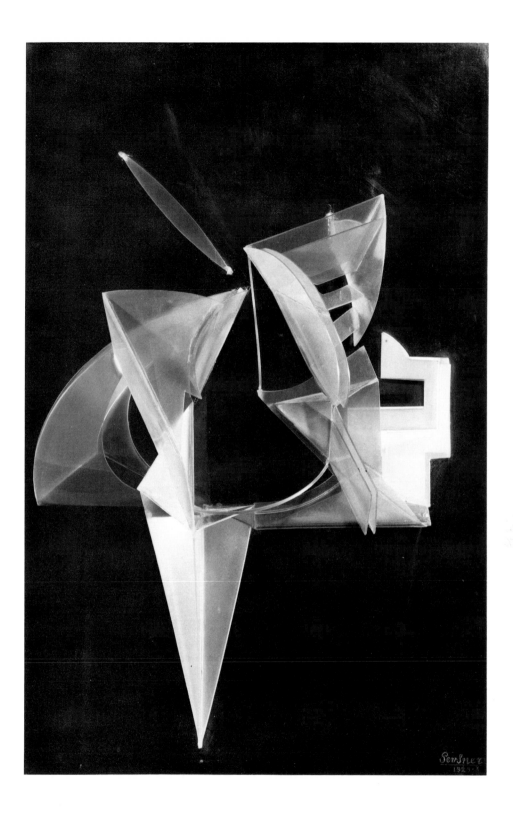

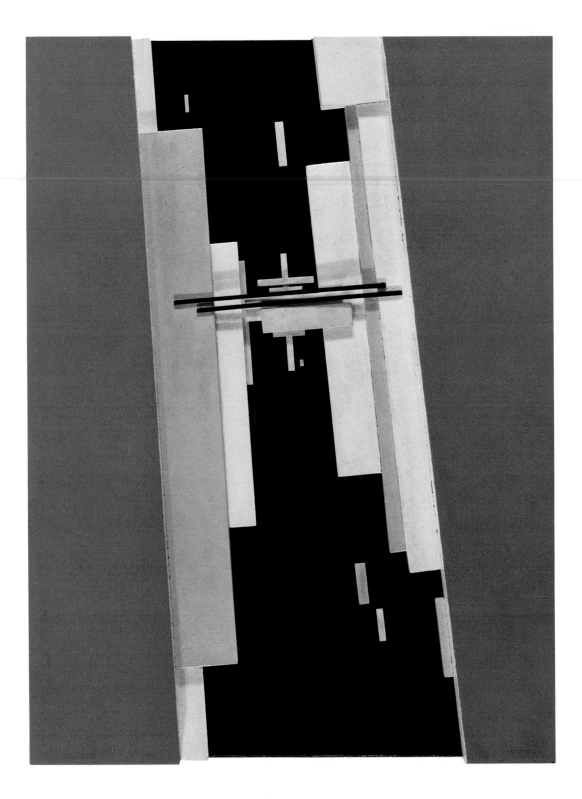

Ilya Chashnik

Born 1902, Latvia
Died 1929, Leningrad

105 *Large Suprematist Relief.* 1920-26

Painted wood and plaster on painted
glass, 33 x 25½" (85 x 63 cm.)

Collection Thyssen-Bornemisza,
Switzerland

REFERENCES:

Kunstmuseum Düsseldorf, *Ilja G.
Chashnik,* May 10-July 2, 1978, pp. 81,
repr., 82, no. 90 (1926). See also related
drawing, pp. 69, no. 55, 70, repr. Texts
by Andrei B. Nakov, Lev Nussberg,
Stephan von Wiese and the artist

Galerie Bargera, Cologne, *Russische
Avantgarde 1910-1930,* May 31-Sept. 30,
1978, pp. 105-121. Texts by Lev Nuss-
berg (reprint of above), Peter Spielman
and Stephan von Wiese

Chashnik, a student and then a pro-
fessor of Malevich's Vitebsk-based
UNOVIS school, sought his own inter-
pretation of Suprematist principles.
Moving away from Malevich's white
ground (as infinite space), in many
works he stressed the "absolute
(colored) surface." True to the prin-
ciples of *UNOVIS,* he believed that
artists should create forms as models
for the new society. This eventually
led him, like Malevich, to create archi-
tectural models.

"Spatialization is the door to the final
realization of the Suprematist objective.
This work leads us to the reconstruc-
tion of the world, the new Nature.
When humanity perceives the dynamics
of this artistic cosmos, then it will come
to the idea of Suprematism as a new
planetary system" (Chashnik, quoted
in Kunstmuseum Düsseldorf, 1978,
p. 20).

106 *The Seventh Dimension: Suprematist
Stripe Relief.* 1925

Painted wood, paper, cardboard and
glass, 10¼ x 9⅞ x ⅝" (26 x 22.5 x
1.4 cm.)

Collection Lev Nussberg, Paris

REFERENCE:

Kunstmuseum Düsseldorf, 1978, p. 81,
no. 89

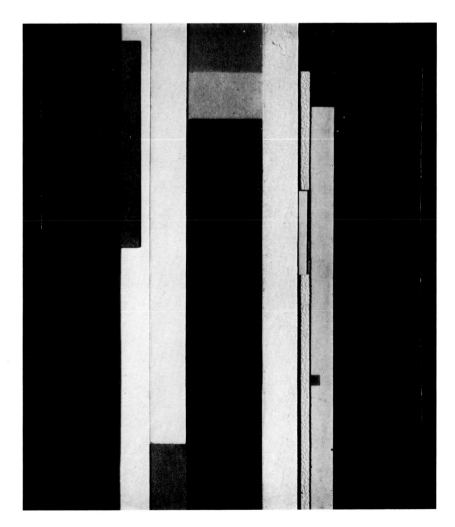

Ilya Chashnik

107 *Suprematist Architectural Model: Cross and Circle.* ca.1926

Plaster, 7⅜ x 6½ x 1⅛" (18.7 x 16.4 x 2.7 cm.)

Collection Lev Nussberg, Paris

REFERENCE:

Kunstmuseum Düsseldorf, 1978, pp. 82, no. 92, 83, repr.

Katarzyna Kobro

Born 1898, Moscow
Died 1951, Łódź

108 *Suspended Composition 2.* 1971 reconstruction by Bolesław Utkin and Janusz Zagrodzki of 1921-22 original

Steel, 16⅞ x 11" (43 x 28 cm.)

Collection Muzeum Sztuki, Łódź, Poland

REFERENCES:

Museum Folkwang Essen, *Constructivism in Poland 1923-1936; BLOK, Praesens, a.r.,* May 12-June 24, 1973, pp. 158, no. 13, 172, repr. Traveled to Rijksmuseum Kröller-Müller, Otterlo, July 14-Sept. 2, 1973

Wladyslaw Strzeminski, Katarzyna Kobro, *L'Espace uniste: écrits du constructivisme polonais,* Lausanne, 1977. See particularly ch. "La Composition de l'espace, les Calculs du rythme spatio-temporel," pp. 85-125

Much of Kobro's production has been lost. Utkin and Zagrodzki reconstructed several pieces from photographs and a study of Kobro's creative, sometimes mathematical, process. Zagrodzki has written that *Suspended Composition 2* was "made of ready-made objects including a hack saw, a steel trestle, a wheel and rim . . ." (Museum Folkwang Essen, 1973, p. 55). When it was first executed, this and analogous sculptures were considered a personal interpretation of Malevich's Suprematism. In fact, Kobro and her husband Wladyslaw Strzeminski were living in Smolensk near Vitebsk and working closely with Malevich and Lissitzky in 1920-21. Yet the textures of industrial objects combined with Kobro's implementation of linear, kinetic form evoke the Moscow *Obmokhu* group as well (see discussion pp. 29-30 here).

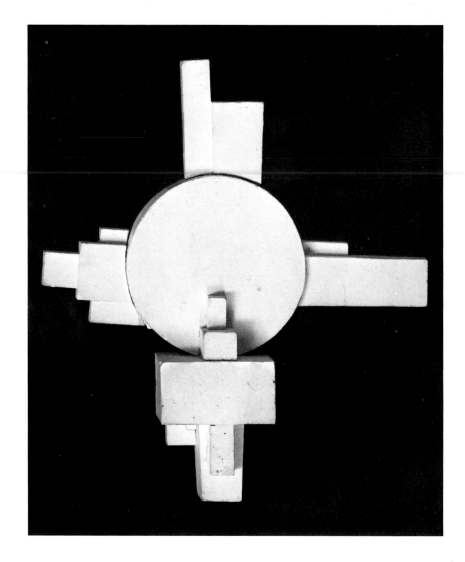

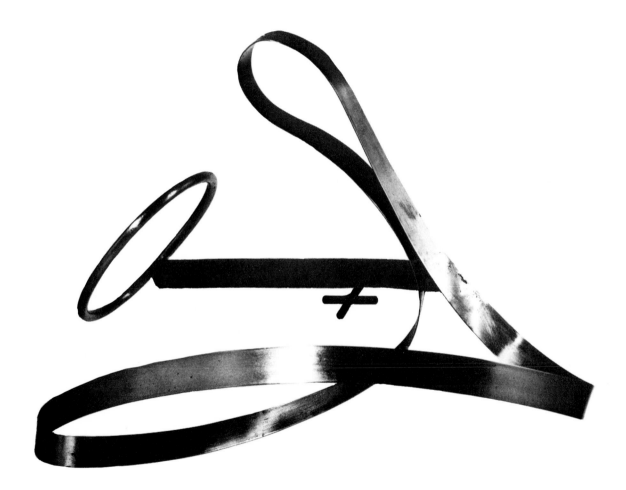

Katarzyna Kobro

109 *Abstract Sculpture 1.* 1924

Glass, metal and wood, 28⅜ x 6⅞ x
6¼″ (72 x 17.5 x 15.5 cm.)

Collection Muzeum Sztuki, Łódź,
Poland

REFERENCE:
Museum Folkwang Essen, 1973, pp.
159, no. 15, 174, repr.

Kobro studied at the Moscow School
of Sculpture and Drawing between
1917 and 1920. During this period her
work showed the influence of Tatlin's
"culture of materials." Although by
1920 she had turned toward Supre-
matism, in this sculpture the com-
bination of materials and the definition
of each substance as a specific form as
well as the organic articulation of the
whole reflect her debt to Tatlin's
aesthetic.

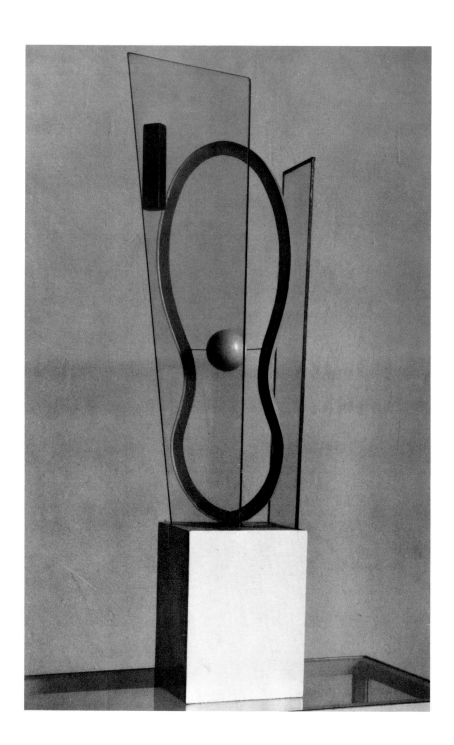

Katarzyna Kobro

110 *Space Sculpture.* 1967 reconstruction, incorporating fragment of original sculpture, by Bolesław Utkin and Janusz Zagrodzki of 1925 original

Steel and wood, 19⅝ x 30¾ x 22″ (50 x 78 x 56 cm.)

Collection Muzeum Sztuki, Łódź, Poland

REFERENCES:

Museum Folkwang Essen, 1973, pp. 159, no. 18, 177, repr.

Westfälisches Landesmuseum, Münster, *Abstraction Création 1931-1936,* Apr. 2 - June 4, 1978, pp. 195, no. 1, 196, repr.

This piece was made in two separate parts. The free-standing curvilinear section is from the original sculpture; the base and semicircular hoop are reconstructions.

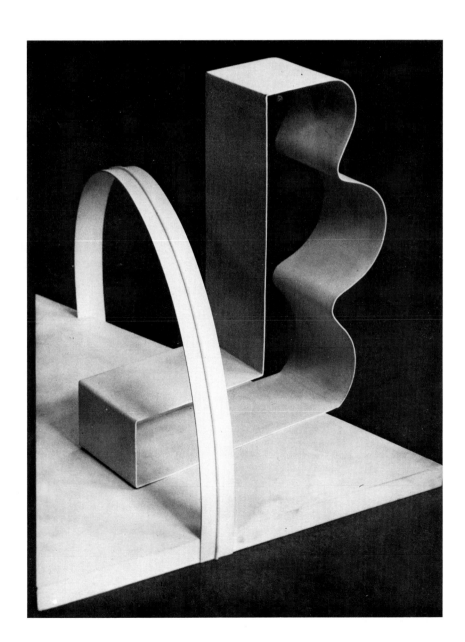

Katarzyna Kobro

111 *Space Composition 2.* 1928

Painted steel, 19⅝ x 19⅝ x 19⅝"
(50 x 50 x 50 cm.)

Collection Muzeum Sztuki, Łódź,
Poland

REFERENCE:

Museum Folkwang Essen, 1973, pp.
159, no. 20, 178, repr.

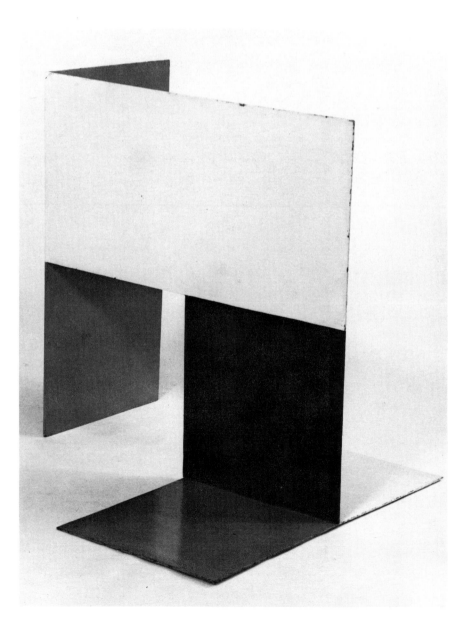

Katarzyna Kobro

112 *Space Composition 3.* 1928

Painted steel, 15¾ x 25¼ x 15¾"
(40 x 64 x 40 cm.)

Collection Muzeum Sztuki, Łódź,
Poland

REFERENCES:

Museum Folkwang Essen, 1973, pp. 159,
no. 21, 179, repr.

Westfälisches Landesmuseum, 1978,
pp. 195, no. 2, 197, repr.

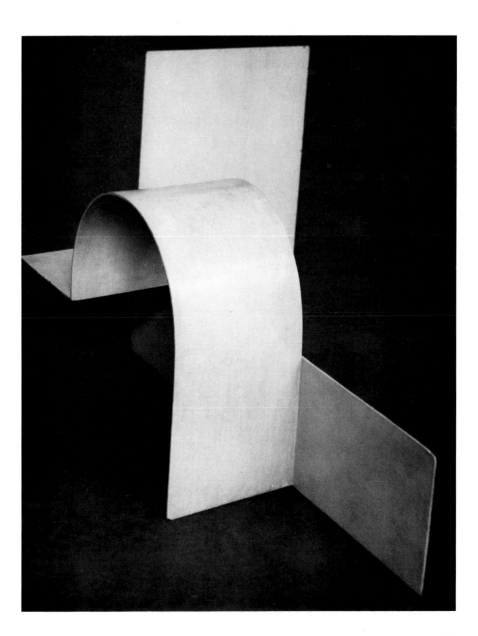

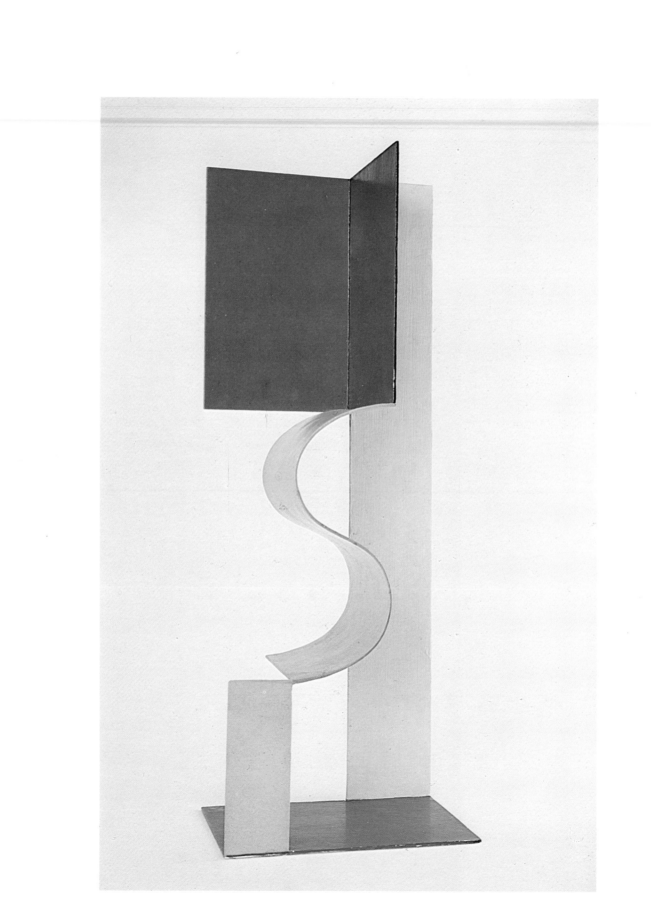

Katarzyna Kobro

113 *Space Composition 6.* 1931

Painted steel, 25¼ x 9⅞ x 5⅞″
(64 x 25 x 15 cm.)

Collection Muzeum Sztuki, Łódź,
Poland

REFERENCE:
Museum Folkwang Essen, 1973, pp. 17,
color repr., 159, no. 24

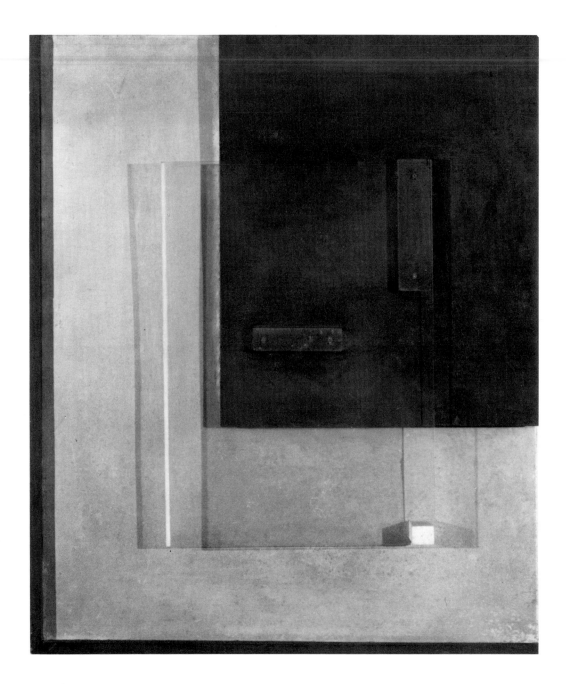

Carl Buchheister

Born 1890, Hannover
Died 1964, Hannover

114 *Aluminum Painting.* 1930
(Aluminiumbild)

Painted wood, aluminum and plexi-
glass, 31½ x 26¾" (80 x 68 cm.)

Collection d'Anethan, Paris

REFERENCE:
Städtische Kunstsammlungen Lud-
wigshafen, *Carl Buchheister,* May 25-
July 27, 1975, pp. 9, 79, color repr. See
particularly texts by Bernhard Kerber
and Wulf Herzogenrath, pp. 13-36

Buchheister, who lived in Hannover
practically all his life, was friendly with
Schwitters, Lissitzky, Moholy-Nagy,
Friedrich Vordemberge-Gildewart and
Alexander Dorner. He was president of
the group he founded with Schwitters,
Die Abstraction Hannover, from
1927-33, and a member of the Der
Sturm gallery and the *Novembergruppe*
in Berlin and of *Abstraction Création*
in Paris.

Buchheister's geometric abstract work
was concentrated in the period 1926-34.
He attempted to extend his paintings
into actual space in a series of reliefs of
1930-31. Here Buchheister painted or
eliminated frames to dispel the "win-
dow-view" effect and superimposed
layers of materials, which were some-
times of industrial origin, to bind the
image into an architectural space. In
the *Aluminum Painting,* the artist
intended to bring the changing en-
vironment into the space of the work
through the reflections in the plexiglass
pane. The *Aluminum Painting* exists
in three identical versions, all executed
by Buchheister himself. Buchheister
believed works of art should be multi-
plied to render them accessible to a
broad public and more appropriate to
architectural use. With this in mind
he chose simple, easily reproducible
forms for these reliefs.

115 *Composition: Glass-Wood-String.*
1931
(Glas-Holz-Faden-Komposition)

Painted wood, glass and string on wood,
26 x 20⅛" (66 x 51 cm.)

Collection Ursula and Hans Hahn

REFERENCE:
Städtische Kunstsammlungen Ludwig-
shafen, 1975, pp. 9, 81, color repr.

The original piece, now lost, was made
in 1930. This is one of three versions
executed by the artist in 1931, one of
which is also lost. A fourth reproduc-
tion was made in 1964.

Here there is very little distinction be-
tween relief and painting but the at-
tempt to do away with illusionary space
is nonetheless clear.

César Domela

Born 1900, Amsterdam
Lives in Paris

116 *Construction.* 1930

Painted metal and plexiglass on wood,
21¼ x 18" (54 x 45.7 cm.)

Signed and dated on reverse: *DOMELA 1930*

Private Collection

REFERENCES:

Kunstverein für die Rheinlande und
Westfalen Düsseldorf, *César Domela:
Werke 1922-1972,* Oct. 12-Dec. 3, 1972,
n.p., no. 14

Galerie Roger d'Amécourt, Paris (organ-
izer), *Domela.* Text by Jan van der
Marck. Traveled to: Colby College
Museum of Art, Waterville, Me., June
26-Aug. 31, 1977; Dartmouth College
Museum and Galleries, Hanover, N.H.,
Sept. 9-Oct. 16; Muhlenberg College
Center for the Arts, Allentown, Penn.,
Oct. 15, 1977-Jan. 15, 1978

Domela's first reliefs, which were Neo-
Plastic in style, date from 1929 when
the artist was living in Berlin. Domela
continued to work in this mode until
he moved to Paris in 1933 and intro-
duced the lyrical curvilinear motifs
which characterize his art to this day.

Jan van der Marck has recently written
about the reliefs of 1929-33: "The geo-
metric relief is a form of art based in
almost equal measure on the evolu-
tionary logic of Neoplasticism and the
material ingenuity of Constructivism.
Neither painting nor sculpture, it is a
hybrid, functioning as the utopian
model of an unseen universal order
and, therefore, reminding the viewer of
the general morphology of architec-
ture" (Galerie Roger d'Amécourt, Paris,
1977, n.p.).

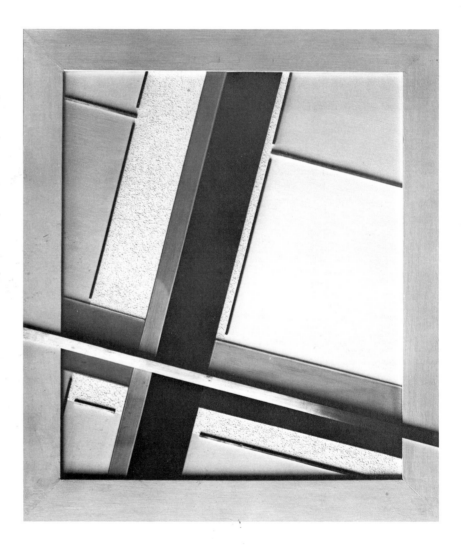

Harry Hess: cat. no. 84

Courtesy Hirshhorn Museum and Sculpture Garden, Smithsonian Institution, Washington, D.C.: cat. no. 14

Courtesy Annely Juda Fine Art, London: cat. nos. 34, 35

Walter Klein: cat. nos. 106, 107

Joseph Klima, Jr.: cat. nos. 20, 21

Courtesy Kunsthaus Zürich: cat. no. 58

Courtesy Kunstmuseum Basel: cat. nos. 10, 41

Courtesy Lords Gallery, London: cat. nos. 81, 82

Courtesy Marlborough Fine Art (London) Ltd.: cat. nos. 77, 79, 80

Robert Martin: cat. no. 114

Robert E. Mates and Mary Donlon: cat. nos. 17, 45, 92

Robert E. Mates and Paul Katz: cat. no. 18

Courtesy McCrory Corporation, New York: cat. no. 89

Courtesy Moderna Museet, Stockholm: cat. no. 9

André Morain: cat. no. 50

Courtesy Musée d'Art Moderne, Strasbourg: cat. no. 39

Courtesy Musée National d'Art Moderne, Centre Georges Pompidou, Paris: cat. nos. 28, 31

Courtesy The Museum of Modern Art, New York: cat. nos. 2, 11, 22, 37, 70, 91, 103

Courtesy National Gallery of Art, Washington, D.C.: cat. no. 40

Courtesy Mr. Neirynck: cat. no. 54

Otto E. Nelson: cat. no. 85

Courtesy Philadelphia Museum of Art: cat. nos. 27, 44, 63, 72

Courtesy The Phillips Collection, Washington, D.C.: cat. nos. 73, 104

Courtesy Galerie Quincampoix, Paris: cat. no. 68

Courtesy Rheinisches Bildarchiv, Cologne: cat. no. 33

F. Rosenstiel: cat. nos. 30, 32

Courtesy Christian Schad: cat. no. 48

Victor Schrager: cat. no. 66

Leonard Sempolinski: cat. nos. 110, 112

Zdzislaw Sowinski: cat. nos. 108, 111

Courtesy Stedelijk Museum, Amsterdam: cat. no. 12

Courtesy Tate Gallery, London: cat. no. 3

Courtesy Galerie Teufel, Cologne: cat. nos. 93, 94, 95, 115

TM Fotografik, Basel: cat. nos. 53, 97, 98

Courtesy Galerie Tronche, Paris: cat. no. 71

E. B. Weill: cat. nos. 42, 43, 46

Courtesy Lydia and Harry L. Winston Collection (Dr. and Mrs. Barnett Malbin), New York: cat nos. 19, 59

Courtesy Yale University Art Gallery, New Haven: cat. nos. 52, 76, 90

From Christian Zervos, *Pablo Picasso: oeuvres de 1912 à 1917*, vol. 2**, Paris, 1942: cat. nos. 1, 5, 6

FIGURES IN THE TEXT

Courtesy Mr. Herman Berninger: fig. 16

J. E. Bulloz: fig. 2

Courtesy Jean Chauvelin: fig. 11

Documentation photographique de la Réunion des musées nationaux, Paris: fig. 15

Courtesy André Emmerich Gallery, New York: fig. 1

Courtesy Miriam Gabo; E. Irving Blomstrann: figs. 12, 13; fig., p. 70

Courtesy Hirshhorn Museum and Sculpture Garden, Smithsonian Institution, Washington, D.C.: fig. 14

Courtesy Leonard Hutton Galleries, New York: fig. p. 49

Courtesy Donald Karshan: figs. 8, 9

From Marthe Laurens, *Henri Laurens: Sculpteur 1885-1954*, Paris, 1955: fig. 3

Courtesy Jean-Claude Marcadé: fig. 10

Courtesy Museo Depero, Rovereto, Italy: fig. 6

Courtesy The Museum of Modern Art, New York: fig. 4

Courtesy Barbara Rodchenko: fig. 18

Lothar Schnepf: fig. 17

Courtesy Lydia and Harry L. Winston Collection (Dr. and Mrs. Barnett Malbin), New York: figs. 5, 7

EXHIBITION 79/1
4500 copies of this catalogue,
designed by Malcolm Grear Designers,
have been typeset by Dumar Typesetting
and printed by Eastern Press
in March 1979 for the Trustees of
The Solomon R. Guggenheim Foundation
on the occasion of the exhibition
The Planar Dimension: Europe, 1912-1932.
Second printing of 5000 copies, April 1981